Watteau

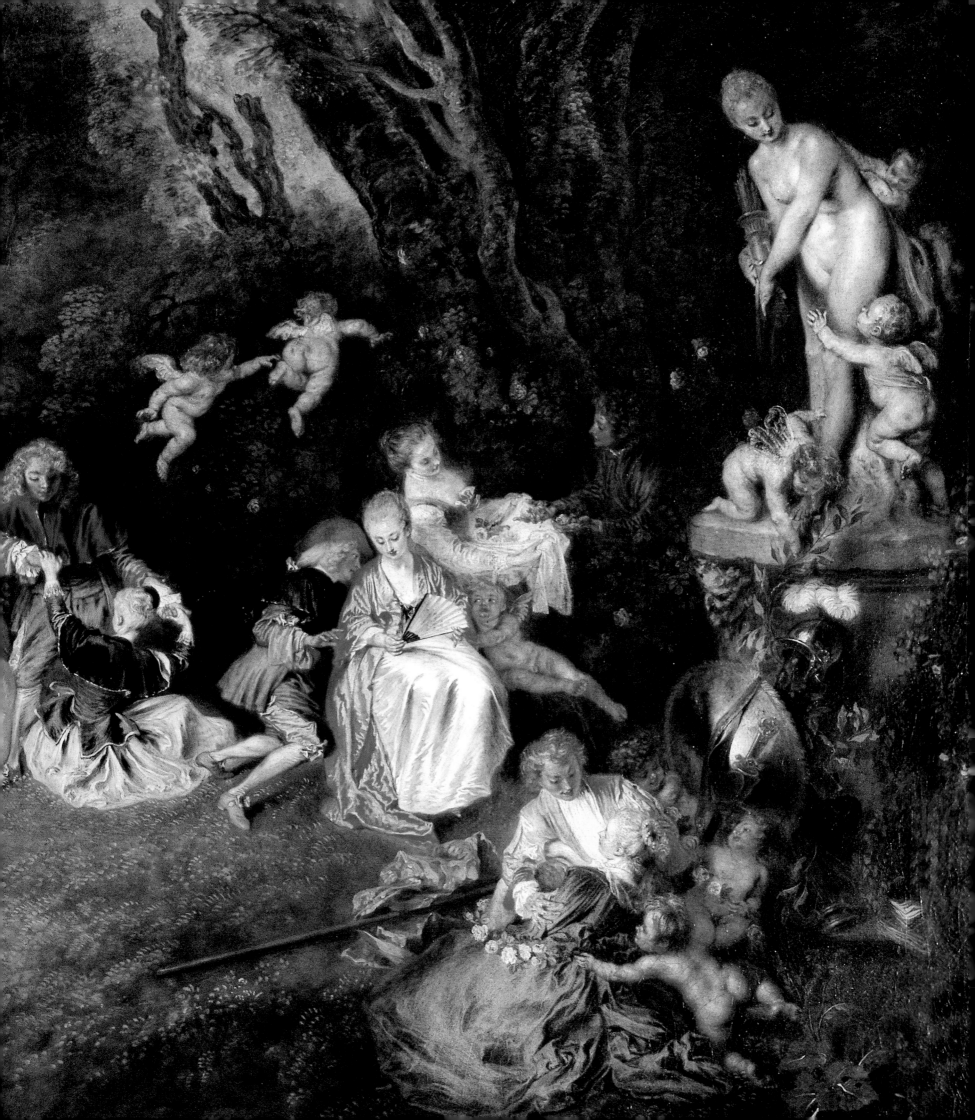

Helmut Börsch-Supan

Antoine
Watteau

1684–1721

KÖNEMANN

Frontispiece

1 *Embarkation for Cythera* (detail, ill. 57)

© 2000 Könemann Verlagsgesellschaft mbH
Bonner Str. 126, D– 50968 Köln

Publishing and Art Director: Peter Feierabend
Project Management: Ute Edda Hammer, Jeannette Fentroß
Layout: Claudia Faber
Picture Research: Stefanie Huber
Production: Petra Grimm
Lithography: Digiprint, Erfurt
Original title: *Watteau. Meister der französischen Kunst*

© 2000 for this English edition
Könemann Verlagsgesellschaft mbH
Translation from German: Anthea Bell in association with Cambridge Publishing Management
Editing: Chris Murray in association with Cambridge Publishing Management
Typesetting: Cambridge Publishing Management
Project Management: Jackie Dobbyne
for Cambridge Publishing Management
Project Coordinator: Kristin Zeier
Production: Petra Grimm
Printing and Binding: Neue Stalling, Oldenburg
Printed in Germany

ISBN 3-8290-3273-0

10 9 8 7 6 5 4 3 2 1

Contents

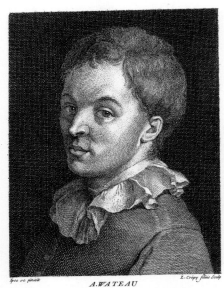

2 Louis Crépy, after Watteau's *Self-Portrait* of 1727
Etching, 15.2 x 12.1 cm
Kupferstichkabinett, Staatliche Museen zu Berlin –
Preussischer Kulturbesitz, Berlin

Louis Crépy's engraving is a version of the self-portrait by
Watteau that in 1727 was in the possession of Watteau's
friend, Gersaint, but is now lost. In depicting his everyday
appearance, and turning a lively, inquiring glance on the
viewer, Watteau shows his dislike of the grandiose style of
the portrait of an artist usual in France at the time. Such
portraits generally showed the subject three-quarter
length, with his hands in view, wearing fine clothing, a
wig, and with professional accessories.

3 Rosalba Carriera
Antoine Watteau, 1721
Pastel, 55 x 43 cm
Museo Civico, Treviso

Watteau had a great liking for Venetian painting, and there
must have been a lively exchange of ideas between the
artist and the celebrated Venetian woman pastel painter,
nine years his senior. She mentions Watteau several times
in her journal. However, in the portrait she depicts him as
a man with only a fleeting glance to spare for the observer.

The 17th century was an age of great painters: the age
of Rubens (1577–1640), van Dyck (1599–1641),
Velázquez (1599–1660), Poussin (1594–1665), Rem-
brandt (1606–1669), and Vermeer (1632–1675). With
the deaths in 1682 of Murillo (1618–1682) and Claude
Lorrain (1600–1682), the last of these outstanding
artists of genius passed away. Two years later, Antoine
Watteau was born in Valenciennes, the son of a roofer.
The town of Valenciennes, founded in Roman times,
was once the residence of the Counts of Flanders, but
was by now merely a border outpost. The troops of
Louis XIV did not take Valenciennes until 1677, in a
surprise attack, and it finally became a French possession
the next year at the Peace of Nijmegen. The time and
place of Watteau's birth can therefore hardly have made
him feel firmly rooted in French culture. Indeed, the
great altarpiece of St. Stephen (ca. 1614) by Rubens,
from the nearby monastery church of St. Amand, and
now in Valenciennes Museum, clearly reminds us that
the town used to be part of the Spanish Netherlands,
and that Tournai, only about thirty kilometers away,
was one of the original centers of Early Netherlandish
painting. Robert Campin (ca. 1375–1444) had lived
and worked in Tournai, and Rogier van der Weyden
(1399/1400–1464) was born there. These artistic
glories, however, were now in the distant past, and by
1700 the artistic life of the region was very modest.
Jacques-Albert Gérin (ca. 1640–1702) was the best-
known painter in Valenciennes. He is said to have been
Watteau's first teacher, but if so his teaching had no
obvious influence on the young painter.

The air of mystery in Watteau's life can probably be
explained partly by the complex effect of these cultural
and political conditions on his private circumstances.
We know that his father was a violent man, a quality
that must have greatly distressed the sensitive son, and
perhaps that is why there is no reference to Watteau's
family anywhere in his work. He certainly had friends,
but though love and children are central subjects in his
art, he never married. Nothing is known of any love
affair, nor can any clue to such a relationship be found
in his work, which indeed conveys the impression,
instead, that Watteau saw art as complementary to life,
not as something growing directly out of it. It is as if

an invisible wall separates the painter from the world
he is painting.

Scarcely anything written in the artist's own hand
exists, and the archival records of his life are meager.
Most of what we know about him comes from the more
or less extensive biographical writings of contemporaries
who were his friends: the art dealer Edmé-François
Gersaint (1694–1750); his patron Jean de Jullienne
(1686–1766); the collector Antoine de La Roque
(1672–1774), the subject of one of Watteau's few
portraits; and among art critics the Comte de Caylus
(1692–1765), Pierre-Jean Mariette (1694–1750),
Antoine Dézallier d'Argenville (1680–1765), and the
Abbé Josse Leclerc. The comments of these authors
enable us to form an idea of the artist's character that is
reflected in his oeuvre as it has come down to us. They
also allow us to fully appreciate the difficulties arising
from the chronological order of his works, and thus the
course of his artistic development.

Watteau lived quietly, without ostentation. He was a
reserved and thoughtful man, dissatisfied with himself
to the point of bitterness. The painter of cheerful social
gatherings was not himself a sociable man. He knew a
great deal about music, and he read voraciously; he was
therefore an educated artist, though he expressed no
opinions on artistic theories, nor did he construct any
himself. The mystery surrounding the artist as a man is
also evident in the few portraits of him. With the
founding of the Paris Académie in 1648, a sense of
community as well as increased self-confidence had
developed in artistic society, and this was expressed not
least in the many portraits that artists executed of their
colleagues. Painters or sculptors who specialized in
portraiture were frequently asked to portray another
artist as a reception work for the Académie. In this way
France formed a unique collection of artists' portraits,
which later passed from the ownership of the Académie
to the Museum of French History at Versailles. Watteau
is not represented in it, though he became a member of
the Académie in 1717.

The one undoubtedly authentic portrait of the artist is
a pastel painted by Rosalba Carriera (1675–1757)
during her visit to Paris six months before Watteau's
death, when his consumption was already well advanced.

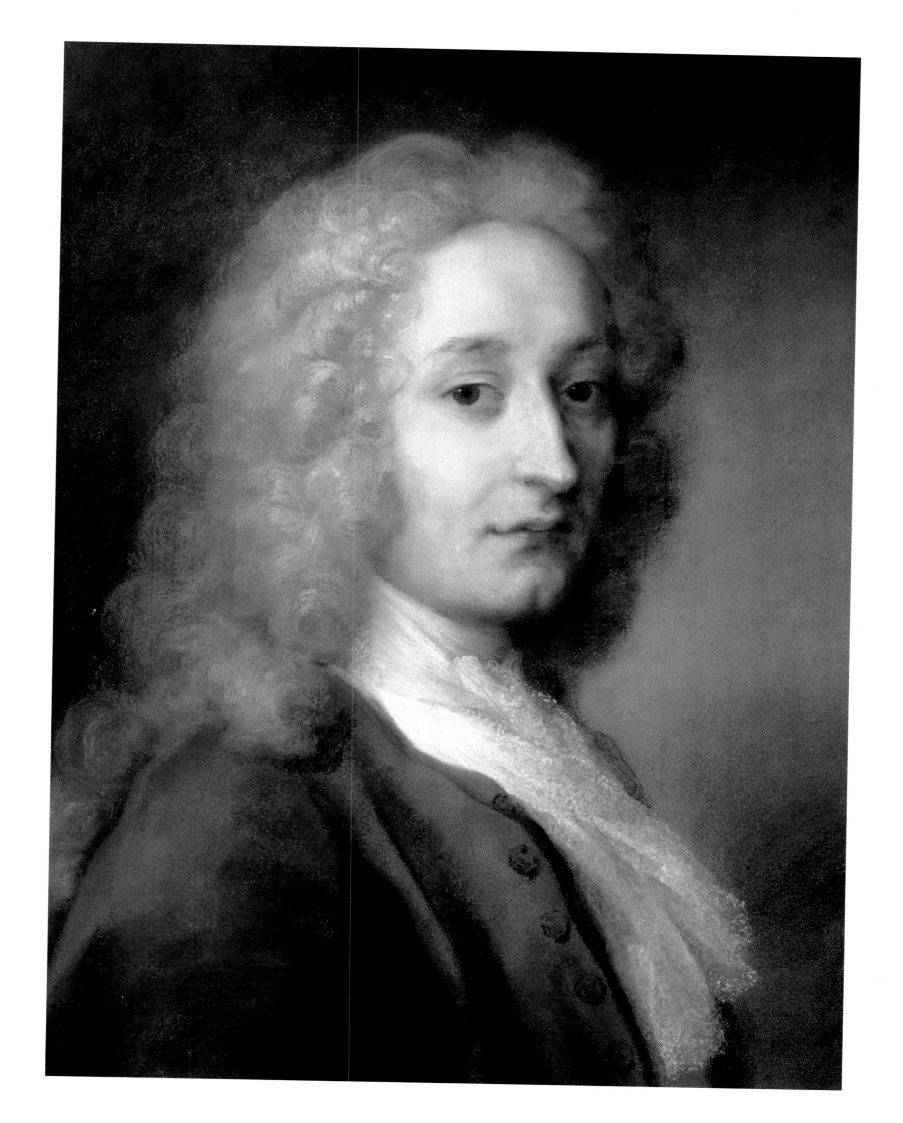

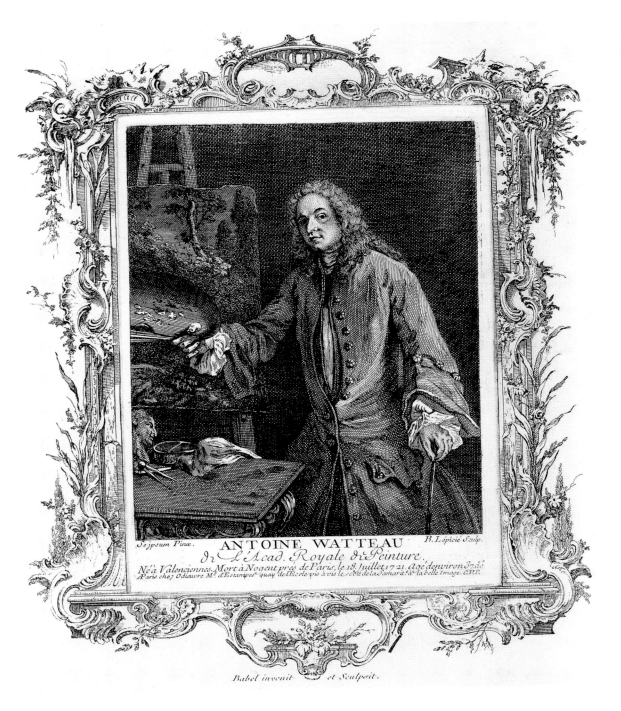

Se ipsum Pinx. B.Lépicié Sculp.

ANTOINE WATTEAU
de L'Acad. Royale de Peinture.
Né à Valenciennes, Mort à Nogent près de Paris, le 18. Juillet 1721. Age d'environ 37 ẽs.
A Paris chez Odieuvre M.^d d'Estampes quay de l'Ecole vis à vis le costé de la Samarit.^e à la belle Image. C.P.R.

Babel invenit et Sculpsit.

5 opposite page
François Boucher, after Watteau
Antoine Watteau, 1726
Etching, 33.3 x 22.7 cm
Kupferstichkabinett, Staatliche Museen zu Berlin –
Preussischer Kulturbesitz, Berlin

This etching, from a drawing by Watteau himself, was
used by Boucher as the title page for his book of
engravings *Figures de différentes caractères*. Boucher
intended this portrait to be chiefly a memorial to the artist
as a draftsman; he himself had profited greatly by
Watteau's example. He enriches the painter's clothing by
adding a fur-lined coat.

4 Bernard Lépicié the Elder,
after Watteau's *Self-Portrait* of 1736
Etching, 13.1 x 10.6 cm (frame by Babel)
Archiv für Kunst und Geschichte, Berlin

This print reproduces a small self-portrait Watteau painted
around 1720, in Jullienne's possession in 1736, but now
lost. The palette in front of the landscape painting, which
shows a "pure landscape," in other words a natural scene
without human figures, is symbolic of the harmony
between a painting dominated by color and nature itself.
The self-portrait therefore makes a programmatic
statement.

The famous Venetian painter had been commissioned to
produce this work by Watteau's rich patron Pierre Crozat
(1665–1740). The portrait (ill. 3) now in the Museo
Civico of Treviso is probably the one done for Crozat,
though it may be a authorized replica. The sitter's youth-
ful appearance does not suggest a man of 36. But he was
sick, and looks out of the picture at the observer with a
despondent gaze, the only movement he seems to be
attempting. A touch of pain plays around the expressive
mouth, and the nose is very narrow by comparison with
the rather portly body. Rosalba Carriera was no
psychologist; her success was based on her ability to
suggest something of the aura of a sitter's personality, and
to convey the atmosphere of luxury that usually
surrounded her models. She used the method here,
though this convention seems incongruous in view of

Watteau's pain; it is as if the sick man's fate inspired her to
transcend her usual limitations.

Two self-portraits by Watteau have come down to us
only in engravings. The later example (ill. 4), which can
be dated at around 1720 and which was reproduced in
reverse by Bernard Lépicié (1698–1755), is very like
Rosalba's portrait. Watteau is holding his maulstick in
his right hand, like a walking stick, while with the brush
and palette in his left hand he points to the landscape
standing on the easel, at the same time obscuring the
central subject – a statement of his love for nature. A
small table stands directly in front of the easel, with a
cloth on it for wiping his brushes; a divided vessel
probably intended to hold fluids for cleaning his brushes
and thinning his paint; a pair of compasses, symbolizing
moderation; and finally, in direct contradiction to that

symbol, the head of a faun. The table and its objects indicate that the painter is not at the moment working on his picture, but has time to devote to the observer. It is not easy to reconcile this likeness with the other self-portrait, probably dating from over ten years earlier, which is extant only in an engraving by Louis Crépy (1680–1746). This head and shoulders portrait (ill. 2) shows the artist without a wig, wearing his natural hair cut short, and leaning slightly backward in the confident attitude that is typical of a self-portrait. As well as the clear, direct glance of the eyes, the striking feature once again is the sensitive mouth, this time contrasting with a rounded, almost peasant-like skull.

In the concept of this self-portrait there is a borrowing from a self-portrait by Watteau's first Parisian teacher, Claude Gillot (1673–1722) – certainly not because he lacked ideas of his own, but in acknowledgement of the example Gillot had set. The period between the two extant self-portraits of Watteau corresponds roughly to the brief span of his creative career – so far as his career is known to us, for the early stages are hidden in obscurity. We may look in vain for any hidden self-portrait in his paintings; the world he painted was not the world in which he lived. This distancing of himself from his work is also reflected in the fact that he did not sign his paintings. The more a great artist withdraws personally from his public, the more it wants to see him in a portrait. In his youth François Boucher (1703–1770), who was eighteen at the time of Watteau's death, had been an ardent admirer and imitator of the older artist. He produced a variant on the late self-portrait in a drawing and an engraving (ill. 5), giving Watteau a crayon to hold instead of the maulstick and showing him in a conventional pose, holding a portfolio of drawings.

Jean de Jullienne, Watteau's friend and an enthusiastic collector of his paintings and drawings, who distributed Watteau's work as engravings after the artist's death, went even further. For the title page of his collection of engravings *L'Oeuvre d'Antoine Watteau* he had himself depicted against a landscape background, playing the cello in the painter's company. The picture is reminiscent of the late self-portrait: Watteau has assumed the same attitude, and the landscape on the easel in the portrait is similar to the landscape in which the friends are seen together. However, Jullienne did not really do his friend justice with this montage. The cheerful playfulness of the engraver, Nicolas-Henri Tardieu (1674–1749), is alien to Watteau's own personality, though at least this picture shows how he and his art were regarded by others.

The mystery surrounding Watteau's person is also reflected in the mystery of his work; yet if we look at it in the right way it provides the most reliable information available about its creator. Since nothing is known of his early artistic work, the extant oeuvre, consisting of about 200 original oil paintings, many of them preserved in engravings and copies, and his works of interior decoration, almost without exception extant only in engravings, are crowded together into a period of about fifteen years.

In this relatively short space of time, the artist went through a dramatic development. It is difficult to determine the motive force behind that development, more particularly because it is not so much a straight path as a network, with many interconnections to be borne in mind. There is still much uncertainty about the ascription, dating, and interpretation of Watteau's works. Many small fragments of information have been accumulated from a range of sources, including close studies of the artist's work, in the attempt to build up an overall picture, like a mosaic, but it refuses to fit neatly together. Watteau did not think like other artists, and in view of the atmospheric intensity of his pictures critics have not always realized that he was thinking at all, particularly as the concept of iconography does not feature prominently in his work. What his paintings really communicate cannot be summed up in their titles, which indeed are generally taken from later reproductions in engravings, since Watteau himself did not name his works. Their titles should therefore be used only for purposes of description, as a convenient nomenclature. Study of his developing personal style is important, but it is even more important to notice not just changes in form, but also the modification of his ideas as they mature. For Watteau does indeed communicate something in his pictures, even while he appears to be merely dreaming. Order can be imposed on his oeuvre as a whole only if we look at the statements made by the individual works, and then we shall soon see that there is more variety in Watteau than may appear at first glance.

Watteau developed his gifts in Paris, but all his life he was an outsider in the city, a man inwardly wishing to get away from this center of power, yet unable to withstand the magnetic attraction of the metropolis. It is impossible to imagine him drawing subjects from the life of the inner city, or even the environs of Versailles, to which the king had moved his court in 1682. He noticed only those areas where the city merged with the countryside, or rustic settings far from the centers of cultural and economic life. A general readiness to leave the city is characteristic of the painter, who never had a permanent address of his own in Paris, but always stayed with friends. When Watteau first came to Paris in 1702 at the age of 18 to continue his education and earn his living, the War of the Spanish Succession was a year old and the first cracks had already appeared in the grand façade of absolutist power with which the Sun King so expertly dazzled all of Europe – even though in 1701 Hyacinthe Rigaud (1659–1743), a skilled propagandist, depicted not only the French aristocracy but the king himself, then aged 63, in a pose that can hardly be surpassed for majesty (ill. 7). For a long time this work was the model for many portraits of rulers: here, in a historical phenomenon sometimes observed in other cases, the artistic expression of potency compensates for the reality of dwindling political power. Those who remain unimpressed will turn a keener eye on the world and see it afresh. It was such a view that Watteau acquired.

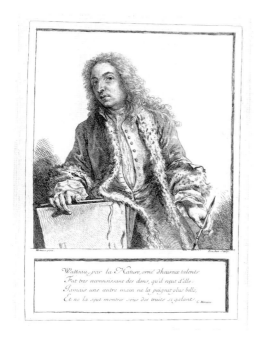

6 Nicolas-Henri Tardieu
Double Portrait of Antoine Watteau and Jean de Jullienne in a Landscape, 1726
Etching, 37.9 x 29.4 cm
Kupferstichkabinett, Staatliche Museen zu Berlin – Preussischer Kulturbesitz, Berlin

Jean de Jullienne commissioned this etching for the title page of his collection of engravings, *L'Oeuvre d'Antoine Watteau*. He himself, playing the cello, sits in front of the artist in a luxuriant landscape. This picture of friendship is also intended to symbolize the close links between music and painting, and the common attraction to nature of both arts.

7 Hyacinthe Rigaud
Louis XIV in Armor, 1701
Oil on canvas, 238 x 149 cm
Museo del Prado, Madrid

Louis XIV is painted as a military commander in armor in a style that was no longer worn at this period, with an exaggeratedly large, flowing sash. Rigaud presents the king in exactly the same pose as in his famous state portrait of the monarch in an ermine robe, painted the same year, the ultimate expression of the equation of state and sovereign. In the state portrait, the king holds the royal scepter; here, he holds a field marshal's baton. Joseph Parrocel painted the battle scene in the background.

It would be very misleading to regard Watteau's art as a direct reflection of life in Paris in the early 18th century. If it makes any statement about its time, it does so as a countertype, expressing political realities only through presenting images of the aspirations of the time. Following half a century of great political power and cultural brilliance, the period when Watteau lived and worked in Paris was one of political, economic, and artistic decline. The rise of France to the status of the leading nation of Europe was closely linked to the outstanding personality of Louis XIV (r. 1643–1715), who, though king at an early age, finally took up the reins of power in his early twenties on the death of Cardinal Mazarin (1602–1661), who as chief minister had guided the country's destiny with such skill. Known as the Sun King, Louis was brilliantly gifted, impressive in appearance, and possessed by a determination to become the mightiest king in Christendom and to make Paris greater even than Rome; he achieved his aims with the help of outstanding ministers and generals, and through a tightly organized state. It was a state which he, as its sovereign, equated with himself. However, it was a form of state organization that entailed the repression of all libertarian impulses and individual life-styles at home, and encouraged campaigns for the ruthless acquisition of territory abroad. From its neighbors, France won both admiration for its cultural achievements, and hatred for its foreign policy.

Under Louis, industry and trade flourished, and the country's wealth allowed the king's absolute power to be depicted with a splendor unprecedented in Europe. Imperial Rome was the model. Châteaux were built and parks laid out; Versailles became the most brilliant court in Europe; the city of Paris was enlarged. Science and the arts received generous encouragement from the state, which aimed to establish national supremacy in those fields as well as others. French literature saw a literary golden age, with works by the dramatists Pierre Corneille (1606–1684), Jean Racine (1639–1699), Jean-Baptiste Poquelin, otherwise known as Molière (1622–1673); the poets Jean de La Fontaine (1621–1695) and Nicolas Boileau (1636–1711); the homilists Jacques Bénigne Bossuet (1627–1704) and François de Salignac de la Mothe Fénélon (1623–1715); and the moralists Blaise Pascal (1623–1662) and Jean de La Bruyère (1645–1696). All these men were born between 1606 and 1645, and none of them survived the Sun King. Architecture, sculpture, and painting too could boast of more outstanding figures in the 17th than in the early 18th century. The deaths of Charles Lebrun (1619–1690) and Pierre Mignard (1610–1696) brought an epoch of French historical painting to an end, and thereafter the portrait became the leading pictorial genre, with the works of Hyacinthe Rigaud (ill. 7) and Nicolas de Largillière (1656–1746) (ill. 66). Portraiture did not come naturally to Watteau, however.

These intellectual and artistic developments cannot be seen in isolation from political circumstances: the turning point in France's expansionist policy came, after several unsuccessful campaigns, with the Peace of Rijswijk (in 1697), when certain areas of conquered territory had to be given up. The French navy had been defeated by the English at La Hogue as early as 1692. And not only were the country's power reserves exhausted by constant wars, the state had also weakened itself through its own intolerance. For in 1685 Louis XIV rescinded the Edict of Nantes enacted by Henry IV (r. 1589–1610), which had allowed Protestants religious freedom, and 400,000 Huguenots fled the country. Jansenism, a sternly moralistic Catholic tendency, was also suppressed. The support given to Louis by King James II of England and Scotland (r. 1685–1688) brought about the Glorious Revolution of 1688 that toppled James from his throne.

Even worse loss of power was suffered in the Wars of the Spanish Succession of 1701–1714. On the death of Charles II of Spain (r. 1665–1700), his lands were inherited by a grandson of the Sun King, Philippe Duc d'Anjou, who became Philip V of Spain (r. 1700–1746). The Holy Roman Emperor Leopold I (r. 1658–1705) raised objections to this shift in the balance of power, and France soon felt the wrath of most of the other major European states, suffering several severe setbacks. These might have led to complete disaster but for the political changes of 1710 in England, when the Whig government fell, which led in 1711 to the withdrawal to England of the victorious Duke of Marlborough (1650–1722) with his troops, and finally to the Peace of Utrecht in 1713. It was followed in 1714 by the Peace of Rastatt and Baden, concluded between France and the Emperor. Louis XIV's idea of his own universal claim to sovereignty was weakened by these events, a decline accompanied by economic problems. In 1709 Paris was afflicted by famine. The following winter was very severe, and the national debt amounted to two billion livres. Rumors of poisoning surrounded the sudden death of Louis' son the Grand Dauphin (1661–1711), the deaths of the Dauphin's eldest son Louis de Bourgogne (1682–1712) and Louis' wife the next year, and the death in 1714 of Louis' brother Charles Duc de Berry (1686–1714). When Louis XIV died in 1715 he was succeeded by his great-grandson, who at the age of five became Louis XV (r. 1715–1774), under the regency of his great-uncle Philippe Duc d'Orléans (1674–1723).

Under the peace-loving Duc d'Orléans, a witty but immoral man who loved the arts, life in Paris changed fundamentally. A new age had begun, one that was to have a profound impact on the arts. The permission granted to the Scottish financier John Law (1671–1729) to found a private bank indicated an adventurous financial policy. Later, Law's idea of a national bank were adopted, and the public began speculating wildly; poor men suddenly grew very rich, and in this financial frenzy the old social order was undermined. In the summer of 1720 the bubble burst. Watteau, living in England at the time, would have lost his entire fortune had Jullienne not succeeded in salvaging 6,000 livres for him.

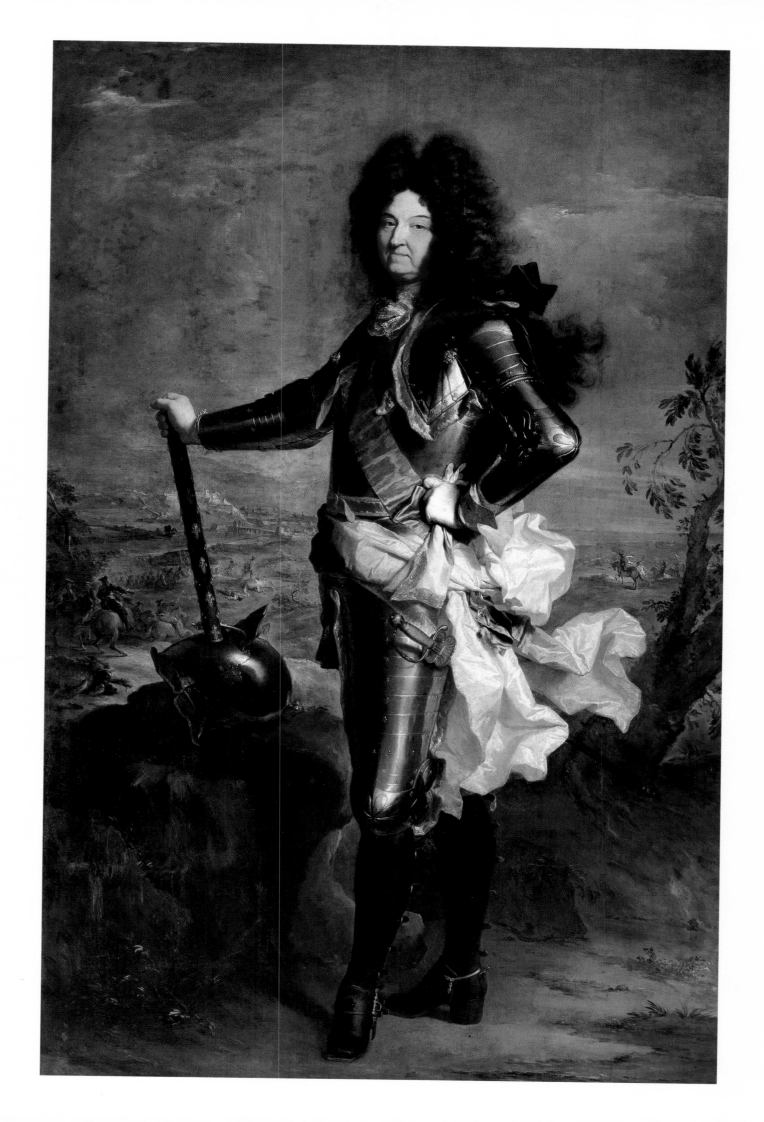

Gersaint's Shop Sign

8 *Gersaint's Shop Sign* (detail, ill. 9)
The Porter

The porter is waiting until he can load the crate onto his handcart, which originally stood on the paving stones where the bundle of straw now lies. He is not poorly clothed; manual labor seems to provide him with an adequate income. Gersaint would presumably have employed only the most reliable men to transport works of art for him.

9 (double spread, next two pages)
Gersaint's Shop Sign
Oil on canvas, 166 x 306 cm
Schloss Charlottenburg, Berlin

Along with the *Embarkation for Cythera* (ill. 57), this is Watteau's best-known work. It was originally intended as a shop sign, but was soon turned into two gallery pictures instead, with its format considerably altered. The shallow arch of the original upper edge of the picture can still be made out. On the right, the stone pillar that originally matched the one on the left has been trimmed away. The oval of the large painting, like the shape of the seated woman's skirt, relates to the arched shape of the upper edge of the sign.

A few months before his death on July 18, 1721, at the age of only 37, Watteau produced *Gersaint's Shop Sign* (ill. 9), his greatest painting – not only in its dimensions but for what it says about his ideas. A shop sign was normally a task for unpretentious ornamental artists; in this case it is the masterpiece of an artist who had become a member of the distinguished Paris Académie as early as 1717. But like his reception piece for the Académie, the brilliant *Pilgrimage to the Island of Cythera* (ill. 55), in which Watteau showed no particular esteem for that ultimate artistic authority, the shop sign expresses a critical attitude toward the art world. It is with this in mind that we should study the curious history of the painting, later to be hung in the picture gallery of a royal castle when, in 1754, Frederick the Great acquired it for the music room of Charlottenburg palace near Berlin.

There is something provocative, yet also a hint of bitterness and resignation, in the story of a great painter summing up his ideas in a picture intended to hang out in the street, where of course everyone could see it, but where it would be exposed to wind and weather and likely to deteriorate rapidly. Or was the possibility of what in fact happened part of his calculations from the start? When the picture had been hanging over Gersaint's shop doorway for fourteen days, admired by many viewers, Claude Glucq (1674–1748) bought it. Though Glucq thereby saved it from destruction, he considerably impaired its appearance, for the change of function from a shop sign with an arched upper edge to a rectangular gallery picture entailed altering its format, some sections being enlarged, others cut down. In fact he turned the original painting into two rectangular pictures. Since they were to be the same size, and since the only place to divide the original work was between the two main groups, a strip about 30 cm wide was trimmed from the right-hand side, and a piece of this strip was used to extend the pictorial area in the top right-hand corner. It is easy to see where the original upper edge ran. X-ray photographs have also shown that remnants of canvas already trimmed away by Watteau were used to enlarge the picture, since the irregularities created by freehand cutting with scissors match exactly on the original

picture and the extension. The enlargement of the pictorial area and the trimming of the right-hand side were therefore the work of someone with access to Watteau's studio, most likely his pupil Jean-Baptiste Pater (1695–1736). It was certainly not Watteau himself, for though the rapid brushwork is almost identical on the original painting and the new area, there is one crucial difference: all the pictures shown within the new area of the painting are copies of existing works of old masters – Rubens, Titian, and Jordaens – whereas the pictures in the original painting are all Watteau's own inventions.

The alteration may not have been carried out until after Watteau's death. According to Gersaint, Pater had been accepted as the artist's pupil only a month earlier; Pater acknowledged later that he "owed all he knew to this brief period of time." He was a pleasing but only moderately talented painter, and his ability to imitate his master's style was an asset that he skillfully exploited. It was also Pater who at some time before 1732 made a copy of the shop sign as the model for a reproduction engraving by Pierre Aveline (1702–1760), with the proportions greatly altered.

The first owner of the shop sign, the art dealer Edmé François Gersaint, gives a full account of its creation in a biographical essay on Watteau, which was printed in the auction catalog of the de Lorangère collection in 1744:

"On his return to Paris in 1721, the first year of my company's existence, he came to ask if he could stay with me, and if he could be allowed to get the stiffness out of his fingers – those were his words – by painting a picture which, if I liked, could be hung outside the shop. I protested, suggesting that he ought to put his mind to something more substantial, but when I saw that it would give him pleasure, I agreed. The success of this picture is well known. It was all painted from the life. The movements were so relaxed and true to life, the composition so natural, the grouping so skillful, that it attracted the glances of passers-by, and even the most distinguished of painters came several times to admire it. The picture was done in eight days, during which time he could work only in the mornings, as his frail state of health would not allow him to paint for longer.

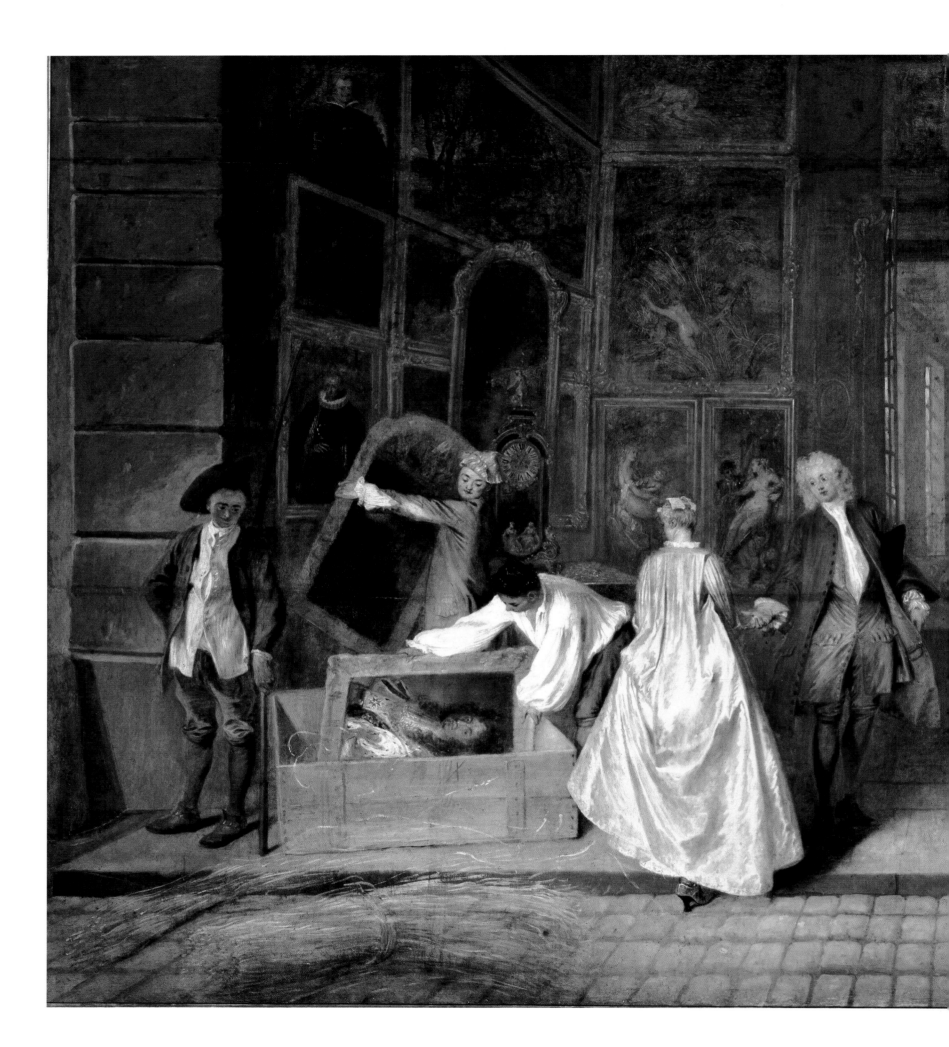

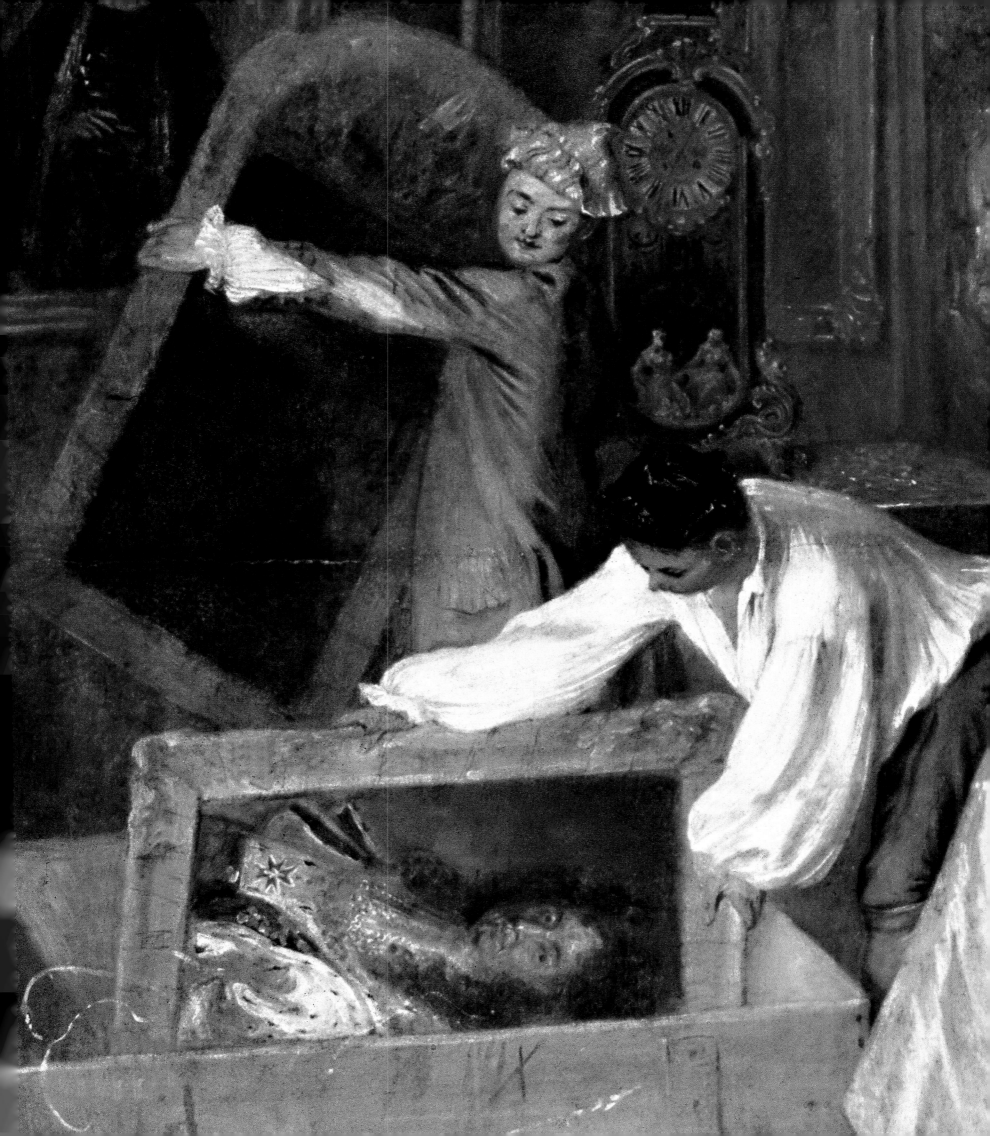

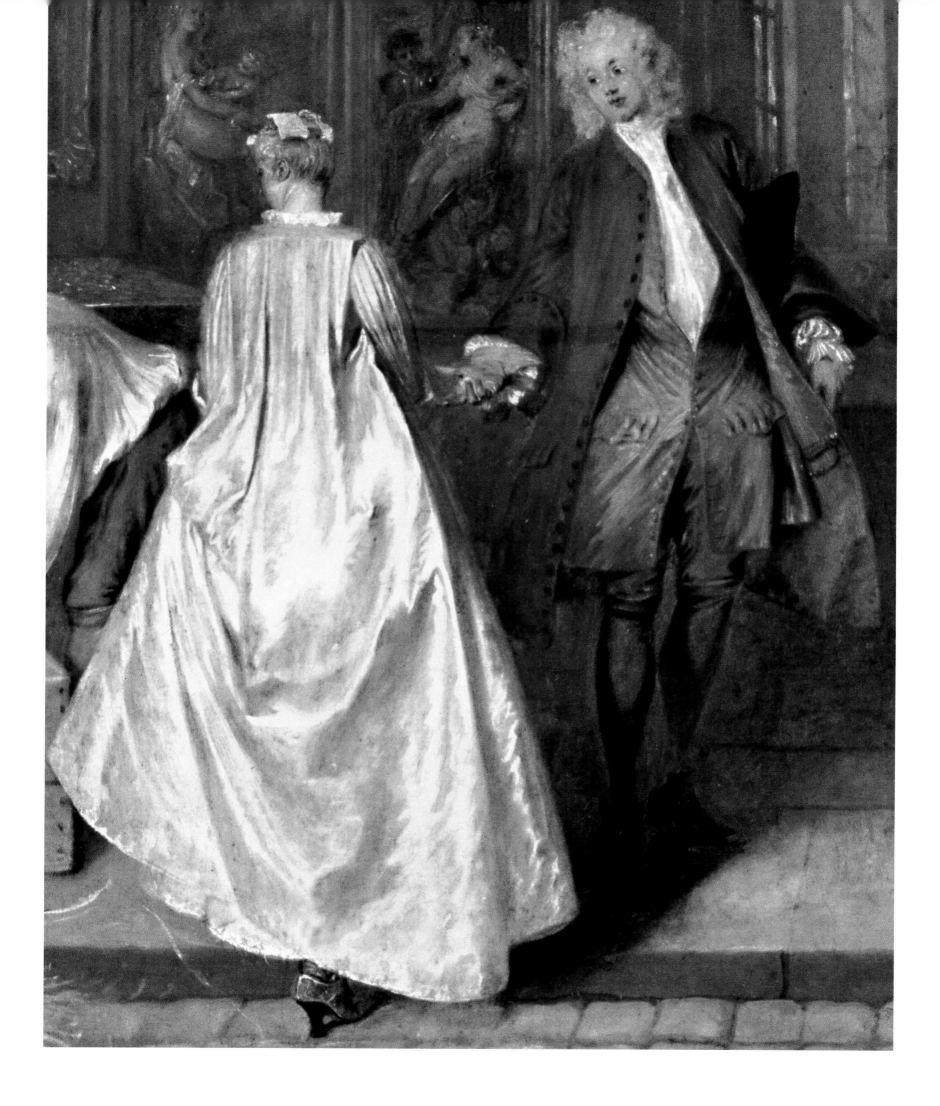

picture intended for public view very soon disappeared into private ownership. Did Watteau really intend to paint a sign for Gersaint's shop?

To answer this question we need to examine the picture. The groups of figures are set side by side, as in a frieze. If we "read" them from left to right, we can trace the painter's line of thought. The scene begins with the portrait of Louis XIV being packed in a crate (ill. 11). This half-length replica of Rigaud's famous ceremonial portrait alludes to the name of the shop taken over by Gersaint in 1718, *Au Grande Monarque*. His portrait, hung in many places as a reminder of his monarchy, no longer has any function; it is being placed in the crate, as if in a coffin, to be taken away. The art dealer has not sold the picture: by having it stored in a crate for removal he is getting rid of something no longer saleable. Busy with this royal portrait are a servant employed by the shop and a porter, waiting until he can load the crate onto the handcart on which he will take it away. They are looking down at the picture of the king, and so is a second servant as he carries a mirror past. In the background is an ornamental buhl clock of a kind regarded at this period as old-fashioned – further confirmation that the king's day is over. Furthermore, the ceremonial portrait of a formal gentleman wearing a ruff in the fashion of before around 1630 hangs on the wall to the left. Louis XIV was born in 1638, and in the view of those who wanted change he had lived and reigned far too long. Watteau, whom Louis XIV had made a Frenchman through territorial expansion, was one of those forward-looking spirits who welcomed the comparatively liberal rule of Philippe d'Orléans' regency.

The message conveyed by this first group of figures, therefore, may be interpreted as an ironic rejection of the Sun King's reign and his grandiose style. It may be added here that the Comte de Caylus, one of Watteau's earliest biographers, confirms that Watteau was inclined to indulge in mockery and sarcasm.

If the interpretation of these first figures, and of the pictures and other items around them, is correct, then the whole painting can be understood in such terms. The paintings on the wall are not just the art dealer's stock in trade; they provide a commentary on the figures depicted, and through them on society as a whole.

The group next to the scene just described belongs to a higher social class (ill. 12). The woman in the pink gown, seen from behind, is also casting a fleeting glance down at the royal portrait, thus providing a link with the group of servants. As she steps up from the street into the shop, she gathers up the folds of her skirt in her left hand; and her elegant companion looks at her, holding out his hand in a gesture of invitation to both her and the viewer.

These two figures are directly associated with a pair of tall, narrow pictures of a shape usually found only in the wings of altarpieces. The picture on the left shows Venus and Cupid, the picture on the right Venus and Mars. The proximity of the woman in pink to the goddess of love makes her appear to be a lover herself, while her suitor, unwarlike as he may look, must inevitably be equated with Mars. However, the love affair between Mars and the goddess of love was illicit, since Venus was married to Vulcan: a situation that hints at the relationship between the couple in the shop. A depiction of Ovid's tale of Pan pursuing the nymph Syrinx (ill. 14) hangs above the two narrow pictures. This allows us to contrast the decorous appearance of the couple in public with man's lustful impulses and secret thoughts. There is a deeper meaning behind his inviting gesture.

The couple to the right of these two provide a counterweight. They belong to the group in the right-hand half of the picture, which again is divided into two, and since it contains seven figures is more densely populated than the left-hand side. In the original format it also occupied more space (ill. 15). The two figures, obviously an old married couple, are looking at a large oval picture of women bathing; the subject may be *Diana Discovering the Pregnancy of Callisto*. The man is kneeling to get a better view of the female figures that intrigue him, while the dark-clad matron is examining the inoffensive foliage of a tree. She has in her hand a fan, an familiar attribute of many of Watteau's *dames galantes* because it could be used to give signals to lovers – but here we notice that she holds it not by the handle but at the other end, so that it cannot be unfolded.

The man's kneeling posture links him with the Carmelite monk in the picture above him. This painting, which would probably have reminded a contemporary Parisian observer of a cycle of scenes from the life of St. Bruno painted by Eustache Lesueur (1617–1665), conjures up the deep religious feeling of the past, enabling us to judge the conduct of the kneeling connoisseur of art: the modern Parisian has no religion but the enjoyment of earthly pleasures, an interpretation that is also suggested by the opulent still life of fruits above the oval picture. These people are in pursuit of folly. The point is reinforced by the picture of a court fool caressing his bauble as if it were a child, a common theme of Flemish painting from the 16th century onward. There are fools in many of Watteau's pictures, and one of his depictions of such a figure, *The Sick Cat*, is described as a *tableau de l'humaine folie*, a "picture of human folly," in its engraved reproduction by Jean Michel Liotard (1702–1796).

The art dealer stands beside the picture of the nymphs, holding it up and making an explanatory gesture with his left hand. Finally, there is a group of four people arranged in a triangle on the right (ill. 16). A woman and two men are looking into a mirror that has been placed on the counter by the saleswoman. The face of the seated lady in the striped silk dress and black cloak is seen in profile. She balances the figure of the woman in the pink gown seen from behind, and dominates the right-hand side of the picture in the same way as the pink-clad woman dominates the left-hand side. One foot is just emerging from beneath her full skirt, and the toe of her shoe rests exactly on the place where four of the stone flags on the floor meet. The three people are looking in the mirror with a degree of attention which, in a room like this, ought more properly to be directed at the works of art. However,

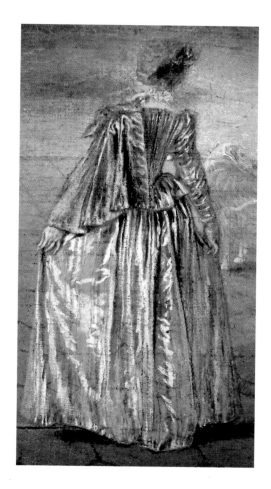

13 *The Pleasures of the Ball* (detail, ill. 44)

Watteau liked to include back views of figures in his compositions, not only to enhance the effect of spatial depth but also to depict the fall of the folds of rich garments as part of the wearer's intriguing charm. Most of the clothes he paints in this way are women's dresses.

12 *Gersaint's Shop Sign* (detail, ill. 9)
Woman in Pink Gown

A woman in a pink gown steps up from the street into the shop. We see her gathering the folds of her skirt in her left hand. Watteau liked to paint women from behind wearing flowing garments that fall and drape smoothly; they gave him an opportunity of catching the play of light in the shifting folds of the fabric. Here he also emphasizes the curve of the outline.

14 *Gersaint's Shop Sign* (detail, ill. 9)
Syrinx and Pan

This picture within the picture shows the nymph Syrinx trying to escape the rustic god Pan as he pursues her. In the next moment, as she calls out for help, her sisters will turn her into a reed, from which Pan will make the flute known as a syrinx and conjure mournful sounds from it. The subject of a lustful nature god recurs in similar form in *Jupiter and Antiope* (ill. 89).

they have eyes only for their own reflections, and so symbolize vanity. There are no fewer than four mirrors in the shop. One is being carried past the chest with the royal portrait, while another, behind the buhl clock, actually conceals several paintings – a detail designed to incense any artist or art lover. The vanity of society is obviously more important than the message of art. A fourth mirror, which has an elaborate frame in the contemporary *Régence* style, accentuates the group of figures to the right of the picture, towering above them.

The paintings to the right of this mirror are on very different subjects. Above the figures on the right hangs a picture of Silenus accompanied by Bacchantes, a scene reminiscent of Rubens, and to the right of this picture

there is a scene on a subject that cannot be clearly made out, although it may be Leda and the Swan. Both, in any case, are mythological pictures on the theme of the pleasures of wine and physical love. Beneath them is a religious subject, linked by its serious character to the picture of the kneeling Carmelite: it shows the mystical wedding of St. Catherine of Siena to the Christ Child. This late medieval saint – she lived from 1347 to 1380, and was venerated for her devoted care of the poor and the sick – entered into so close a relationship with Christ through her severe self-mortification that she believed he had given her His blood to drink, and had exchanged His heart with hers. St. Catharine therefore provides a striking contrast to the self-regard of

15 *Gersaint's Shop Sign* (detail, ill. 9)
Women Bathing in a Landscape

The painting shows two women bathing in a landscape. Before 1799 the oval format was most usually employed for portraits. Watteau liked to use it for other kinds of pictures, and started a Rococo fashion that originated in his experience of decorative painting. The oval clearly marks the painting out as distinct from the rectangular format of the other pictures that line the walls like paneling.

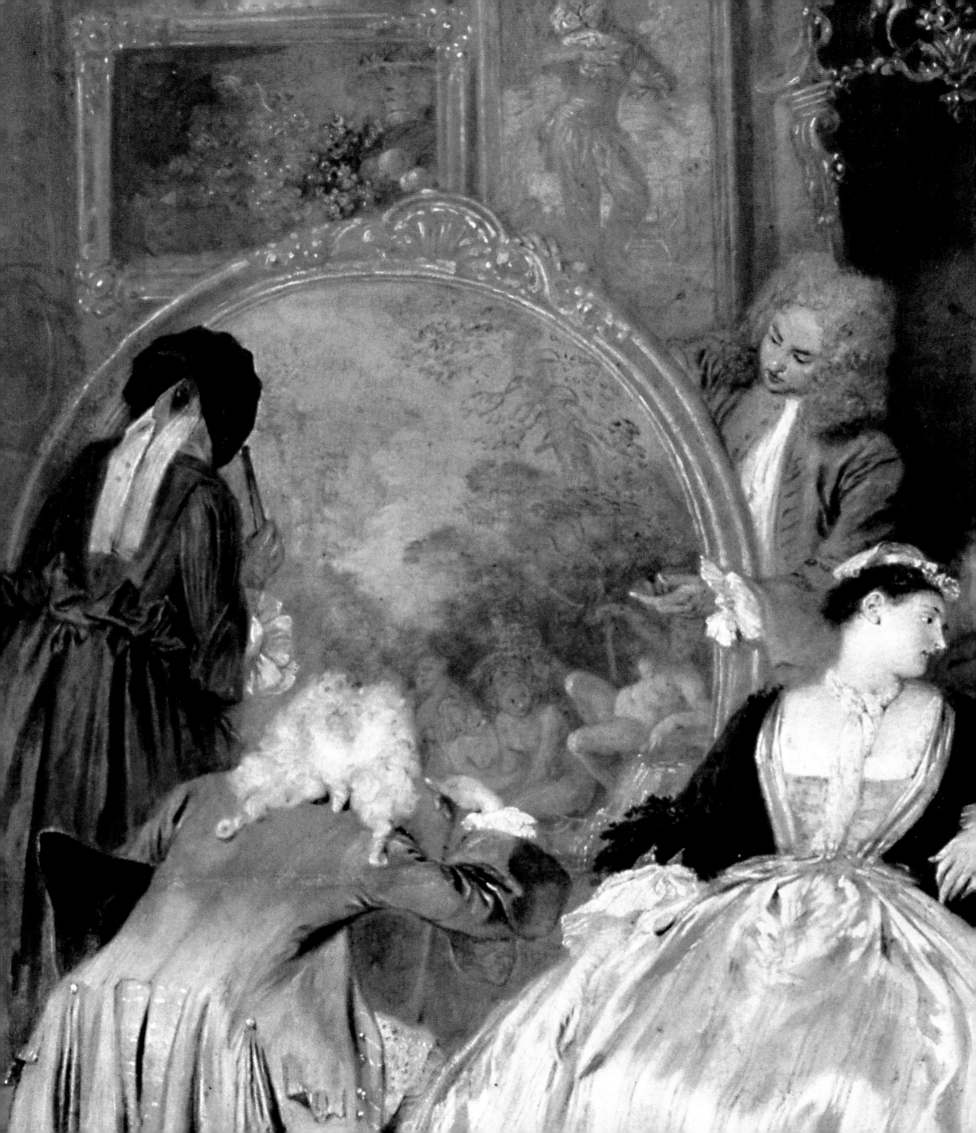

16 *Gersaint's Shop Sign* (detail, ill. 9)
Saleswoman

The saleswoman sitting behind the counter is offering the shop's wares to her customers. A mirror and an open lacquer box stand on the counter in front of her. The latter item tells us that Gersaint dealt in *chinoiserie* as well as pictures. It has been suggested that the saleswoman is Madame Gersaint, a daughter of the glazier Pierre Sirois, whom Watteau painted (ill. 50).

Gersaint's customers. Framed by the group looking at their reflections and the saleswoman, the picture stands in a curious relation to them. The attitude of the young woman sitting behind the counter corresponds symmetrically to the pose of the saint in the picture: just as a bridge was built over the centuries between the Christ Child and St. Catharine, a second arch spans the distance between the saint and the modern saleswoman.

During the last months of his life, Watteau turned to religious subjects with increasing frequency. Two surviving examples are a *Rest on the Flight into Egypt* (ill. 117), now in the Hermitage in St. Petersburg,

Russia, and a small *Holy Family* in private ownership. They can be compared with this picture within a picture not only in subject but in the rapidity of their execution. However, Watteau's last work, a *Christ on the Cross* painted for the church of the village of Nogent-sur-Marne, where he died, is now lost.

Depictions of the mystical wedding of St. Catharine were particularly popular in Venetian painting, and a drawing in the Courtauld Institute in London suggests that Watteau based his composition on a painting from the workshop of Paolo Veronese (1528–1588), now in Detroit.

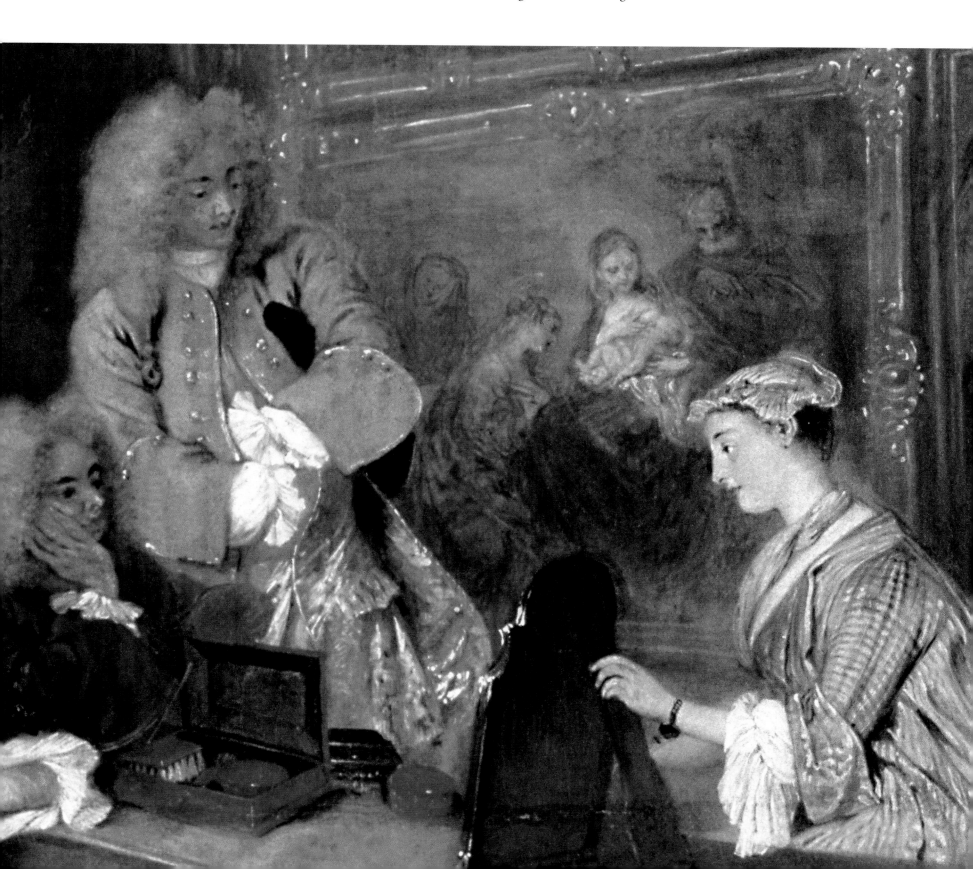

If the paintings shown by Watteau on the walls really have some connection with what is going on in the shop itself, then this depiction of religious fervor not only enhances the figure of the young saleswoman and her modest charm, but also marks a break in the narrative.

There is one final painting to be considered: the landscape hanging behind the saleswoman. It shows a stormy, autumnal landscape in the evening, an uncanny scene containing no human figures and full of elemental forces. This picture too is in stark contrast to the world of Parisian polite society. Rubens, a fellow countryman of Watteau and an artist whom the later painter greatly admired, loved such natural scenes. Formally, the isolation of this last picture from the others is also emphasized by the edge of the counter beneath it, a vertical that cuts right through the composition.

Together with the *Wedding of St. Catharine*, this landscape may be seen as a profession of faith by the painter, who withdrew from the city a few weeks before his death in order to end his days in the country. According to Gersaint and Caylus, Watteau was even planning to return to his native Valenciennes.

The dog in the foreground (ill. 18) relates to this landscape. In terms of composition it balances the bundle of straw that serves as packing material for the portrait of the king on the left, but over and beyond that it has a subjective significance. There are many dogs in Watteau's work. In his *fêtes galantes* they symbolize natural instinct rather than loyalty, and they quite often occupy a central place in the composition. In the late work *The Shepherds* (ill. 63), the chain of figures begins with a dog uninhibitedly licking itself, and in *Love in the Country* (ill. 105), a dog lies in the center foreground, relating to the distant panorama of the landscape in very much the same way as the dog in the shop sign does to the painted landscape.

In addition, the dog in the shop sign represents an allusion that only a connoisseur would pick up: Watteau is quoting from one of the most famous and admired pictures in Paris, Rubens' *Wedding of St. Catharine* in the Palais du Luxembourg. Watteau had been able to study the cycle to which this picture belongs very closely when he was working in the palace before 1709, as assistant to Claude Audran III (1658–1734). Since then the cycle had been widely distributed through engravings, and Watteau's dog must have been taken from one of these reproductions, for it appears reversed on the shop sign. The dog painted by Rubens is a noble hound, lying on the floor of the cathedral of St. Denis where kings were crowned and buried, the most solemn church in France. Watteau moves his own dog, no longer an elegant pedigree animal, to the gutter of the Pont Notre-Dame. Once observers have been reminded of the royal burial place, their minds go back to the king whose portrait is just being placed in a crate like a coffin, and the picture ends as it began, with an insult to royal majesty (although a skillfully coded one). Its message is rejection of the absolutism of Louis XIV, and with it the rejection of Parisian society and its ideas of art and culture.

While clearly acknowledging both his Flemish models and the great Venetians of the 16th century in the paintings on display in Gersaint's shop, Watteau made no reference to the specifically French tradition of Nicolas Poussin and Charles Lebrun, whose neo-classicism had suited Louis XIV's own ideas of art.

On the title page of the second part of his extensive collection of engraved reproductions of the artist's work, Jean de Jullienne, Watteau's most enthusiastic patron, described him as a *peintre flamand*. The term should be understood not only as a reference to the artist's origins, but as indicating Watteau's wish to introduce elements of Flemish art into French painting.

The shop sign, an interior full of paintings related to each other and to the figures in the room in their content, is thus in the Flemish tradition of the depiction of Teniers the Younger (1610–1690; ill. 20). Watteau links this tradition to the genre of the shop sign informing passers-by about the nature of the establishment beyond it. Two sketches provide evidence that he had already painted such shop signs during his early period in Paris: one of these drawings shows a draper's shop, the other a barber's.

This late shop sign, however, goes far beyond the earlier examples. While it appears to be an advertisement for the firm, it really looks back to Flemish *Kunstkammer* pieces and uses satire to arouse discussion of public attitudes to art. Watteau is expressing his own ideas rather than advertising the wares of the art dealer Gersaint.

However, certain ideas have also entered the picture from another source: the world of Italian comedy, to which Watteau felt very close. Italian comedy at the time was extremely popular among the lower classes, since it voiced criticism of social evils in the upper echelons of society by making fun of them. Watteau's many theatrical pictures, in which he showed his sympathy for traveling players, did not merely depict famous scenes from drama but also supported social criticism seeking to change the structure of the state. One way in which he indicated the link between his painting and the world of Italian comedy was by including a fool. We might go even further and see the entire picture as a comedy intended to reveal the real nature of Parisian society. Watteau brings the comedy out into the street, where everyone can see it; the sign is street theater, played out on the stage of Gersaint's shop.

If we look at the picture in this way, we can understand why Watteau positively pressed it on his friend, and why Gersaint in his own turn was quick to sell it, although it had been greatly admired. It was not at all suitable as a shop sign, for a dealer cannot both invite customers in and mock them. Naturally enough, Gersaint said nothing very precise in his biographical essay on Watteau about this situation, from which he could hardly distance himself. He confined himself to mentioning Watteau's tendency to mockery, his misanthropy, and his complex character in general.

In view of the beauty of the picture, not least the harmony of its coloring, some may doubt whether it is really a piece of social criticism, and while we may take

17 *Gersaint's Shop Sign* (detail, ill. 9), Fool

Pictures often included a fool as part of a group, less frequently as the single figure shown here full length. Such fools were court jesters, and were portrayed as such.

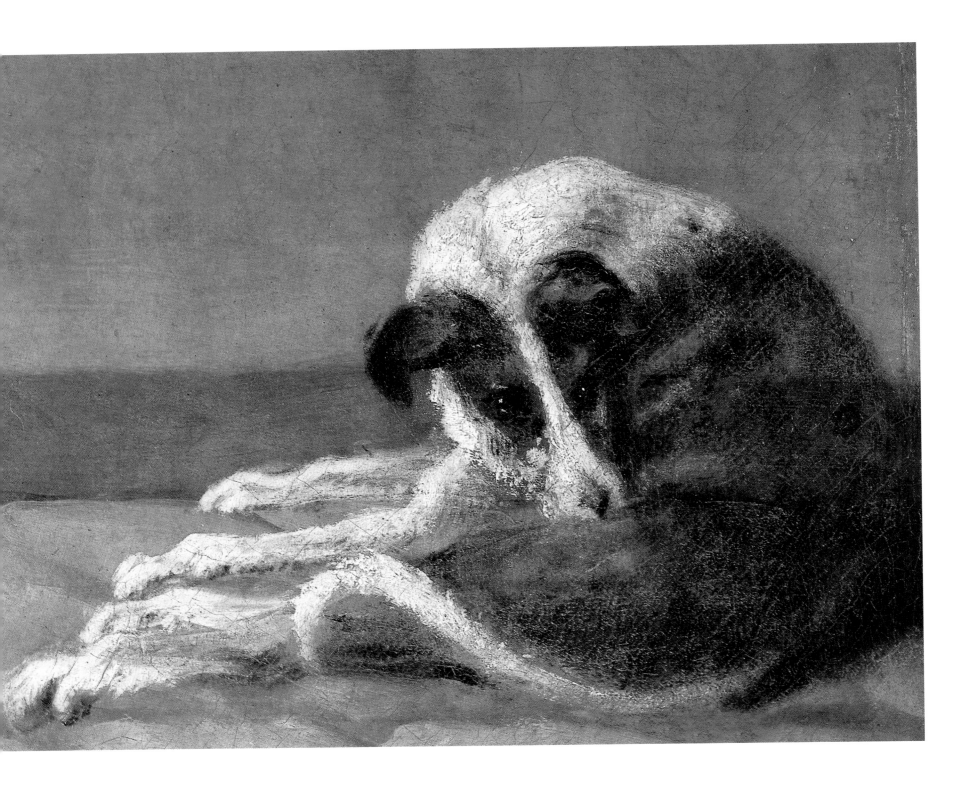

18 *Gersaint's Shop Sign* (detail, ill. 9), Dog

The dog fleaing itself also appears in *The Pleasures of Life*
(ill. 77), painted about two years earlier.

intellectual pleasure in the jest and its critical allusions, we cannot disregard that beauty. Antoine Watteau expressed both admiration and criticism in his portrayal of the two women who dominate the scene. They are not looking at the pictures; they are there not to see but to be seen, as if they themselves were the works of art.

Another late work by Watteau illustrates this ability to combine ironic criticism with delicate beauty: the *French Players* (ill. 19), a depiction of the rival troupe that competed with the Italian players. It has been interpreted, probably correctly, as a parody of the French theater, which at this time was heavily overloaded with dramatic action. The costumes suggest the period of Louis XIV. The leading male actor is clenching his right

fist, the woman beside him laments dramatically, and the woman on the extreme left sobs uncontrollably. An actor turns away and sees an officer coming up from the back of the stage, about to give a dramatic new turn to the plot. The accumulation of effects tips tragedy over into comedy, and the grandiose architecture of the set suits the bombastic action: four columns, standing side by side, support lofty archways. As an engraved reproduction shows, they were originally ornamented with a coat of arms containing the royal lilies.

On a visit to Paris in 1725, the Danish writer Ludwig Holberg (1684–1754) confirmed that it was the practice of Italian players to poke fun at the drama of their rivals by parodying the French style.

19 *French Players*, ca. 1720
Oil on canvas, 57.2 x 73 cm
The Metropolitan Museum of Art, New York

The coloring of the picture is exquisitely delicate. The salmon pink in the clothing of the leading actor predominates, and is associated with silver tones and pale, shimmering hues of blue, brown, gray, and black, while radiant white merges with the clouds. The subject is a scene so overloaded with action and dramatic effects that tragedy turns into comedy. The picture may be seen as a parody of the French drama of the time.

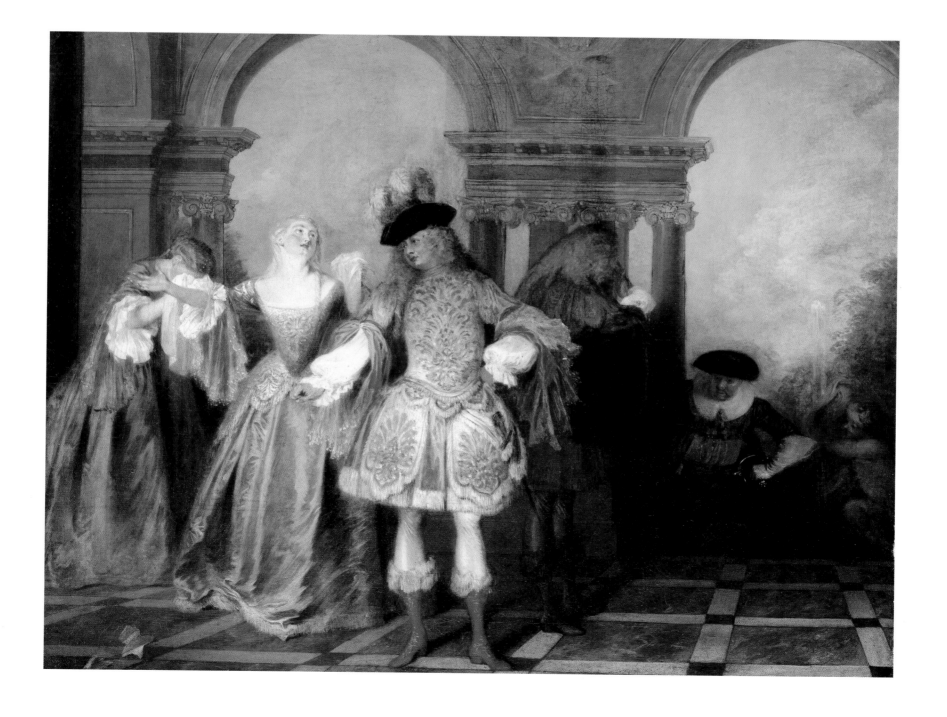

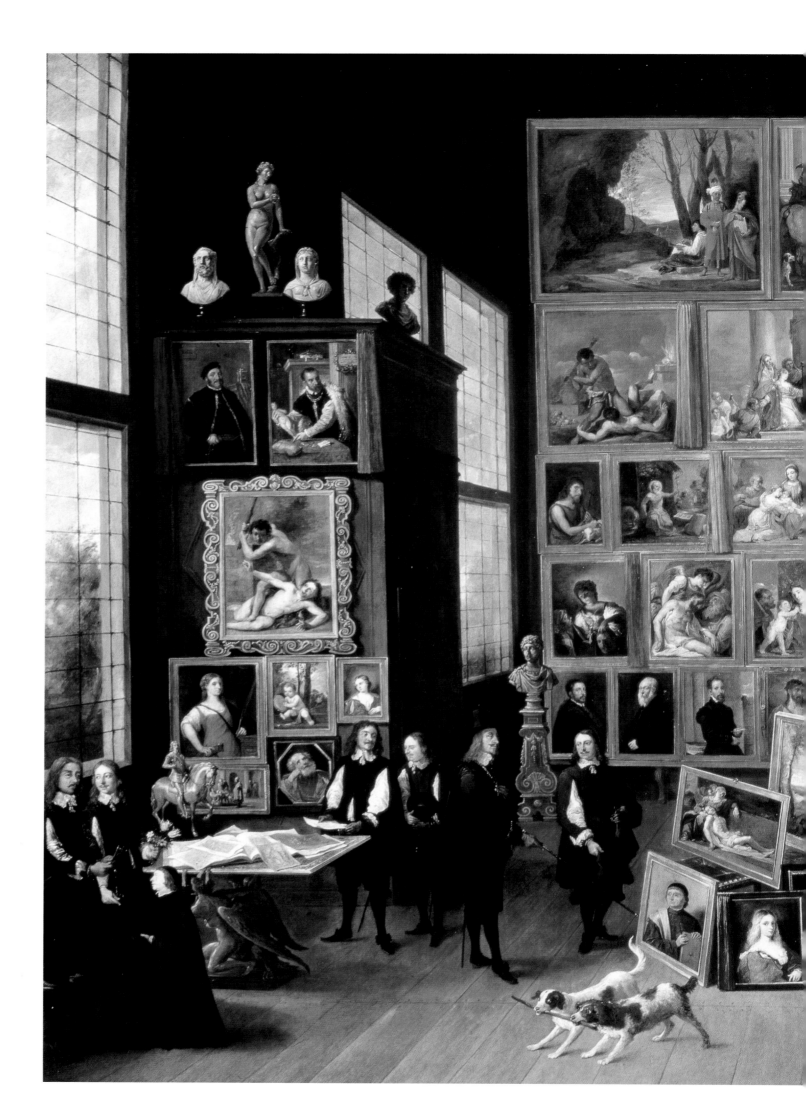

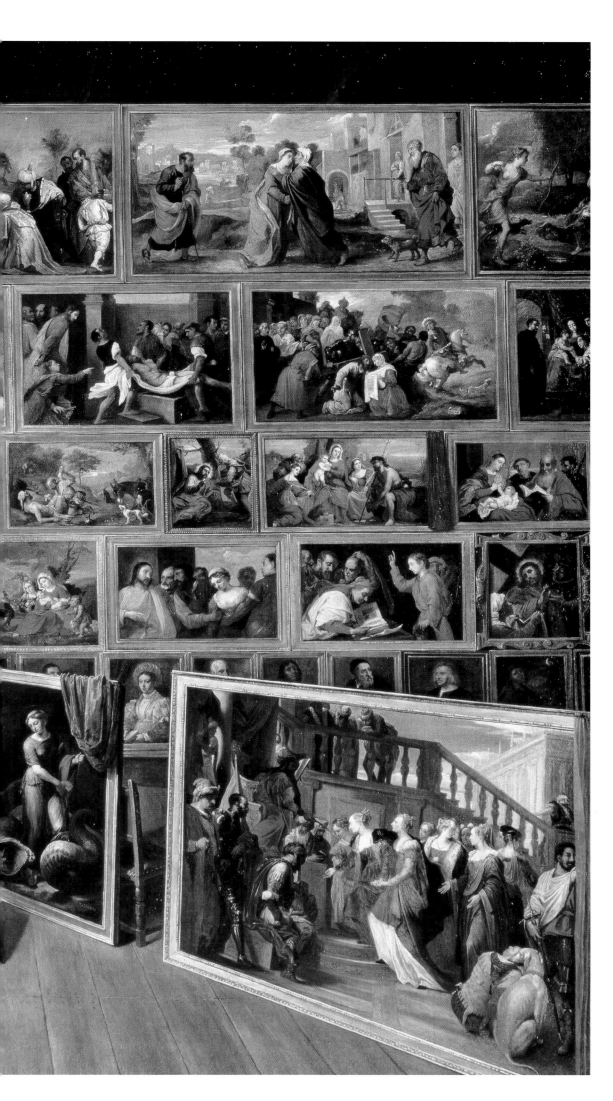

20 David Teniers the Younger
Archduke Leopold Wilhelm in his Gallery in Brussels, 1653
Oil on canvas, 123 x 163 cm
Kunsthistorisches Museum, Vienna

Although all the paintings in this picture exist, or did exist, and were in the Archduke's possession, the artist was not trying to represent the real interior of a gallery. Instead, he aimed to illustrate the owner's love of art. Watteau treats the theme in a different way: the art dealer's shop was real, but the pictures were the artist's own invention.

EARLY WORK

21 *Harlequin, Emperor on the Moon*, ca. 1707
Oil on canvas, 65 x 82 cm
Musée des Beaux-Arts, Nantes

Sketches vouch for Watteau's authorship of this picture, which is still rather clumsy in style. The subject is from a comedy by Nolant de Fatouville, and shows the characters Mezzetin, Doctor Baloardo, Colombine, and Harlequin. According to the information given on an engraving by Gabriel Huquier (1695–1772), Gillot painted a picture showing much the same cast of characters, but with a different background that obviously depicted the real backdrop of the play.

When he first arrived in Paris, Watteau earned his living by making copies for a dealer in devotional pictures. This man had his shop on the Pont Notre-Dame, the bridge where *Gersaint's Shop Sign* (ill. 9) would later hang. Among the pictures Watteau copied was one of an old woman reading, by Gerard Dou (1613–1675). This was the artist's first encounter with the 17th-century Dutch painting from which he would later draw a great deal of inspiration.

Watteau's first real teacher, from about 1704/5, was Claude Gillot, eleven years his senior and a man who crucially influenced his style, his attitude to art, and his choice of subjects, three closely and significantly connected fields (see ill. 21). Gillot's temperament resembled that of his more famous pupil: like Watteau, Gillot was a satirist, a malcontent, and a man who distrusted grandeur and sought to make something extraordinary out of ordinary subjects. He also painted scenes of theatrical life, mainly drawn from Italian comedy.

Although Watteau became the central artistic figure of the early French Rococo style, he was therefore by no means a bold, pioneering innovator. Instead, he stood on his predecessor's shoulders, though his ease of execution enabled him to express his teacher's artistic concept far more effectively. One could say that he finished what Gillot began. To see himself surpassed in this way must have been a bitter pill for the older man to swallow, and it appears that pupil and teacher did not part on friendly terms.

Watteau's debt to Gillot in the painting of theatrical scenes can best be illustrated by two works in particular. One is the painting *Harlequin, Emperor on the Moon* (ill. 21), from a comedy by Nolant de Fatouville and now located in a museum in Nantes; it is not an especially brilliant work, and has sometimes been attributed to Gillot. However, since some sketches by Watteau for this painting still exist, it is more probably his own. It is comparable to Gillot's *The Two Coaches* (ill. 22) in the rather wooden figure composition. Watteau's picture was probably inspired by a performance of de Fatouville's play staged in 1707, which provides some indication of both the date

of the work and the length of time Watteau spent in Gillot's studio.

More important is another painting, although it is preserved only in an engraving after Watteau by Louis Jacob (b. 1712). It shows the expulsion from Paris of the Italian players in 1697 (ill. 23). Louis XIV had probably banned their performances because the troupe's mockery had offended the king's mistress, the strictly religious Madame de Maintenon (1635–1719). In depicting a minor event that had taken place some ten years earlier as if it were a matter of great importance, Watteau was reminding the public of the folly of censorship, while at the same time showing his sympathy for the Italian players and so identifying himself as the artistic supporter of opposition from below.

Like Gillot, Watteau executed decorative paintings on wooden panels. In the late Louis XIV period, and not least because of financial constraints, there had been a trend toward a lighter style of ornamentation decorated with "grotesques," instead of magnificent furnishing schemes in costly materials and with grandiose and vainglorious cycles of paintings. Light colors were preferred to dark, heavy hues; drawing and line became more important than volume. All this went hand in hand with a tendency to favor small, intimate rooms. Emotionalism was replaced by wit, and imagination mattered more than a display of scholarship. Artists were expected to produce a wealth of ideas. The rooms they decorated were meant to please those who used them, not overpower them with splendor.

Watteau worked very prolifically in this field, particularly once he had moved on from Gillot (in 1708) to study with Claude Audran III (1658–1734), and found himself assisting one of the king's leading court painters and decorators. In 1704 Audran had been appointed curator of the Palais du Luxembourg, on whose walls hung Rubens' cycle on the life of Marie de' Medici. Drawings copying certain details in the Medici cycle show that Watteau had studied it thoroughly.

Audran's significance for his young colleague's development should not be underestimated, nor should the proportion within Watteau's entire oeuvre

of the wall decorations he executed according to designs by others or simply designed himself. His individual artistic language was strongly influenced by that genre. In the general absence of any conspicuous iconographic theme to guide the viewer's attention in his easel paintings – which instead call for independent observation and the linking of impressions – they reflect the ability of the interior decoration of the time to suggest associations. Jullienne said that Watteau worked fast and was quick to get his ideas down on canvas, a practice that must have been related to the special skills of an interior decorator. Apart from sketches and engraved reproductions, however, only two fragments of the decoration of a room by his hand have been preserved.

Furnishings such as cupboards and harpsichords were also decorated in the delicate grotesque style. In designing the lid of a harpsichord (ill. 25), Watteau gave witty ornamentation to the irregular form of the instrument, a rectangle cut away in a curving line and tapering toward the narrow end. The decoration consists of an oval pictorial area, monkeys in human clothing making music, birds, a dog, vegetative motifs, festooned draperies, and above all non-representational linear elements. All these features relate to each other in an imaginative but orderly sequence, with constant surprising transformations. The oval contains the theatrical comic character Mezzetin playing the violin, with a woman dancing to the music in the elegant style of the period before 1710. This subject was replaced on the inside of the lid by a seated couple, a woman singer and her cavalier. The ornamentation develops from right to left, and if the eye follows it in that direction the static images become a consecutive narrative. The symmetries on the right dissolve as the line moves to the left. As it does so, the comical gestures of the

22 Claude Gillot
The Two Coaches, ca. 1707
Oil on canvas, 127 x 160 cm
Musée du Louvre, Paris

This incident is from the play *La Foire de Saint-Germain* by Régnard (1655–1709) and Dufresny (1648–1724). The scene shown can be clearly identified, and the backdrop must also have been depicted exactly as Gillot saw it in performance.

DEPART DES COMEDIENS ITALIENS EN 1697
Gravé d'Après le Tableau Original peint par Watteau haut de
1.pied .7. pouces sur 1. pied .11. pouces de large.
Tiré du Cabinet de M.r L'Abbé Pouço
a Paris avec privilège du Roy.

ITALORUM COMŒDORUM DISCESSUS ANNO M.DC.XCVII.
Scalptus juxtà Exemplar à Watteavo depictum cujus altitudo .1.
pedem cum .7. unciis et latitudo .1. pedem cum .11. continet

L:Jacob Sculp.

23 Louis Jacob, after Watteau
Expulsion of the Italian Players, 1697
Etching, 42.3 x 62.1 cm
Kupferstichkabinett, Staatliche Museen zu Berlin –
Preussischer Kulturbesitz, Berlin

The expulsion of the Italian theatrical troupe is shown as if it were a scene in a play. The various actors are looking at the royal decree up on a wall, banishing them from Paris, and react not as professionals whose careers are under threat but in the attitudes of the stock characters they usually play. The exaggerated perspective of the street, which does not match the foreshortening of the figures, is also borrowed from the stage. Watteau uses this device to protect himself from political repercussions. The comic element defuses his accusations, and simultaneously makes the prohibition itself look ridiculous. The unnatural, deliberately artificial composition is playful in tone, with the actors assuming dramatic, affected poses.

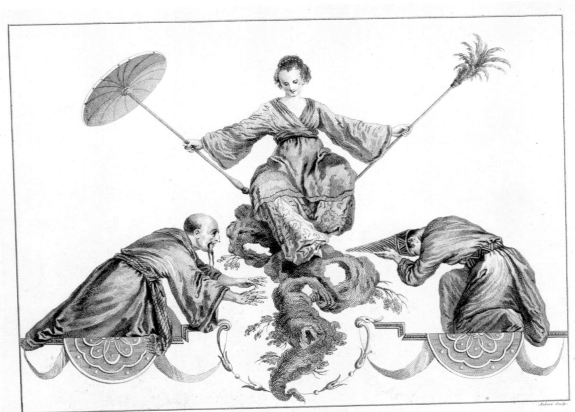

Idole de la Déesse KI MÁO SÁO dans le Royaume de Mang au pays des Laos

Tiré du Cabinet du Roy au Chateau de la Meute
A Paris avec Privilege.

A. Watteau pinxit. Aubert Sculp.

24 Aubert, after Watteau (ca. 1731)
The Goddess Ki Mao Sao
Etching, 27.9 x 39 cm
Kupferstichkabinett, Staatliche Museen zu Berlin –
Preussischer Kulturbesitz, Berlin

Part of the decoration of a room in the château of La
Muette. The paintings, now lost, were examples of early
French Rococo *chinoiserie*. François Boucher recorded
most of them in etchings before going on to create many
original works in the same genre himself.

25 Comte de Caylus, after Watteau
Design for the lid of a harpsichord
Etching, 18.2 x 44.7 cm
Kupferstichkabinett, Staatliche Museen zu Berlin –
Preussischer Kulturbesitz, Berlin

Watteau's teacher Claude Audran III is also known to have
designed a harpsichord lid. However, Watteau's drawing is
much closer to another design ascribed to Audran, also
showing monkey musicians, and including an oval with a
symmetrical frame of grotesques. The idea behind such
paintings was to combine the furnishings and decoration
of a room into a single entity.

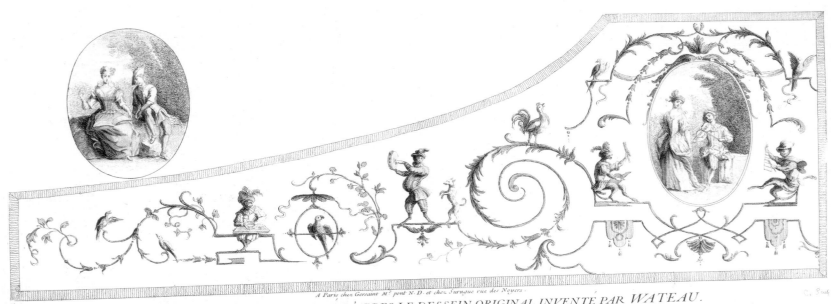

A Paris chez Gersaint M.d pont N.D. et chez Surugue rue des Noyers.

C. Sculp.

Huis. Sc.

DESSUS DE CLAVECIN GRAVE D'APRES LE DESSEIN ORIGINAL INVENTE PAR WATEAU.

Avec Privilege du Roy.

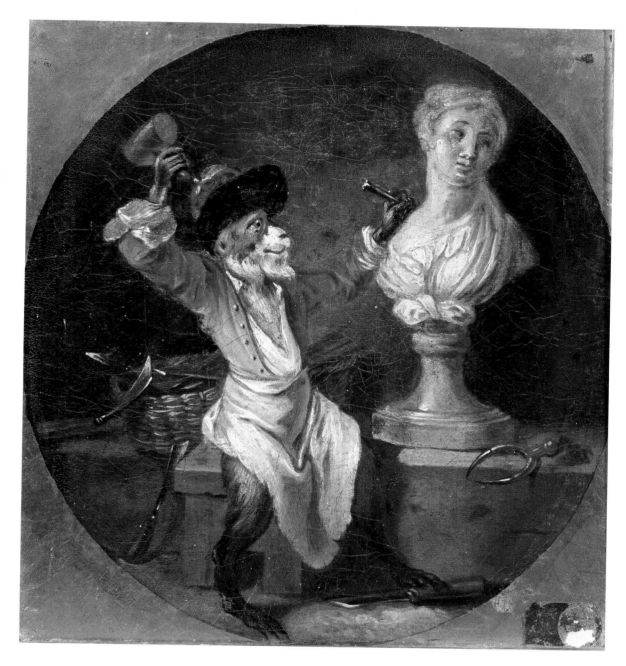

26 *Sculpture*, ca. 1710
Oil on canvas, 22 x 21 cm (oval)
Musée de Beaux-Arts, Orléans

The female bust appears distressed by the activities of the monkey, busily working away with his chisel and wearing a self-satisfied expression. This picture, which is in a bad state of preservation, once had a companion piece, now lost, showing a monkey painting portraits, and making the point that vanity is the motive force behind portraiture. At the beginning of the 18th century the regent of France owned a work on a similar subject by Watteau, the companion piece to a picture by David Teniers the Younger, who is known to have painted several such pictures of monkeys.

monkeys relate to the linear ornamentation, as if keeping time to music. The laws of this kind of art dictate the course of the decoration: straight lines are clearly marked off from the curves that coil into spirals and then uncoil again. The lively nature of the design is produced by the interaction of freedom and discipline.

An apparently casual, undemanding work of this nature illustrates the change in the artistic climate of the time. Magnificence that intended to impress, to glorify power, and to claim permanence is countered here by the light, witty play of imagination mingled with humor. Everything changes, a message that the powerful do not like to hear. In the early 18th century a similarly light-hearted approach was taken to China, a country of which more had become known, to general amazement, in the 17th century. It was probably between 1708 and 1710 that Watteau painted thirty decorative pictures of Chinese figures for the château of La Muette in the Bois de Boulogne, a building long

since gone. Twenty-six of these are in vertical format, two are in horizontal format with landscape backgrounds, and two more are in horizontal format each showing three figures with linear ornamentation and fragments of landscape on a neutral ground. These last two may have been part of a ceiling painting. The worship of the "goddess" in *The Goddess Ki Mao Sao* (ill. 24) is a subject of mockery to Watteau, who makes a solemn pretence of scholarship with her fanciful name. In showing her worshippers revering a very worldly goddess, the artist subtly criticizes the subservient spirit of his time, disguising his criticism under cover of *chinoiserie*. One of the Chinese has bowed his head so low that he has to hold on to his pointed hat, which points forward like the horns of a bull. The other man has ventured to raise his eyes. The goddess herself, elegantly holding her parasol and fly-whisk, is seated on a convoluted rock formation of the kind generally supposed to be typical of a Chinese landscape.

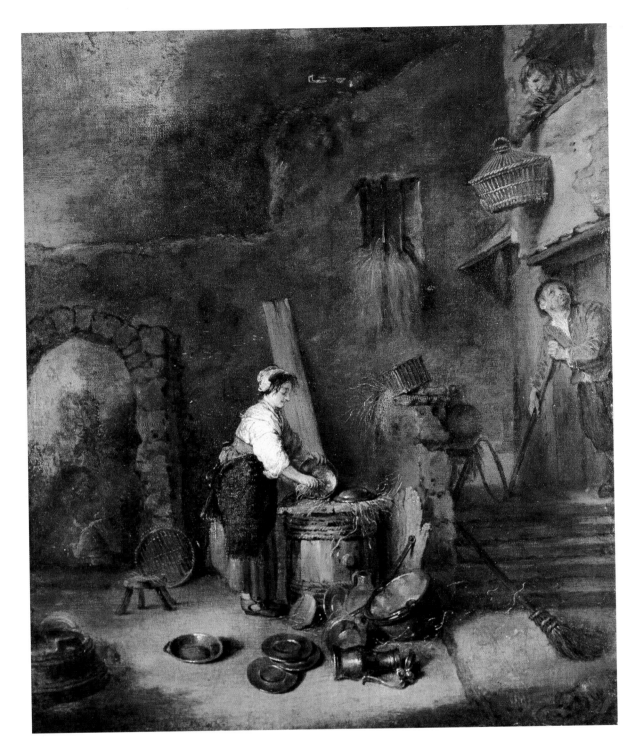

27 *Woman Cleaning Copper*, ca. 1710
Oil on canvas, 53 x 44 cm
Musée de Beaux-Arts, Strasbourg

Although not one of Watteau's best-known works, this
picture is very delicately painted, and in content it is close
to certain paintings by the Dutch artist Willem Kalf
(1619–1693). The construction of the buildings, which
resemble a stage set, is comparable to Watteau's early
village landscapes (see ill. 101), and the still life in the
foreground also has counterparts in his early work. It is
hard to make out exactly what is going on between the two
men on the right, but they suggest a theatrical scene.

We do not know how long a period Watteau spent
designing and executing decorative works that
combined figures with ornamentation. He was
certainly still very active in the field after parting
company with Audran at the end of 1709, and the style
of his sketches suggests that he probably continued
producing such work up to the middle of the second
decade of the century. When the rich and influential
banker Pierre Crozat (1665–1740), owner of a large
art collection, had the dining room of his home in Paris
decorated with four paintings of the Seasons, he chose
traditional figures to represent them. Unfortunately we
do not know exactly when Watteau painted these
slightly smaller than life-size figures. Only Summer

(ill. 28) has been preserved. Watteau apparently painted
them from sketches by Charles de La Fosse
(1636–1716), who died on December 13, 1716, at the
age of eighty, and if so, it seems most likely that they
were painted shortly after that date, for La Fosse had
gone on working well into old age. It is not so far from
these fluently executed pictures to *Gersaint's Shop Sign*
(ill. 9), the painter's late work and his masterpiece.

28 *Summer*, ca. 1717
Oil on canvas, 142 x 115.7 cm (oval)
National Gallery of Art, Washington

Ceres, the goddess of harvest, attractively depicted in the
bright light of summer, is shown with three of the signs of
the Zodiac: Gemini, Cancer, and Leo. The curving lines of
the composition are skillfully fitted into the oval, which
effectively emphasizes the shape of the goddess's face and is
echoed by the sickle. The other Seasons are extant only as
engravings, but there is a photograph of *Spring*; the
original was destroyed in a fire in 1966.

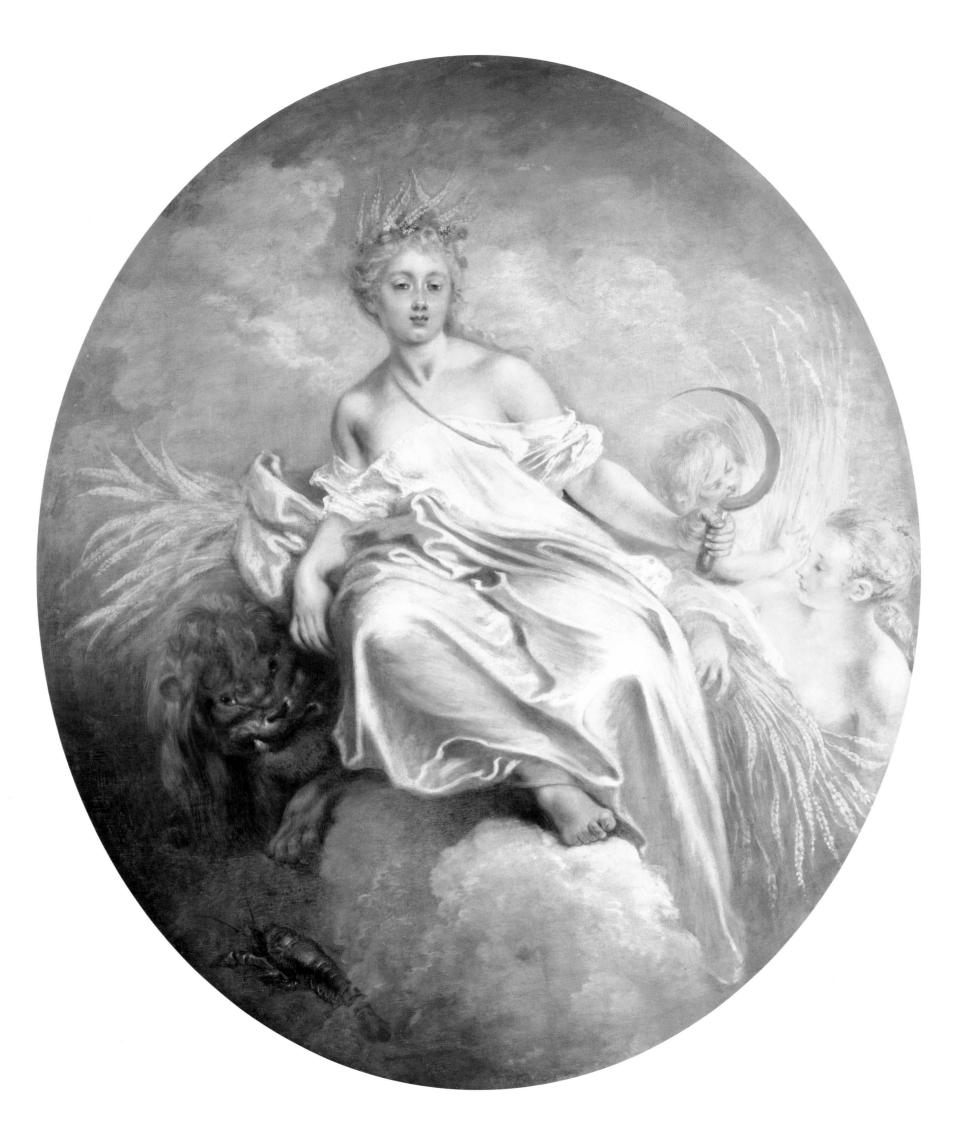

SCENES OF MILITARY LIFE

29 *The Bivouac* (detail, ill. 32)
Group with nursing mother

Watteau liked to include nursing mothers in his military scenes as a poignant contrast to the slaughter in which the soldiers were engaged.

Before Antoine Watteau became the master of the *fête galante*, he was a painter of military scenes. In fact, judging by the works that have survived, military scenes form the most homogeneous group of pictures among his early work. It would appear a difficult task to combine cheerful social gatherings with the murderous business of warfare, yet Watteau manages to link them skillfully; was not Mars, the god of war, also the lover of Venus? In fact it is only at first glance that Watteau's scenes of army life can be associated with military pictures of the kind that glorified war from the viewpoint of rulers and commanders, a genre that had been growing steadily more popular since the early 17th century. Adam Frans van der Meulen of Brussels (1632–1690) had painted a work for Louis XIV that convincingly, though with some reticence, portrayed the king's supremacy (ill. 31). He showed the battle from above, as if looking down from the hill on which a military commander might stand.

The most successful battle painters of the time were several members of the Parrocel family: Joseph, known as "Parrocel des Batailles" (1646–1704), who was a pupil of the famous Jacques Courtois (1621–1676) in Rome, and received commissions direct from the minister of war Louvois (1641–1691) (ill. 30); Ignace Jacques (1667–1722); and Charles (1688–1752). Charles actually served with the cavalry in 1705/6, so that he could make his battle scenes more authentic and gripping.

The most popular theme of all was the cavalry engagement, which allowed the artist to construct intricate groups of figures involving horses and men in violent movement, often sketched in great haste in order to emphasize the heat of battle. Such scenes were frequently painted as a background to portraits of military commanders, making the bold and fearless strategist shown in front of them appear all the more impressive (ill. 7). Watteau saw war in very different terms, and consequently his pictures of soldiers were not intended for generals and their lackeys, but for those who bore the brunt of warfare or observed it with scepticism.

We can date the beginning of Watteau's interest in military scenes accurately. Jean de Jullienne tells us that when the Académie held a competition on August 31, 1709, for the Prix de Rome, with a stipend for the winner to visit Italy as first prize, Watteau was deeply disappointed to come only second, and decided to go back to Valenciennes. This defiant and not very sensible reaction reveals both the twenty-five-year-old artist's personal pride and his dislike of Paris. It is also evidence of Watteau's love of his hometown, despite the difficulties it was suffering.

At this time Valenciennes was in the war zone, and on September 11, 1709, the French commander Maréchal Villars (1653–1734) and his army were defeated there by the Austrian and English troops under Prince Eugen of Savoy (1663–1735) and the Duke of Marlborough. But Paris had its own problems. There was famine in the capital in the winter of 1700, and it was at this time that Watteau painted the first two of his pictures that can be dated with some certainty. Gersaint recounts their history. His own father-in-law, the master glazier and dealer in engravings Pierre Sirois (1665–1726) bought a military scene for sixty livres, a sum that enabled Watteau to go home to Valenciennes. Sirois was so pleased with his acquisition that he asked Watteau for another, similar scene. Watteau painted it in Valenciennes, and this time sold it for 200 livres; he obviously had a good head for business.

The art dealer Gersaint writes of this second picture showing a bivouac (ill. 32), now in the Pushkin Museum of Fine Arts in Moscow, that: "It was all painted from life." He means that Watteau drew studies of soldiers in Valenciennes, and then assembled them into a composition. Many of these studies of uniformed men in various different attitudes are still extant. In fact the picture by no means gives the impression of a situation observed as a whole, unlike the effect conveyed by its companion piece *Return from the Campaign*, painted while Watteau was still in Paris and surviving only in an engraving.

In all, Watteau is known to have done eleven paintings of military scenes, and seven of these are preserved in their original form. The other four have come down to us through engravings. Since all the extant pictures but one were also reproduced as engravings, we may conclude that Watteau cannot have produced very many

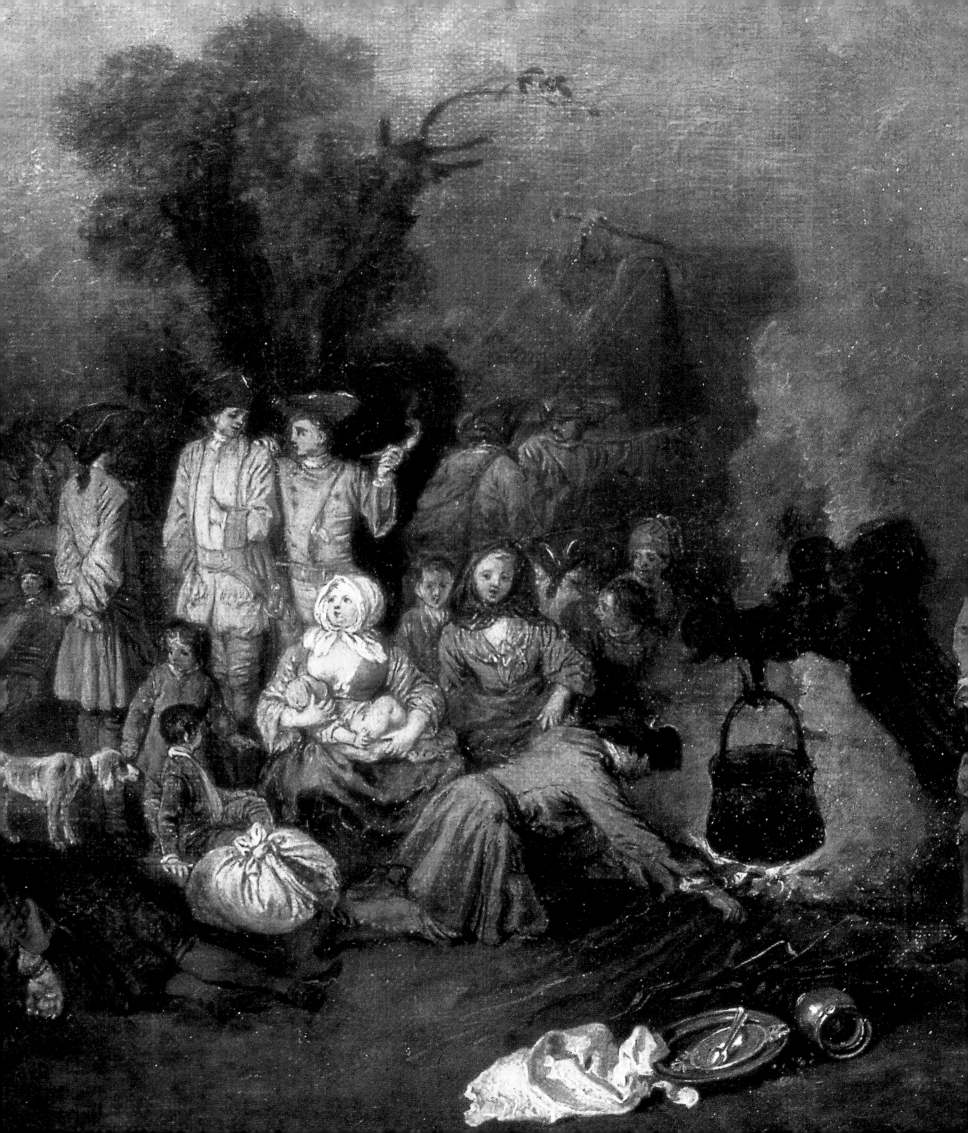

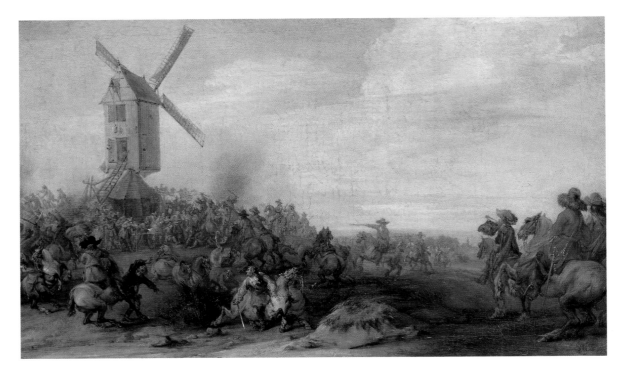

30 Joseph Parrocel
Battle at the Mill, ca. 1700
Oil on canvas, 38.5 x 63 cm
Hermitage Museum, St. Petersburg

A mill towering above a hilltop is defended against the attacking cavalry by infantrymen armed with muskets. The soldiers do not wear uniforms, and even their nationality cannot be determined: Joseph Parrocel is depicting a dramatic situation, not a historical event.

31 Adam Frans van der Meulen, workshop
The Camp of Cambrai, 1677
Oil on canvas, 195 x 310 cm
Bayerische Staatsgemäldesammlungen, Munich

This composition may be compared with Watteau's *On the March* (ill. 35). Louis XIV is seen on a white horse rearing up in a movement (often seen in equestrian portraits) called a *levade*. The painter was anxious to show the whole area, and visited the battlefield to ensure topographical accuracy.

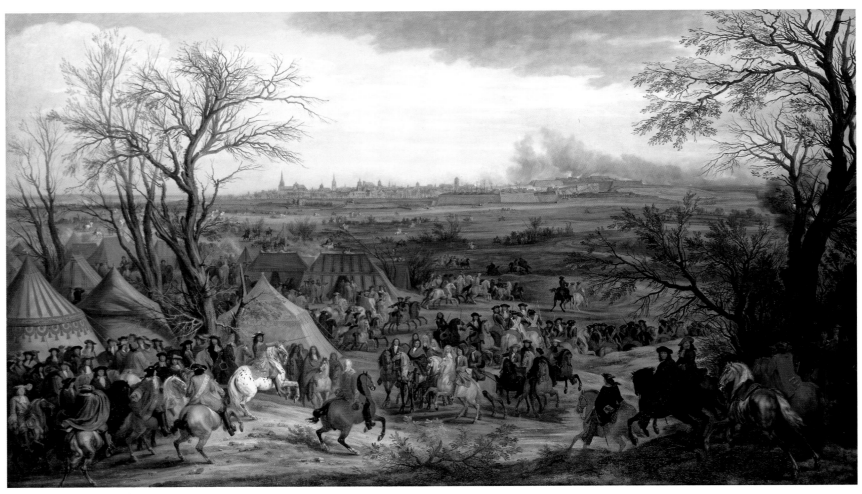

32 *The Bivouac*, 1710
Oil on canvas, 32 x 45 cm
Pushkin Museum, Moscow

The dominant character in this densely populated military
scene is the cook. He is almost the only figure to be
looking confidently at the viewer, and the felled trees
surround him in a manner common in the portraits of
military commanders at the time. One of the stumps is
proving useful: a cauldron hangs from a hacked-off branch
over a fire being raked up by one of the soldiers. In front
lies a striking, isolated still life, showing a cloth with pots
and pans. The two women, one of them nursing a child,
form another focal point. Three more children are
grouped around them. The cannon is banished to the
periphery of the scene as an inessential. The terrain slopes
up into the picture as if it were an amphitheater, a device
that allows Watteau to dispose the group over the pictorial
surface with little overlap.

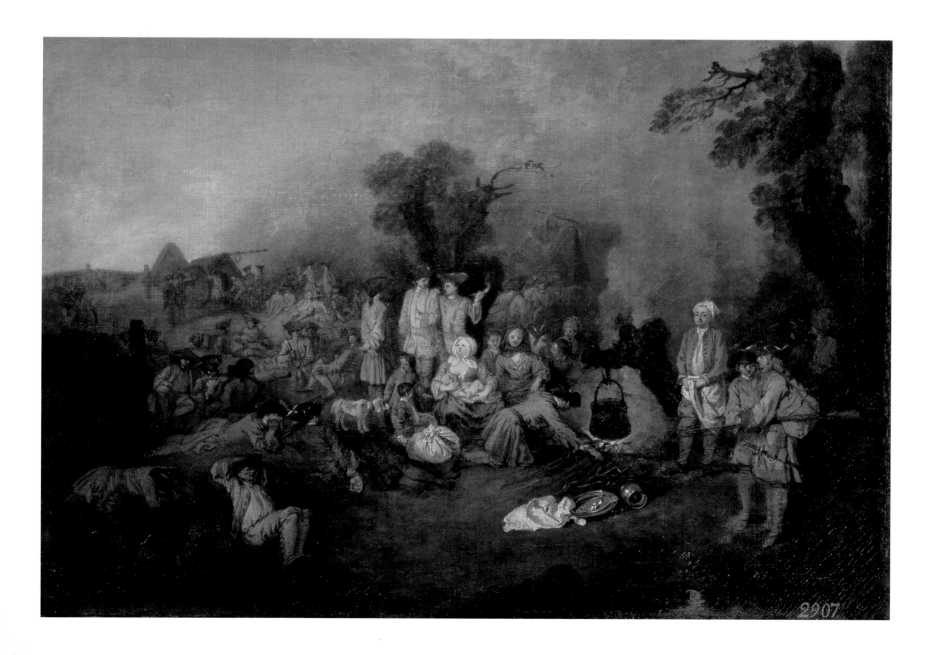

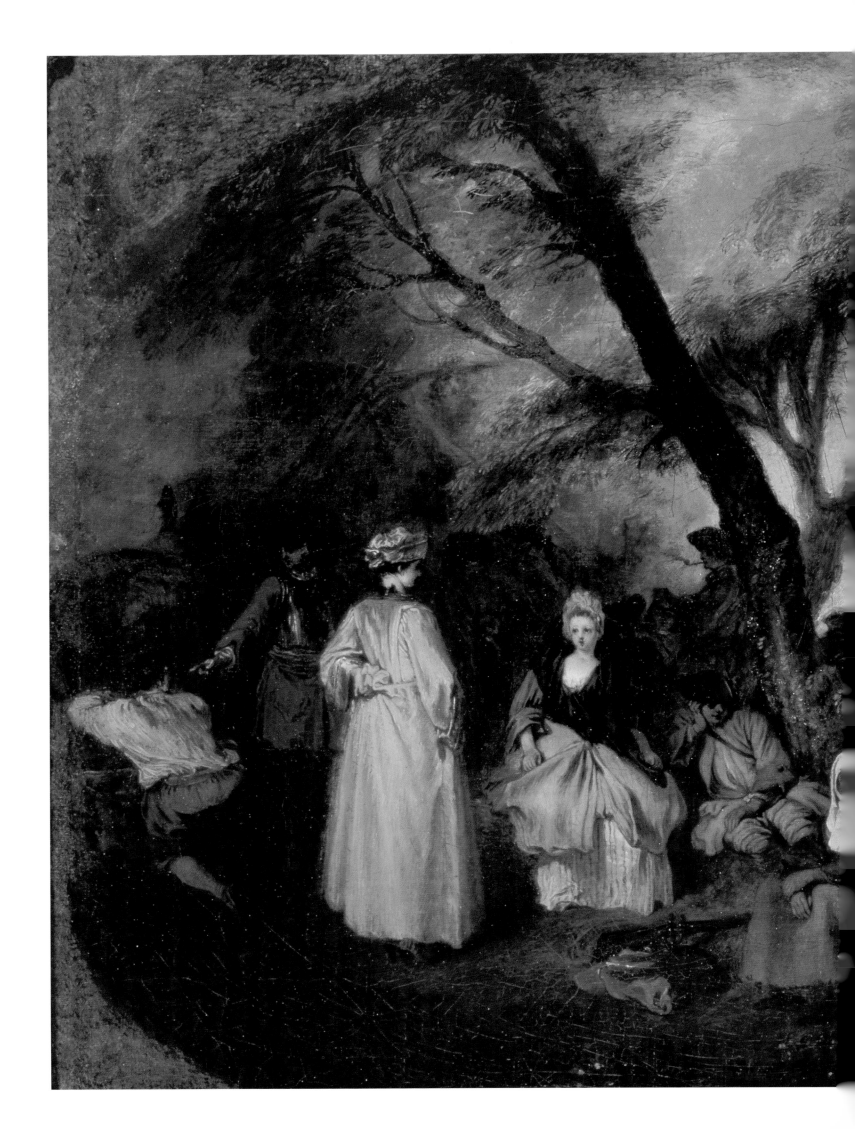

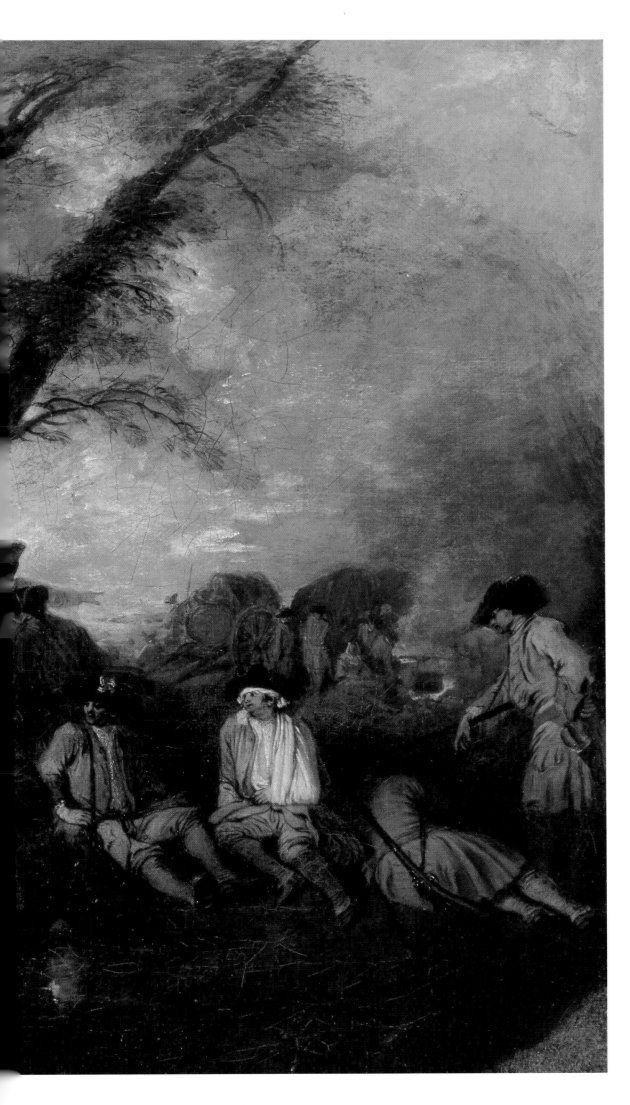

33 *The Rest Stop*, ca. 1710
Oil on canvas, 32 x 42 cm (oval)
Thyssen-Bornemisza Collection, Madrid

The trees with their windblown branches are related to those in the
Respite from War (ill. 37). While their curves echo the oval of the
picture, the movement in them sets out from the poorly dressed
soldier's wife carrying a child on her back. She is seated in the
foreground, and is the only figure looking out of the picture. This
mother, the main character, is associated with the soldiers, who are
also clad in gray. One of them is wounded. The two fashionably
attired ladies on the left of the picture are from another social sphere.
They have come on campaign with the army officers, two of whom
can be seen making imperative gestures. The yellow gown of one of
the ladies responds to the radiant blue of the circle of sky, which is
framed in gray cloud.

more works in this genre. Most of the pictures can be dated to around 1710; only one, *Recruits On the Way to Join Their Regiment* (ill. 34) seems to have been done considerably later. It is also distinguished from the other scenes of military life by the fact that Watteau etched the composition himself. Apart from a series of small fashion plates, the *Figures de Mode* (ill. 65), the artist ventured into this medium only twice. The other etching, entitled *The Costumes are Italian* (Bibliothèque Nationale, Paris), was done from a drawing now in Berlin, for which Watteau used the back of a print of the etching showing the recruits. Neither etching shows complete mastery of the technique, but the artistic style of both is strongly expressive, and they must therefore have been done quite close to each other in time.

The latecomer among Watteau's scenes of military life is clearly distinguished from its predecessors in both composition and narrative style, and it is easier to understand the nature of the others if we start by looking at the later etching. *Recruits On the Way to Join Their Regiment* (ill. 34) is the title usually given to this print, and if it describes the subject accurately, then the officer riding at the head of the procession has been raising recruits to replace the losses he has suffered, and is now leading them back to his company. On closer examination, however, this interpretation seems inaccurate. The rainbow in the sky behind the mounted officer is a symbol of peace, and there is something playful about the way the soldiers are grouped in couples, some of them assuming dancing poses, as if they did not feel burdened by their long muskets and their packs. The figures contrast with the bleak landscape. The only downcast figure is the mounted man riding down the hill ahead of them, and the further away the couples are from this officer, the less they seem to be following him. Instead, they appear as small independent figures

34 *Recruits On the Way to Join Their Regiment*, ca. 1716
Etching, 24.8 x 34.8 cm
Bibliothèque Nationale, Paris

The plate was reworked shortly after it had been etched by Henri-Simon Thomassin (1687–1741). In the process the vigor of the rapid hatching that had imparted a sense of nervous restlessness to the scene was lost.

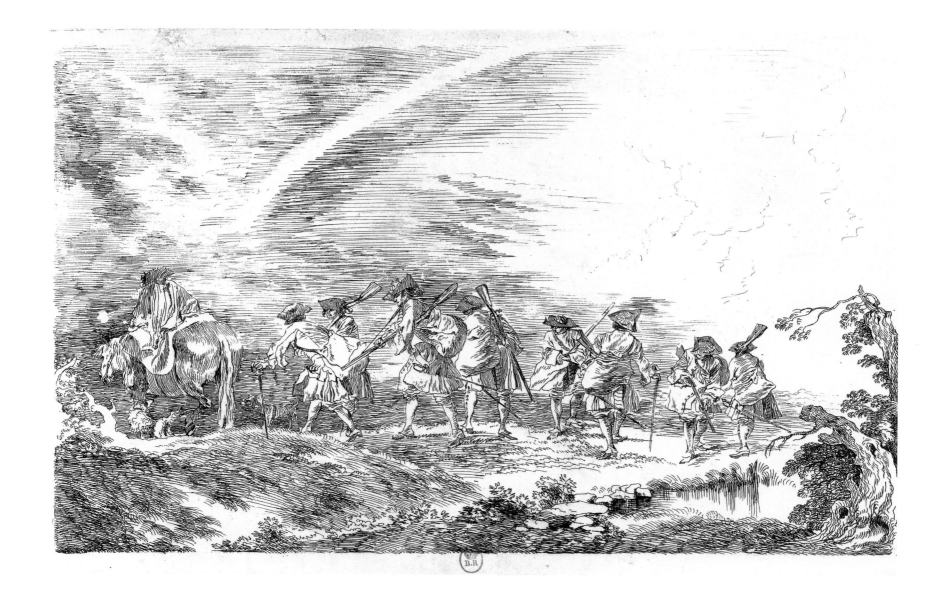

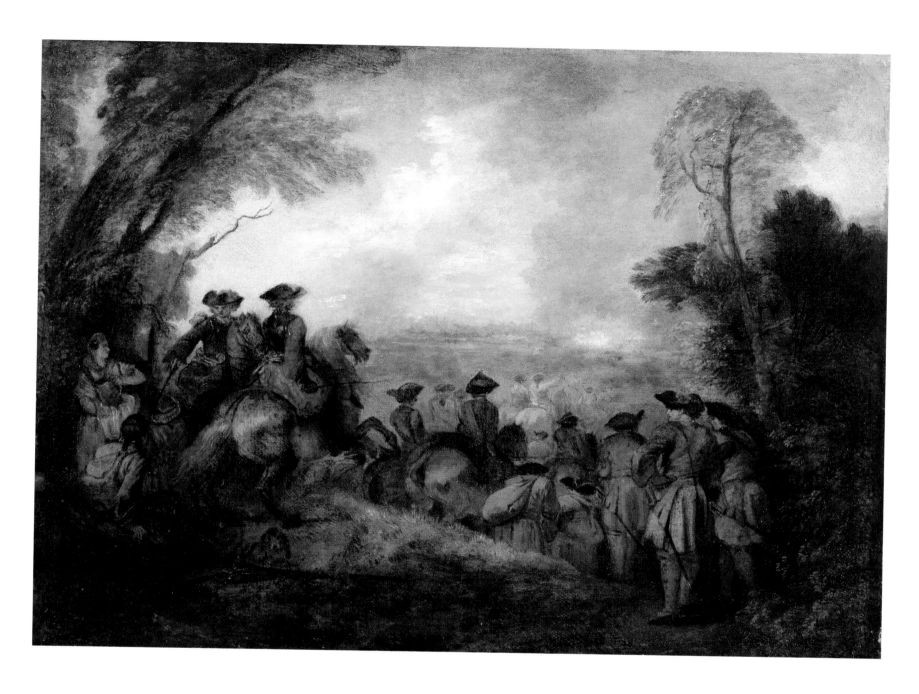

moving in various different directions. Their guns and sticks impart something bizarre and insect-like to their outlines. The stunted trees beside the pond on the extreme right, and the horseman on the left, form the frame of the composition.

If we look in Watteau's work for another procession, a procession of similarly relaxed rhythm as it moves from right to left down the gentle slope of a rounded hill, we find it in a picture on a very different subject, the *Pilgrimage to Cythera* (ill. 55). It is almost as if the engraving were a by-product of that first major work by the painter, completed in 1717.

This comparison supports a recent suggestion that the correct date for the military picture may be around

1716, half a decade later than previously assumed; and if we see these soldiers as men on their way home after a peace treaty, then the print will also fit the political history of the time. The Peace of Utrecht was concluded in 1713, followed by the Peace of Rastatt and Baden in 1714, and the death of Louis XIV in 1715 offered the hope of a generally tranquil period.

Neither this nor any of the earlier military pictures shows actual fighting, and only a small painting now in an art gallery in York (ill. 35) so much as suggests that battle is imminent. This picture shows a town in the distance, with fire and clouds of smoke nearby, indicating the fighting and destruction toward which the soldiers are moving in wedge formation. The

35 *On the March*, ca. 1710
Oil on canvas, 32.3 x 30.6 cm
City Art Gallery, York

A company of soldiers is marching to a besieged town. The muted color, predominantly gray-green – the strongest notes are struck by the leading horseman's red coat, the blue of the sky above, and the bright radiance in the distance – is in keeping with the downcast mood of the soldiers, and the same can be said of the diffuse, dim light and fine, sensitive design. In its delicacy of style the picture is closely related to *The Rest Stop* (ill. 33), and the two works have long been regarded as companion pieces.

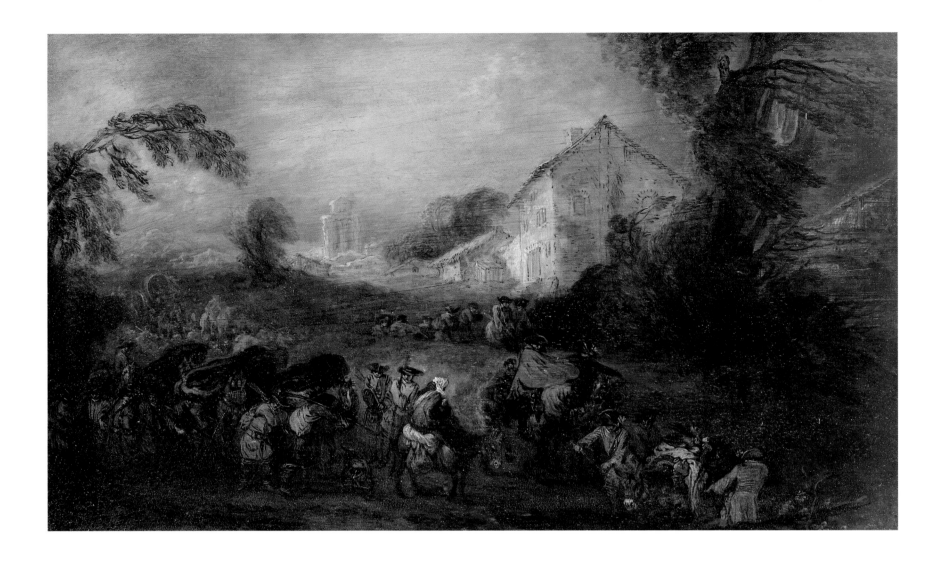

36 *The Burdens of War*, ca. 1713
Oil on copper, 21.5 x 33 cm
Hermitage Museum, St. Petersburg

The pictorial ground, rapidly applied in broad strokes left clearly visible under the layer of paint, contributes to the drama of the scene, thus avoiding the fine, smooth effect usual in painting on copper.

predominance of cavalry is noticeable. Watteau seldom painted cavalrymen, since he did not care for the intensification of human violence they represented.

The French title of the engraved reproduction by Jean Moyreau (1690–1762), *Défilé*, suggests more than the English "On the March" does. A *défilé* is also a strait or a narrow pass, and the painter conveys a sense of danger threatening this group of soldiers as they march off into the unknown. The dominating back view of the rider on the rearing horse responds to the fall of the slope on the right. The composition, framed by groups of trees, begins on the left with a soldier who is still sitting on the ground, his gun lying beside a dog, and a standing provisioner with a pitcher. A mounted officer is ordering the soldier to join the line of men. On the right, two more soldiers are watching the scene. Among the infantrymen in particular there is little trace of heroic sentiment.

In Watteau's work, the military life consists almost entirely of marching and resting. Soldiers on guard appear in only one painting. The artist also watched an infantryman exercising, and drew the sequence of his movements as he loaded his gun. There are no depictions of violence, and the scenes generally contain women and children. The most densely populated

military picture, *Return from the Campaign* (now lost), is also the earliest.

On the March (ill. 35) and *The Rest Stop* (ill. 33) can be seen as companion pieces, especially since they pick up these two main themes. There are two other cases in which Watteau painted military companion pieces, and in the lost *Supply Train* he actually combined both variants in one painting. Two later companion pieces, now in the Hermitage Museum in St. Petersburg, are interesting, and not just because they are painted on copper. They are also distinguished from Watteau's other military scenes by their freer, nervous brushwork, as if the drama of the action in the first of the two pictures, *The Burdens of War* (ill. 36), had communicated itself to the artist's hand. The soldiers here are contending not with an enemy but with the weather. Carrying heavy packs, they are making their way along bad roads as a storm sweeps over the countryside. The sun, low in the sky, breaks through the clouds and shines down on the houses of a poverty-stricken village where the soldiers are unlikely to find shelter. It will soon be dark. The company is moving from the depths of the picture toward the foreground and is going downhill (probably both literally and figuratively), as the towering forms of the two-story

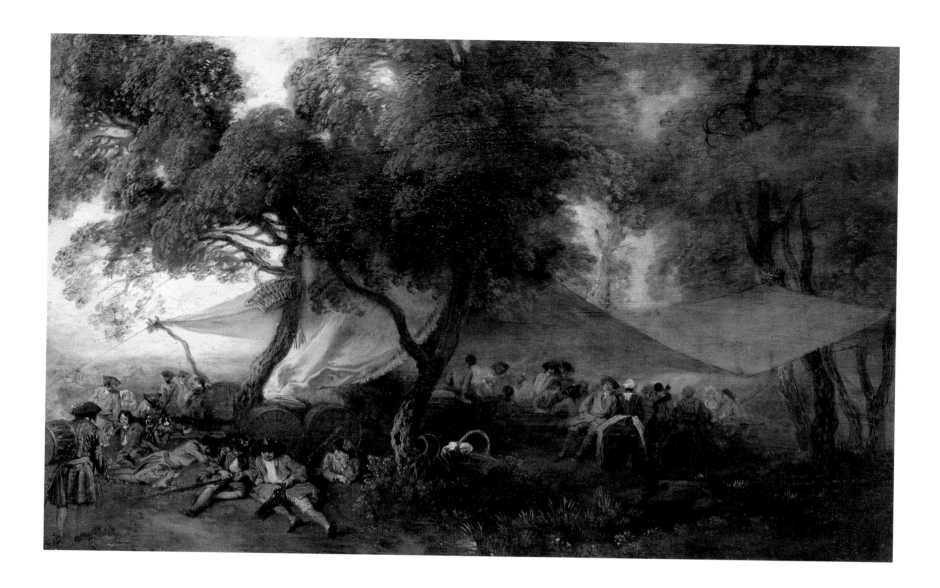

house and the tree on the right suggest. Apart from the stormy woodland landscape in *Gersaint's Shop Sign* (ill. 9), no other picture by Watteau is as dramatic.

The companion piece, *Respite from War* (ill. 37), presents a peaceful scene, but the style is equally sketch-like. The storm has died down. A kind of shelter has been made from the trees and a huge awning. Some of the soldiers are lying on the ground, exhausted, some are sitting at a long table. They have women with them, and casks of wine promise other pleasures. The pale-blue sky seen through the foliage of the trees here and there, together with the pale gleam of the cloths in the foreground, gives rhythm to the picture. The whole scene is dominated by a sense of both spatial closeness and moment, and already looks ahead to the peaceful *fêtes galantes* of Watteau's later period.

These pictures were certainly not done in Valenciennes, for the style is very different from that of the early military scenes. No one knows how long Watteau stayed in the provinces, where he would not readily have found buyers for his pictures. There is no definite record of his presence back in Paris until he applied for admission to the Académie on July 20, 1712, offering several works. He is mentioned in its archives as a "painter in Valenciennes." At this time he

was again hoping for a stipend to visit Rome, and he obviously saw the South as the way in which his artistic progress would develop. He never did go to Italy, but whenever he could he studied the works of Italian and more particularly Venetian painters. Toward the end of his life Watteau met Sebastiano Ricci (1659–1734), Rosalba Carriera, and Giovanni Antonio Pellegrini (1675–1741) in Paris.

Strange as it may seem, it was from the military pictures that two subjects which would later bring him great success grew: the theme of the *Embarkation for Cythera* develops from the procession of marching soldiers, and the scenes in camp contain the germ of the *fêtes galantes*.

37 *Respite from War*, ca. 1713
Oil on copper, 21.5 x 33 cm
Hermitage Museum, St. Petersburg

Watteau used two figure studies, probably drawn in Valenciennes in 1710, in this picture. No studies for the companion piece have been found.

Theatrical and festive performances were important in Louis XIV's France, particularly since the character of court life itself was so theatrical. The Sun King, for instance, had himself depicted as Apollo, blurring the borderline between reality and play-acting, human nature and divine nature. At performances in the theater, the stage action and the audience, with the king seated in its midst, formed a single entity, for the spectators were to some extent also playing parts, as themselves. Huge sums were spent on equipment including sets, costumes, and stage machinery and much of it was designed by outstanding artists. The royal palace of Versailles itself was a dramatic production with the monarchy center stage.

Two royal decisions had a far-reaching influence on the theatrical life of Paris. First, the Italian-born composer Jean-Baptiste Lully (1632–1687) was granted a concession to run the opera company and created the genre of French opera, which included such new features as the inclusion of ballet and instrumental interludes, as well as the development of the overture. Second, in 1680 the king decreed that two rival troupes of actors should be merged to create the Comédie Française, a company that

Razullo. Cucurucu.

39 Jacques Callot
Razullo and Cucurucu
Etching, 7.3 x 9.2 cm
Kupferstichkabinett, Staatliche Museen zu Berlin –
Preussischer Kulturbesitz, Berlin

This etching is one of a series of twenty-two prints
entitled *Balli sfessania*, depicting the stock characters of
Italian comedy. There is a stage of the kind used in street
theater in the background, and the actors are wearing
traditional masks.

38 *The Coquettes*, ca. 1718
Oil on panel, 20.2 x 25 cm
Hermitage Museum, St. Petersburg

The name of this picture is taken from the opening of a
little poem printed under the engraved reproduction of it
by Henri-Simon Thomassin. However, it is only a
makeshift title. Several interpretations of the content of
the painting have been attempted, none of them very
convincing. The presence of the stock character Mezzetin
(background), the woman with the mask, and the curtain
show that there is at least some connection with the
theater. Although the black boy looking fixedly down
does not really seem to fit such an interpretation, the
direction of his glance could indicate that the company
and the spectators are on a platform. The five people are
crowded close together in this small picture: Mezzetin has
to push to get into it. None of the characters, however, is
looking at any of the others. Even the lady in Polish
costume with her mask removed seems not to be looking
straight at the old man with the stick, who wears an
abstracted smile. Only three hands are visible, painted in
the sensitive style of the artist's later period. The depiction
of the subjects half-length behind a barrier – only the old
man is standing in front of it – is reminiscent of equally
puzzling groups painted by artists of the circle around
Giorgione and Titian.

continued the tradition of Molière (1622–1673). Another
company was the Comédie Italienne, which was allowed
to stage productions in the same theater as the Comédie
Française at the Hôtel Bourgogne, until the Italian
company was banned from the city in 1697 for offending
the king's mistress Madame de Maintenon. The Italian
players offered popular drama in a style going back to the
16th century and originating in Venice. Traditionally, the
actors formed traveling companies that toured Europe,
performing on makeshift open-air stages consisting of a
platform made of few planks and a painted backcloth.
There were no fixed texts, only scenarios that gave the
actors plenty of opportunity for improvisation, so no two
performances were exactly the same. The actor was more
important than the dramatist, and his success depended
largely on quick repartee and his skills in mime and
acrobatics. He could adjust his performance to the
audience and refer satirically to local themes.

The stock characters originally consisted of the Venetian
merchant Pantalone and the doctor from Bologna, a
character who always invited laughter because of his
pompous pedantry. The ensemble also included the two
cunning servants Arlecchino and Brighella and other
characters. In France, native French characters such as
Pierrot joined the original Italian types. Italian comedy had
no established literary form in France until after 1720,
when it was established by the plays of the writer Pierre
Carlet de Chamblain de Marivaux (1688–1763).

After the expulsion of the Italian troupe in 1697, these
popular characters continued to appear in performances
staged by companies of players at the fairs. In Paris, these
fairs were held at Saint-Germain and Saint-Laurent, and
Watteau liked to go to them and make studies. The
improvisations of the Italian players appealed to his
imagination and lively mind more than did the clear,
structured form of French drama; in any case he had a
fondness for anything Italian. A comparison with Jacques
Callot (1592–1635), whose etchings Watteau certainly
knew, and with whom he had in common originality of
artistic thinking and an unerring eye, shows how the genre
had been refined since the early 17th century. Callot, who
had trained in Italy and worked chiefly in Nancy, was the
first major artist to turn his attention to the popular theater,
and he exaggerated the earthy burlesque of the *commedia
dell' arte* characters to the point of caricature (ill. 39).

During the Régence period the theater of Paris received
a boost. The Italian troupe returned in 1716, and a new
age of drama began in France with Voltaire (1694–1778),
ten years Watteau's junior, whose first play, *Œdipe*, was
staged in 1718. Portraits of famous theatrical figures after
around 1700 show that individual performers and
theatrical events in general had now risen greatly in public
esteem. Watteau himself portrayed actors, although he
cannot be considered a chronicler of the stage. For him the
stage was a source of inspiration.

A PASSION FOR THE THEATER

Only one of the paintings tendered by Watteau when he applied for acceptance by the Académie in the summer of 1712 can be identified, on the testimony of Pierre-Jean Mariette, and even this work is extant only in an engraving by Gérard Scotin (b. 1698), entitled *Les Jaloux* (The Jealous Ones) (ill. 42). Watteau obviously felt that its clear, rigorous composition, structurally in the tradition of Poussin, was likely to appeal to the jury of the Académie. His application was successful, and he was admitted. In view of the difficulty of classifying his paintings within any of the traditional genres, he was even allowed to choose his own subject for the reception piece that had to be provided when an artist wished to become a member.

Scotin's engraving shows characters from Italian comedy, not on stage but as if living their own lives in their free time. The spheres of theater and reality mingle, and the distinction between illusion and existence is finely balanced – which is particularly confusing because the actual structure of the picture is extremely clear and simple.

It shows six people in a parkland setting. Two couples, Mezzetin and Pierrot, with their female friends, are sitting on a grassy bank, in front of a faun-headed herm that stands between two tree trunks with forking branches. Two jealous onlookers, Harlequin and a companion, are eavesdropping on this group of four. The statue of a sphinx in the foreground conveys a sense of threat. The central figure is simple-minded Pierrot in his white outfit, symbolic of innocence, with his limbs disposed in awkward symmetry.

This image was so important to Watteau that he produced three variants on it, reducing the narrative element within the picture and instead simply depicting the figures. The last, the most mature, and greatest of these three versions, the *Party of Four* (ill. 41), which can be dated to around 1713, transfers the sense of mystery previously surrounding the sphinx to the group of characters themselves. The calm silence of the scene in a park in the evening, where only the water from a fountain in which a *putto* rides a dolphin would make any sound, enables the viewer to concentrate on the emotions of the actors. The only gesture is being made by the pretty woman who has removed her mask as she reclines on the grassy bank, forming part of a group with Pierrot, who is seen from behind. His rear view as he faces Mezzetin and the two ladies, the pillar surmounted by a stone urn standing behind them, imports an element of surprise into the picture. The guitar slung on his back by a red ribbon emphasizes this bold idea yet further.

Watteau quite often placed figures seen from behind in the foreground of his pictures to create a strong effect – with particular success, for instance, in *Gersaint's Shop Sign* (ill. 9) – but he never used the device more tellingly than here. The composition is symmetrically arranged around the figure of Pierrot and the pillar, with a view of the sky opening out through the foliage of the trees on both sides. The colors of the clothes worn by the figures glow like the panes of a stained glass window, and the *putto* on the dolphin seems to be commenting discreetly on the interaction between them.

The clarity of structure in the *Party of Four* is far removed from the painting of the *Fair with Players* (ill. 43), which dates from some five or six years earlier, now in the palace of Sans Souci in Potsdam. Comparison between them clearly shows the way in which the artist was developing, but the earlier work contains features that recur in the later picture. It too contains Pierrot, Mezzetin and their ladies, one of the latter even wearing a red jacket and yellow skirt, like the girl in the *Party of Four*. Again, and despite the great numbers of people in the crowd that send the eye looking restlessly back and forth, Watteau was, at least in part, seeking a more rigorous style of composition in this earlier work, distinguishing between his main subject and incidental features. The two dancing couples in the foreground, for instance, are carefully related to each other, and their raised arms have a rhythmic echo in the tents further in the background.

The group of three seated ladies on the left is framed by Pierrot and Mezzetin on one side, and three figures in fancy dress, including a sultan and a princess, on the other. The erect stance of these elongated characters, next to the cubic form of the dignified group of seated figures, lends the whole company a sense of delibera-tion and gravity – hardly in tune with a popular

41 *Party of Four*, ca. 1713
Oil on canvas, 49.5 x 63 cm
Museum of Fine Arts, San Francisco

Watteau liked to divide his pictures into two unequal areas
by a vertical element. Here, the pillar marks the dividing
line, and Pierrot becomes the focal point of the larger part
of the canvas. Mezzetin is confined to the smaller part.
Such methods help to elucidate the human relationships
between the characters.

entertainment that itself is depicted in order to
entertain the owners of pictures like this one. The rich
clothes of the characters also elevate them to a higher
rank of society. Even the fortune teller with the child
on her back, reading a young man's hand at the table
on the right, seems to have been ennobled. As well as
the players in the left foreground, other actors appear
in the middle ground of the picture, including some
Harlequins followed by a man riding a donkey and
greeting the bystanders with a tambourine.

Crowd scenes of this kind, offering almost inexhaust-
ible material to the eye, were especially popular in
Flemish art. Jan van Eyck himself (ca. 1390–1441)
satisfied the demand for such visual indulgence with the
wealth of painted figures in his *Adoration of the Lamb*
on the Ghent Altarpiece. The milling throngs in such
pictures are depicted with a delicacy of execution
reminiscent of a miniature. In France, Jacques Callot
(1592–1635) in particular drew and etched crowd

scenes of this nature; he also anticipated Gillot and
Watteau by depicting the characters of Italian comedy
in his works (ill. 39).

Compositions crammed with figures are most
characteristic of Watteau's early period, up to around
1712. Some years later, however, he produced another
painting of this kind in *The Pleasures of the Ball* (ill. 44).
He had reverted to earlier themes in a similar way in the
1716 etching of the recruits (ill. 34). *The Pleasures of the
Ball* seems to have been painted even later, perhaps
about 1717. It is not primarily a scene showing actors,
but as in the *Fair with Players*, characters from Italian
comedy mingle with the crowd, which contains sixty-
four figures in all, including those in the background.
However, the stage characters are hidden among the
rest, and viewers relishing all the details will enjoy
finding them. Pierrot with his round, smiling face and
halo-like hat stands in the background, on the left of
the vaulted hall; the figure suggests a subtle quotation

from the famous *Gilles* (ill. 53). Directly in front of him, the almost grotesquely mobile Harlequin is in direct contrast to his still figure. The fool with a guitar, a prominent figure in the foreground joking with a child, also suggests the world of the theater; and, last but not least, the stately architecture has something of a stage set about it. It is impossible to work out the logic of this building, as one so often can with the architecture in Watteau's pictures; presumably he wanted to ensure that viewers could not take a down-to-earth view of its nature.

The rusticated columns would have reminded a Parisian of the old Palais du Luxembourg, where Watteau had worked for some time; it was then a century or more old. This was a style of architecture that Rubens too liked to depict in his paintings. Two

men standing in front of the double pillar also wear the costume of that earlier time, confusing any chronological ideas of period.

The masterly nature of the work depends chiefly on the artistic disposition of the many figures it contains. The music played by the small orchestra not only governs the movements of the dancing couple, but seems to determine the arrangement of the whole company; on the whole, and in spite of the vigorous movements of some of the individual figures, the composition is clear and calm in form, like the architecture. All the lively impulses of pleasure and enjoyment are subject to a gentle discipline. The two human pyramids on the right rise in a form that echoes the buffet standing between the two female caryatids. On the left, a compact group builds up, beginning with

42 Gérard Scotin, after Watteau
The Jealous Ones, ca. 1712
Etching
Kupferstichkabinett, Staatliche Museen zu Berlin –
Preussischer Kulturbesitz, Berlin

The seated figure of Pierrot is accentuated by the presence of the faun-headed herm in a manner similar to the composition of *Gilles* (ill. 53). He also sits in the same attitude as the little boy dressed as Pierrot in the later *The Happy Age* (ill. 107). As in *The French Theater* (ill. 45), the tambourine and the fool's bauble belong together, a characteristic touch linking this picture to other works by Watteau.

A. Watteau pinxit.

LES JALOUX
Gravée d'apres le Tableau originale Peint par
Watteau, de mesme grandeur.
du Cabinet de M.^r de Jullienne.

INVIDIOSI
Sculpti juxtà Exemplar Ejusdem magnitudinis
à Watæavo Depictum.

G. Scotin Sculp.

a Paris chez F.Chereau graveur du Roy rue S.Jacques aux deux pilliers d'or avec privilege du Roy.

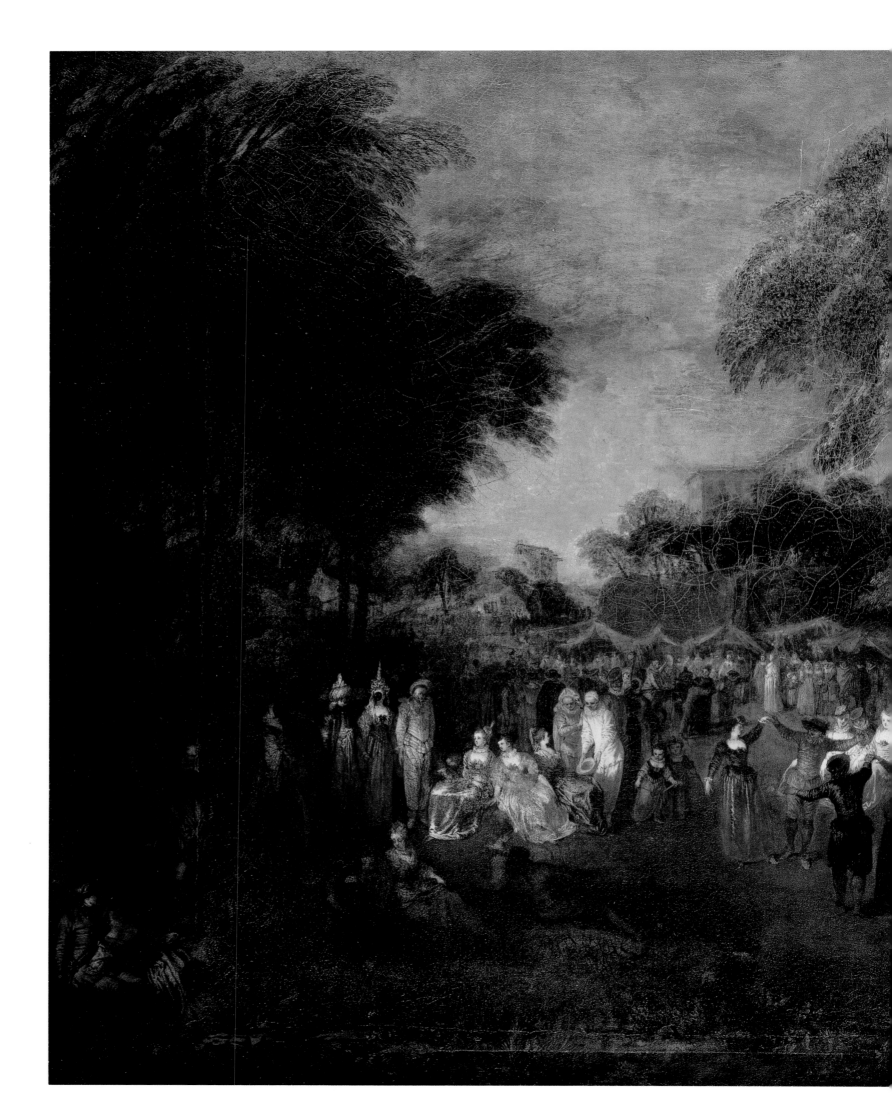

the reclining fool, moving on to seated and then to standing figures, with the form dying away like a melody in the graceful attitude of the male dancer. In his ornamental designs, Watteau's sense of rhythmic form was expressed in a strongly accentuated sequence of straight lines and curves; here he brings this sense of form to bear on human figures. The two dancers, their prominence stressed by the arch above them, are at the central focus of the composition, which moves away into the landscape of tall trees, where the fountain leaping up behind the dancing man symbolizes effervescent yet decorous pleasure. This upward movement is answered by the downward glance of the black boy on the balcony at the top right-hand side of the picture, the witty conclusion to an entertaining narrative.

When the Italian players were allowed to return to Paris in 1716 after the death of Louis XIV, Watteau painted the troupe in the landscape of a park by night (ill. 47). It is the only nocturnal scene in his oeuvre. The full moon, breaking through the clouds, relates to the torch held by Mezzetin. He and Pierrot are the most striking of the twelve figures and form the major axes of the composition, which appears more loosely and less elaborately assembled than in most of the painter's other works. From left to right, these characters emerge gradually into the light more and more clearly: they are (extreme left) Cantarina, a male singer, Violetta, the doctor, Flaminia with her mask removed, Silvia, Pierrot playing a guitar, Harlequin, Scapino, Mezzetin holding the torch, Pantalone, and Scaramouche. The sequence ends with a dog turning to look at the moon. The profiles of the doctor and Pantalone frame and emphasize the central group. If the painting is celebrating the return of the troupe, it is presented not as a triumph but as a gathering overshadowed by melancholy, with the torchlight lending it a dramatic note. The scene is accompanied by the music of Pierrot, who stands not in his typical pose but in a relatively relaxed attitude.

Watteau depicted the Italian players very differently in a painting now extant only in copies and an engraving, and dating from around 1719/20 (ill. 52).

43 *Fair with Players*, ca. 1708
Oil on canvas, 64.7 x 91.3 cm
Schloss Sans Souci, Potsdam

This painting, not shown to the public until 1924 and only then ascribed to Watteau, had been acquired by Frederick the Great. In the early 19th century it was enlarged by 3 cm at the bottom and 10 cm on the left, so that it could be hung as a companion piece to *The Village Bride* (ill. 56). As in many early paintings by Watteau, it is poorly preserved because of technical errors in the execution: paint was applied before the ground was perfectly dry.
It is unique among the painter's works due to the accumulation of so many themes, as if he wanted to display his entire repertory. The care he took with the execution is also noticeable. The picture is therefore likely to date from the time when Watteau was very anxious to find buyers.
This early work already shows Watteau assembling a large composition out of smaller, self-contained groups. These groups can be easily divided up again, and each may then be seen as a separate work.

As in *The Pleasures of the Ball* (ill. 44), it begins in the left foreground with a fool seated on the ground, who, like the fool on Gersaint's shop sign (ill. 9, 17), is caressing his bauble as if it were a doll. In this picture the players are presenting themselves to the audience at the end of a performance, and the central figure of Pierrot assumes his characteristic rigid stance.

Of all the stock types of Italian comedy, it was Pierrot whom Watteau painted most frequently. He seems to have been the artist's favorite character; perhaps Watteau even identified with him to some extent.

On an engraving of 1734 by Charles-Nicolas Cochin (1688–1754), this picture bears the intriguing title of *L'amour au théâtre italien* (Love in the Italian Theater). It was probably already being seen as the companion piece to the painting entitled, with rather more justification, *L'amour au théâtre françois* (Love in the

French Theater) (ill. 45), which Cochin reproduced in the same year. By 1766 both pictures, now regarded as particularly valuable cabinet pieces, were in the possession of Frederick the Great.

Undoubtedly *The French Theater* was painted first. The picture shows a theatrical scene in a park. Bacchus, crowned with vine leaves and reclining on a stone bench in front of a tall pillar, has a goblet of red wine in his hand, and is clinking glasses with a man dressed in pink, who stands in a lordly attitude. The quiver of arrows slung over his shoulder identifies him as Cupid or Amor. It is thought that this picture represents a scene from Lully's *opéra comique* of 1672, *Les Festes de l'Amour et de Bacchus*. Colombine is bringing the two gods together. The main figure, however, is a female dancer surrounded by glowing light. She is standing directly beneath the stone bust of a smiling man, who has been interpreted as Momus, the personification of

44 *The Pleasures of the Ball*, ca. 1717
Oil on canvas, 52.6 x 65.4 cm
Dulwich Picture Gallery, London

Particularly in his later years, Watteau often liked to show a paved foreground to his pictures, with the grid-like slabs allowing a precise orientation and providing a basic unit of measurement. This foreground area always ended, as here, with a sharply drawn line beyond which nature can unfold freely.

censure. In classical myth, Momus criticized all the gods, and was very angry when he could find no fault with Venus. If this interpretation is correct, then the beautiful dancer would be Venus herself, although her partner in the dance is a figure in a straw hat who moves in an awkward, rustic manner. An oboist, a violinist, and a bagpiper, all depicted as subsidiary figures in muted tones, are playing music for the dance. A Pierrot can be seen among the spectators standing behind them, and the bauble lying below the tambourine in the left foreground most likely belongs to Momus. The figure at the front of the group on the right is probably a portrait of the actor Paul Poisson in the part of Crispin, a stock character of French comedy. The delicate, doll-like ladies beside him are reminiscent of Watteau's earlier works.

Watteau's liveliest depiction of Pierrot is in the small picture painted on a coach door, *The Italian Serenade*

(ill. 48), now in the National Museum of Stockholm. The sight of Colombine sitting on a grassy bank beside him, modestly drawing back and looking shyly at him, inspires his guitar playing. Pierrot's glance and his whole physical attitude express his love for her. Behind him, however, like a continuation of the diagonal axis of his body, stands the figure of the fool, holding up his tambourine like a warning sign, and a dark gap separates Colombine from the group of men. The fool not only dictates the beat of the music, his presence seems to announce that love is folly. Above him, the shadowed face of an actor in an unidentifiable part emerges from the darkness of the woodland set, looking calmly down on the interaction between Pierrot and Colombine. Mezzetin and Crispin are watching too. The line of the cloak hanging from Crispin's shoulders continues in the trunk of the tree above him. To the right, the eye is led to an open

45 *The French Theater*, ca. 1714
Oil on canvas, 37 x 48 cm
Gemäldegalerie, Staatliche Museen zu Berlin –
Preussischer Kulturbesitz, Berlin

As in the later *The Italian Theater* (ill. 46), Watteau arranges the colorful figures on the right in a semicircle. However, the central figure of the female dancer and the white cloth behind her bring the curve to a sudden end. The muted colors of the musicians and spectators on the left make them seem like people from another world. Only the pale blue sky above them echoes the right-hand side of the picture.

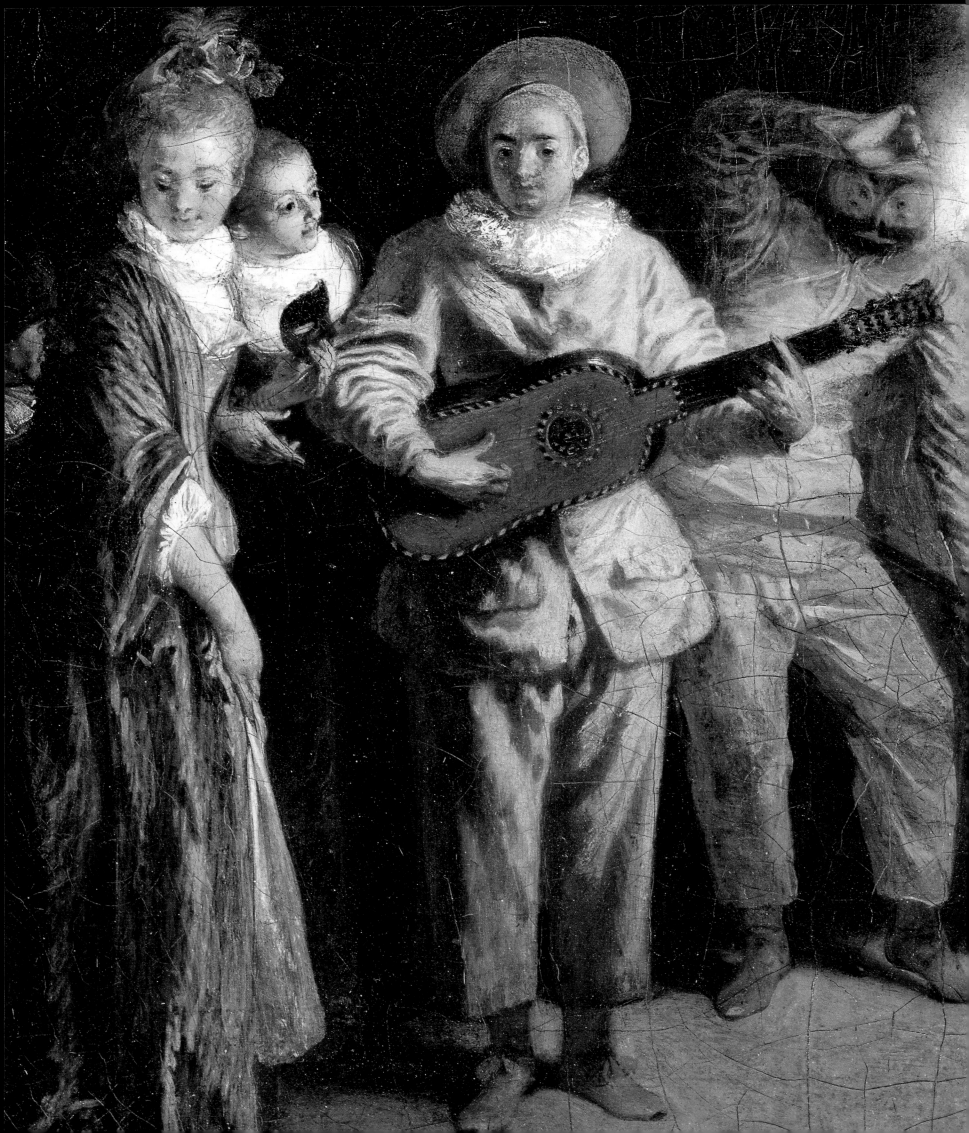

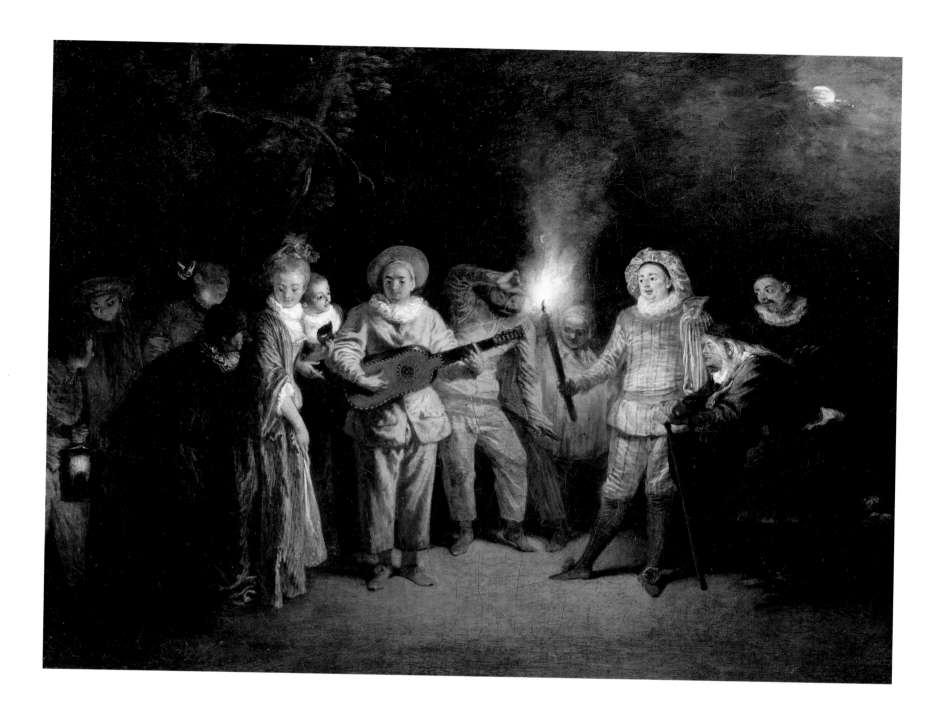

46 *The Italian Theater*, ca. 1717
Oil on canvas, 37 x 48 cm
Gemäldegalerie, Staatliche Museen zu Berlin –
Preussischer Kulturbesitz, Berlin

Here Watteau arranges the figures of Italian comedy
roughly in a semicircle. He picks up the form of the curve
again within the picture by placing the bowed figures of
the doctor and Pantalone on the outside left and outside
right of the semicircle. The two central items of guitar and
torch – one for hearing, one for seeing – almost form a
right angle with each other, while the light of the lantern
on the left answers the moonlight.

47 *The Italian Theater* (detail, ill. 46)

Watteau places the contrasting figures of Pierrot and
Harlequin side by side, one calm and relaxed, the other
engaged in grotesque and hectic movement, forming a
close-knit group with the two pretty young women on the
other side of the picture.

landscape. The figures are painted with the fluent and
shimmering brushstrokes of Watteau's middle years,
reflecting something of the highly strung temperament
of the actors, while the tones are autumnal.

By far the most important of Watteau's representa-
tions of the figure of Pierrot is *Gilles* (ill. 53), a not
entirely accurate title given to the painting only later. It
once belonged to Baron Vivant Denon (1747–1825),
Napoleon's famous art expert, and its original function
is not clear. It has been suggested that it was originally
painted as a shop sign for a coffee-house proprietor
called Belloni (ca. 1680–1721), who had been a
celebrated actor in the part of Pierrot before retiring
from the stage in 1718. This hypothesis would also suit
the style of the painting, which could well have been
executed around 1718/19.

The figure probably does have certain features of
portraiture, but as a full-length, life-size portrait it

would have seemed to compete with official likenesses
of that nature, and they were usually reserved for
persons of very high rank. If it is a portrait, then, that
very fact implies provocation by Watteau similar to
that of *Gersaint's Shop Sign* (ill. 9), which seems to
advertise Gersaint's shop but is really a critical
comment on society. The picture would be showing
Belloni in the character of an Italian actor once again,
even after his retirement from the stage.

Pierrot-Gilles, standing on raised ground like a
military commander, is shown in clear outline against
the sky and overlapping other details only in the lower
part of the picture. A comparison with Hyacinthe
Rigaud's *Louis XIV in Armor* of 1701 makes this work by
Watteau seem almost like a calculated insult to royalty.
The comedy of the role of Pierrot turns to dignity, and
the symmetry of the large format engenders a sense of
majesty based on the nature of humanity. The figures

49 (right) *The Serenader*, ca. 1717
Oil on panel, 24 x 17 cm
Musée Condé, Chantilly

In format and style, this small picture is closely related to
The Indifferent Man (ill. 67) and *The Artful Girl* (ill. 68).
As in those works, the guitar-playing Mezzetin (derived
from the Mezzetino of Italian comedy) is seated on a stone
bench, but unlike the figures they depict, he is full of pent-
up energy. His crossed legs, the tree trunk, the line moving
up from his left hand to above his head, with the face
shown in sharp profile, the outline of the wood in the
background, the neck of the instrument, and the
horizontal of the park bench – all combine into a strict
geometrical figure, giving some idea of the kind of music
that will be played once Mezzetin has tuned his guitar.
Meanwhile, his gaze is bent on someone else, who can only
be a lady. Whether she ever existed in a companion piece,
or whether we are only supposed to imagine her, must
remain an open question.
Watteau was very fond of this figure. He used it again in
Meeting in the Open Air (ill. 83), where the character is
looking at a woman who this time is depicted. Mezzetin
also features again in the composition *The Surprise Attack*.
In the painting of *Mezzetin* in the Metropolitan Museum,
New York (ill. 111), Watteau varies the figure and gives it a
different character, in a style typical of the greater
profundity of his art at the end of his life.

48 (left) *The Italian Serenade*, ca. 1718
Oil on chestnut panel, 24 x 17 cm
National Museum, Stockholm

An X-ray photograph not only showed that this picture
was painted on the fragment of a coach door, but also
revealed the existence underneath of an even older
composition, showing only Pierrot, Colombine, and
the fool, executed with the stiffness typical of Watteau's
early work.

behind Pierrot, dragging along a stubborn donkey with the laughing Crispin mounted on its back, are there only for the sake of contrast. A mysterious relationship between Pierrot-Gilles and the donkey is revealed in their eyes. The actor is looking down on the viewer of the picture, relaxed and rather weary, as a man might feel on retirement from his artistic career. In the grave, wide eye of the donkey, on the other hand, we see its soul. Its intense glance offsets the three figures on the right, and the stubborn animal attracts more sympathy than the human beings who are forcing their will upon it.

From the tree-tops above Crispin on the left, a line runs down to the donkey's head, and then rises again

strongly to the right past the red-clad Capitano, the poplars, the pine, and the faun-headed herm with the clouds towering behind it. Pierrot-Gilles in his white costume, its upper part particularly radiant, forms the still center of the painting.

The picture *In the Costume of Mezzetin* (ill. 50), which was certainly painted later, is comparable to the portrait of Pierrot-Gilles in the full frontal stance of the main character and in the arrangement of the subsidiary figures in a sweeping arch shape (though here the arch is curving the opposite way). It differs, however, in its small format, almost miniature-like for a portrait. However, it is painted in a relaxed and easy style. Both

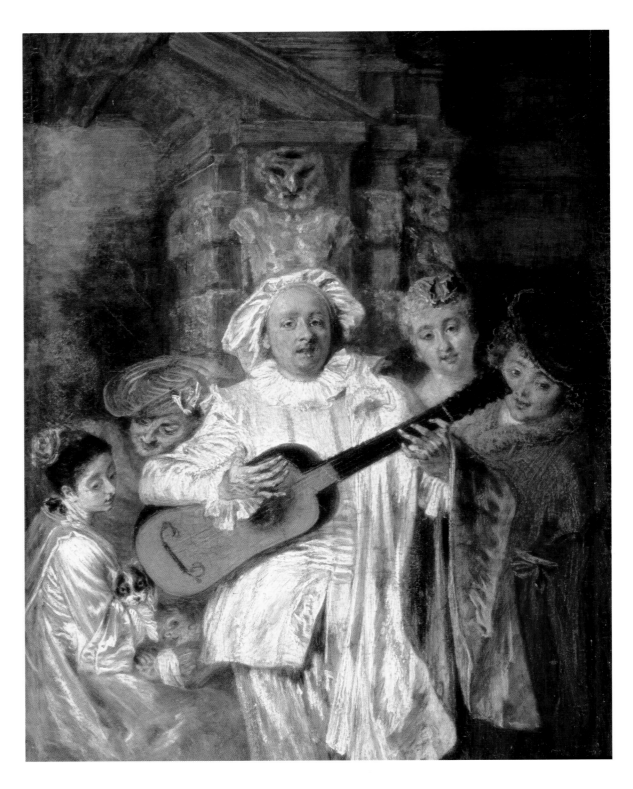

50 *In the Costume of Mezzetin*, ca. 1720/21
Oil on panel, 28 x 21 cm
The Wallace Collection, London

Pierre-Jean Mariette commented on the engraved reproduction entitled *Sous un habit de Mezzetin*: "Sieur Sirois, a friend of Watteau, shown among his family in the character of Mezzetin playing the guitar."

works are evidence of Watteau's greater tendency to turn to portraiture in his late works, though as far as we know he never painted portraits on commission. He usually portrayed people he knew well, or figures to whom he had already given a place in his compositions. It is possible, however, that he merely drew these people and fitted them into the compositions of his paintings later, as they were required. This small Mezzetin picture, therefore, cannot be a group portrait, since the man in the straw hat, who also appears in *The Indiscreet Man* (ill. 109), is certainly not a likeness of any particular person.

According to Mariette, Mezzetin himself is a portrait of the glass dealer Pierre Sirois, who became Gersaint's father-in-law in 1718. The lady beside him is more likely to be his wife than his daughter Anne-Elisabeth, who has been suggested as the model. Anne-Elisabeth married Gersaint when she was twenty-six, and may possibly be the woman with the intellectual and distinguished features with the child on her lap. If this hypothesis is correct, it would date the picture to around 1720/21, the time when Watteau was staying with Gersaint.

Sirois is playing the guitar with the thin, supple fingers typical of figures in Watteau's late period. They are the only hands shown in the picture, apart from one of the child's, and do not really suit the round face. Unusually for the subject of a portrait, Mezzetin even seems to be singing. The grimacing face that adorns the rustic architecture of the gateway, a building in a style reminiscent of Rubens, contrasts with the central character's regular features. A similar grotesque mask appears in profile above the lady beside him. These masks may be bitter references to old age, sickness, and death – they are certainly not flattering elements of the picture.

The six heads in the painting – or seven if the head of the dog is included – are grouped around the guitar, forming a little more than half of an oval. Music is at the center of the composition. The small child, trying to hide with typically childish mischief yet seeking to meet the viewer's eye, is in complete contrast to the grimacing masks, and could be seen as representing the attractive first stages in the cycle of life.

Ten years earlier, Watteau had moved anonymous players of Italian comedy away from the stage and into the theater of life; now he was moving real life into the theatrical sphere.

51 *Pierrot, called Gilles* (detail, ill. 53)

This famous picture begins cheerfully with the smiling character of Crispin (for which there is an extant study, obviously a portrait), moving into more thoughtful mood with the expression in the eyes of Pierrot, and with the silent, suffering animal figure of the donkey.

52 Unknown copyist, after Watteau
Italian Players
Oil on canvas, 63.8 x 76.2 cm
National Gallery of Art, Washington

Watteau probably painted the original of this important
composition in England in 1720, for the physician and art
collector Dr. Richard Mead. It is thought that the occasion
was a successful appearance by the Italian players in
London in 1720. As in the picture of *The Italian Theater*
now in Berlin (ill. 46), the company consists of twelve
characters, in this case with the addition of the fool and
the two children. Pierrot presents himself as the leading
figure, and his status is emphasized by the architectural
background.

53 *Pierrot, called Gilles*, ca. 1718
Oil on canvas, 184.5 x 149.5 cm
Musée du Louvre, Paris

The curious spatial relationship between the central figure
and the other actors can be explained by supposing that
Gilles is standing on a raised, narrow stage made to look
like a piece of ground. Behind this platform, the other
actors are coming up behind him with the donkey, and the
background is a painted backcloth, strictly speaking a
picture within the picture. This witty interplay links the
painting to *Gersaint's Shop Sign* (ill. 9), while the
construction of the stage is reminiscent of that in *French
Players* (ill. 19).

EMBARKATION FOR CYTHERA

54 *The Island of Cythera*, ca. 1709
Oil on canvas, 43.1 x 53.3 cm
Städtische Galerie, Municipal Art Institute, Frankfurt

The rigorous, carefully thought out composition converts an invitation to enjoy life's pleasures into a command. The tension between structural rigor and the light-hearted subject probably reflects the tension between the oppressive social misery of the period and the attempts by artists to create an imaginary, paradisal world.

Watteau delivered his *Pilgrimage to Cythera* (ill. 55, now in the Louvre) to the Académie in the summer of 1717 as his reception piece. He had pledged himself to paint one when he had been provisionally admitted as a member of that venerable institution on July 30, 1712, and the Académie had made a special concession in allowing him to choose his own subject. None the less, Watteau took his time over the task, showing a certain indifference to the status of Academician. He was reminded of his obligation first in 1714, then in the two following years, and finally, yet again, on January 9, 1717. He then produced a masterpiece surpassing all his earlier easel paintings, and not only in size. The novelty of the subject, which would fit none of the traditional categories, gave the Académie recorder some difficulty when Watteau was at last received as a full member. He finally called the picture *Une feste galante* – a "gallant festivity." The problem shows how the painter's work constantly transcended generally accepted subjects and genres, requiring viewers to look instead at the emotions that he translated into painting, something much harder to define. The novel features of this picture, which purports to show the beginning of a pilgrimage to the island of Cythera, should be studied in connection with the far-reaching political and cultural changes that took place after Louis XIV's death, and were certainly welcomed by Watteau.

It is not known when Watteau began to devise and draft this picture, but its genesis was not a long one. The work gives the impression of having been painted with great intellectual concentration, but with an easy hand and in a state of enthusiasm. It is even possible that Watteau did not begin the painting until after receiving his last reminder.

Yet it has a pre-history, looking back to the sphere of the theater and the period around 1709, a time when life in Paris was particularly oppressive, and Watteau felt a particularly strong wish to escape it. There are good reasons for assuming that the production in 1709 of a popular comedy by Florent Dancourt (1661–1726), written in 1700 and entitled *Les trois cousines*, gave Watteau the idea for his painting *The Island of Cythera* (ill. 54), which was rediscovered only in 1981.

Although the picture may not be the reproduction of an actual scene from this production, the play ends with a boat journey to the Temple of Love on an island described as Cythera, and the young men and girls of a village dress as pilgrims for the occasion, mingling religion with eroticism and country life with city life. It shows even peasants wearing rich clothing.

Cythera, geographically an island off the southeast tip of the Peloponnese and in classical antiquity a center of the worship of Aphrodite, the Greek goddess of love, was a term generally understood in Paris around 1700 as a euphemism for free love, and was associated with a real place, the park of Saint-Cloud on the banks of the Seine west of Paris. The landing stage shown in the painting, with its handsome flight of steps and balustrade, would certainly have reminded any contemporary Parisian of the cascade in the park of Saint-Cloud, while the fantastical mountain landscape behind it could easily have been taken as an imaginative stage set.

The connections of this picture with the world of the theater emerge not least in the engraving of a costume design that reproduces one of the central female figures of the painting. She wears a copper-colored gown and is shown from behind. Underneath this etching is the inscription: *M.lle Desmares jouant le rôle de Pelerine* (Mademoiselle Desmares playing the part of the pilgrim).

The picture, therefore, referred to a specific theatrical spectacle and laid claim to no message beyond the present moment. Watteau was content merely to communicate with those of his contemporaries who appreciated him.

He composed this picture as a stage director might. The seven main figures in it, identifiable by their particularly rich clothing as persons of high rank, are all looking to the right, and thus direct the viewer's gaze to seek the beginning of the action in that direction too. They also line the path along which the less strikingly well-dressed figures on the right will pass to board the boat first. There are *amoretti* already standing in the boat, ready to act as oarsmen, and Cupid with his quiver stands beneath the canopy, captaining the vessel for the crossing. Another naked

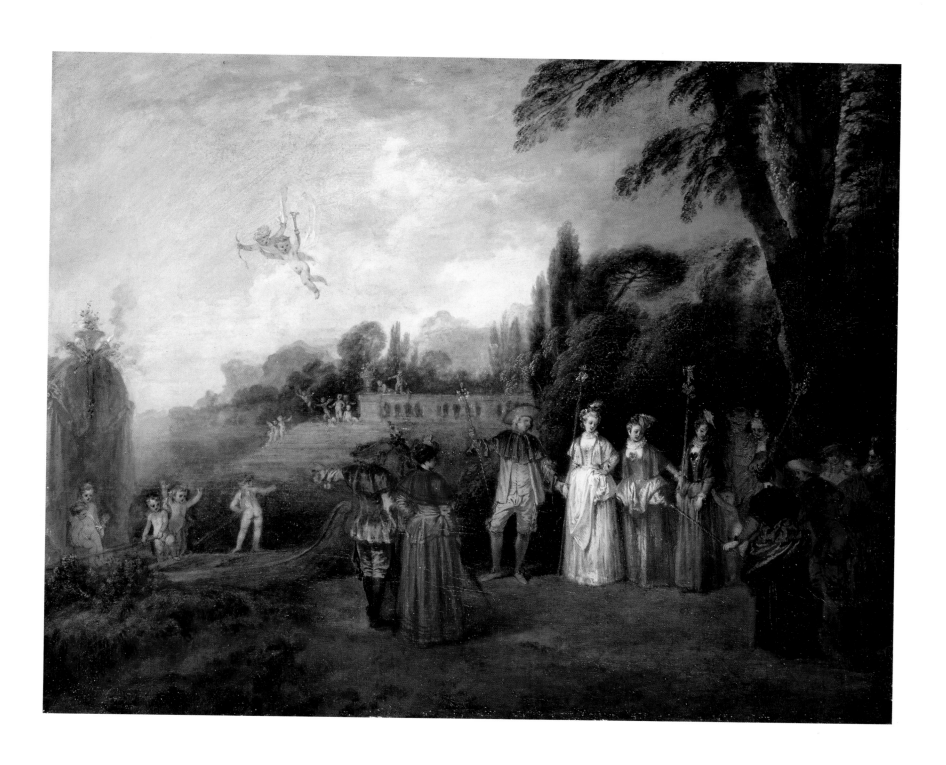

55 *Pilgrimage to Cythera*, 1717
Oil on canvas, 129 x 194 cm
Musée du Louvre, Paris

Here the idea that was still germinating in *The Island of Cythera* (ill. 54) is seen fully grown. The change within about eight years from inhibition to relaxation, from deliberation to excitement, is not due solely to Watteau's greater artistic maturity and happy awareness of his own skill, but also to the general sense of liberation felt after the death of Louis XIV, when hopes were high for favorable political developments. As the pilgrims begin their pilgrimage to Cythera, they are setting off into a new age.

56 *The Village Bride*, ca. 1712
Oil on canvas, 65 x 92 cm
Schloss Sans Souci, Potsdam

The rigor of the composition still resembles that of *The Island of Cythera* (ill. 54), and so does the arrangement of the figures in lines running back into the depths of the painting, and the schematic treatment of the trees. The wide cracks in the paint, the result of technical deficiencies, also occur in *The Marriage Contract* (ill. 73).

boy is urging the double line of central figures to move toward the boat, beginning with the lady in green on the right – a charming motif that Watteau seems to have taken from an engraved reproduction of Rubens' *Garden of Love* (ill. 72).

The pilgrim standing closest to the boat is in command of the passengers, and he also looks to the right as he points to the boat with his left hand. The whole company will eventually be rowed over to the island, where several *amoretti* are already waiting for them. Pines and cypresses suggest the southern setting, and perhaps Watteau meant to convey similar ideas through the glowing yet muted jewel colors he used, which are reminiscent of 16th-century Venetian painting.

Although the entire scene is governed by orderly movement, Watteau's distribution of themes over the

surface of the painting also aimed for a static and geometric effect, and not only in the main figures standing in repose. The pilgrim staves carried by the second, third and fourth figures from the left are held at an angle radiating out from a single point at the bottom of the picture. The two airborne *amoretti* carrying bows and wedding torches continue the line of the staff held by the woman pilgrim seen from behind, and the staff of the lady on the extreme right also points straight to these *amoretti*. This departure for the island of love is not an intoxicating orgy but a disciplined, well-organized event. The impression is restrained and agreeably intriguing.

Only a few years later, in *The Village Bride*, probably painted around 1712, a far more lavishly staged procession escorts a bridal couple to the church where a

priest is waiting for them at the door. Here again we are meant to feel transported to Italy, particularly through the Palladian architecture of the church. In the central group of figures, beginning with the bridal couple seen from behind, Watteau aims to express gathering momentum, but this time there are many more figures lining the path. The bride and groom are not in the coach, but they can be identified by the fact that all eyes are turned to them, and by the two little dogs running on ahead.

This work contains 108 figures in all, very skillfully arranged. Figures reclining, sitting, and standing form tight-knit groups, and Watteau used some of these groups, like building blocks, in other compositions. They suggest that the procession is pausing and lend it a sense of solemnity. The painter knew how to distinguish an expedition to the island of love from a church wedding.

The French title of this picture (from its engraved reproduction), *La mariée de village*, suggests rusticity, and the bridegroom and some of the other men in the picture do indeed wear straw hats, like villagers. On the whole, however, the company is in fine town dress, and the architecture is on the grand scale as well. Distinctions of rank are deliberately blurred, as they were in *The Island of Cythera* (ill. 54).

The Village Bride (ill. 56), which is in a poor state of preservation, is a major work of Watteau's early period in respect of format, the quality of its execution, and its composition, and also in the wealth of detail it contains. One can imagine that Watteau could well have gained admission to the Académie with the work in 1712 if it was painted by then.

Paintings like this and *The Island of Cythera* (ill. 54) were preliminary stages on the way to the creation of the *Pilgrimage to Cythera* (ill. 55), which is double the

57 *Embarkation for Cythera*, ca. 1719
Oil on canvas, 129 x 194 cm
Schloss Charlottenburg, Berlin

The hopeful enthusiasm expressed in the first version of this picture (ill. 55), can never last very long. In style and intellectual content, this second version is notable for the sense of consolidation, enrichment, and greater profundity that it conveys. Many of the more rigorous features of the early *The Island of Cythera* (ill. 54) recur in this composition. Again, Watteau's development shows his maturing humanity.

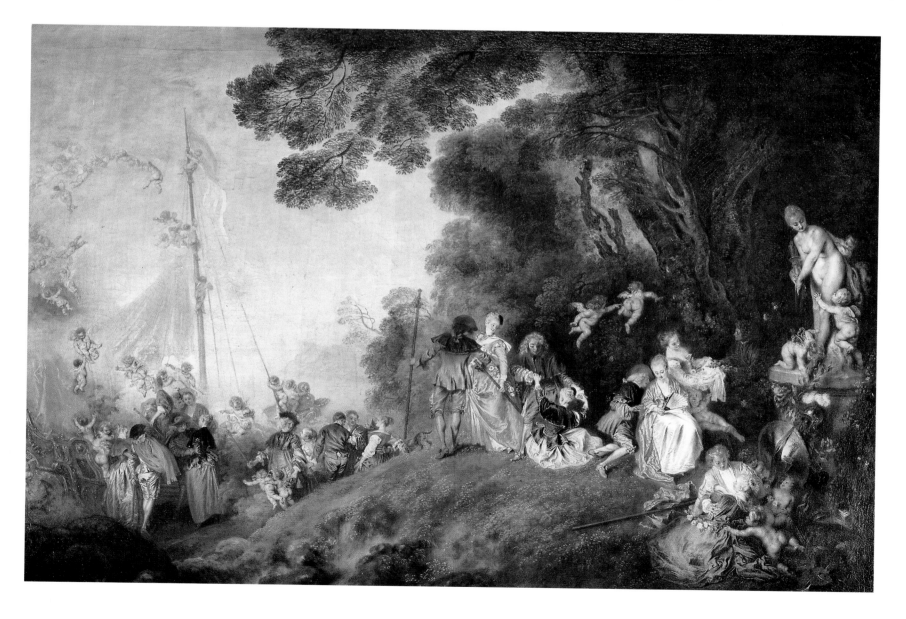

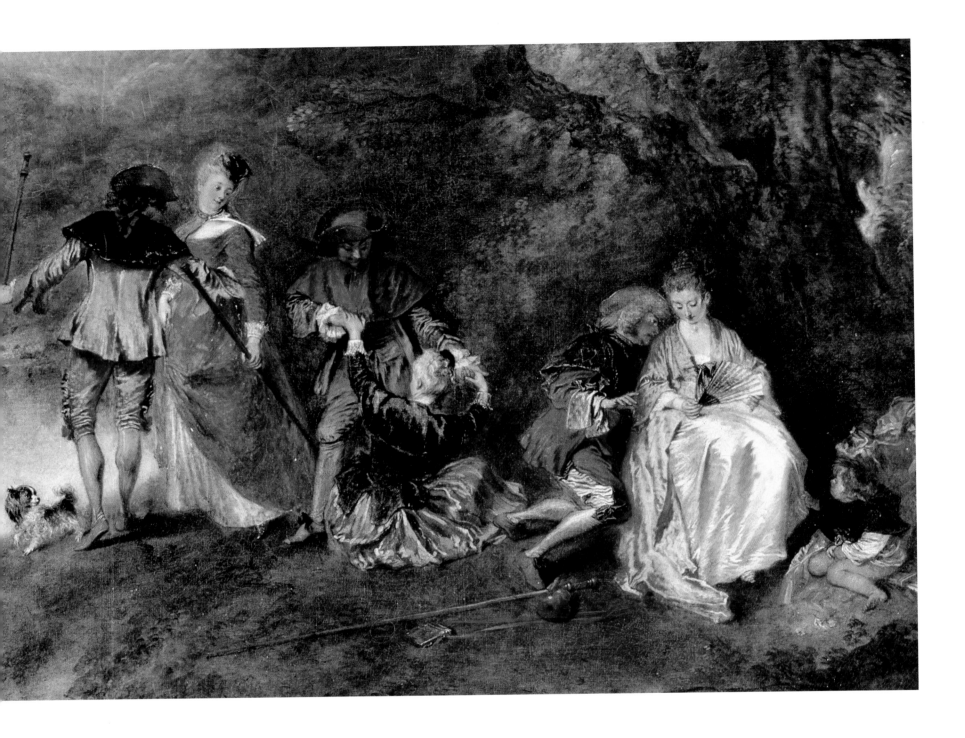

height and breadth of *The Village Bride* (ill. 56), but apart from the *amoretti* contains only nineteen figures.

Here the great strides Watteau had taken in his development immediately leap to the eye. The procession is no longer governed by rules; instead, the pilgrims are moved to set out of their own volition, guided only by love. Furthermore, the *Pilgrimage to Cythera* shows not only phases of their departure and various stages on the way to the boat, but their different conduct within the context of emotions affecting them all. The painting is full of delightful ideas, sparkling in both conception and execution. Its composition begins on the right with a broad band running all the way up the canvas, painted with rapid strokes to represent a thicket, as if the artist were trying out his brush. Next comes the herm of Venus, looking up in ecstasy, its shaft surrounded by roses. At the base of the herm are Cupid's

attributes, his bow and a quiver of arrows. A boy naked from the waist down, half love god, half civilized human being, is seated on a second quiver and gazing up at a beautiful girl. A kneeling pilgrim is trying to persuade her to set out; she seems thoughtful, and holds an open fan in her hand. This fan provides the formal motif for the mighty group of trees, with their trunks and branches growing upward from the place where the boy is seated and then out to the side, like the fingers of a spread hand. These trees reveal the vital energy that is concentrated in nature. They are felt to give impetus to the movement of the pilgrims, up to the impressive figure seen from behind who stands at the center of the composition and directly below the outermost branches of the tree. Three couples illustrate the different stages of the embarkation, with each figure moving differently. Angles of vision are as important as the material

58 *Pilgrimage to Cythera* (detail, ill. 55)

The coloring serves the rhythm of the composition, with black and several tones of red leading the eye through the picture. Blue is used only with great restraint, and the light brown in the robe of the standing woman pilgrim echoes the color of the autumnal foliage. The contour of the group follows a sequence of pointed and rounded arches, and again enhances the clear rhythm of the design.

59 *Embarkation for Cythera* (detail, ill. 57)

This later version of the theme is more colorful, and the coloring helps the details to appear intertwined rather than merely arranged side by side. The pale yellow of the dress worn by the standing woman pilgrim is dominant, but the tones of blue in the gown of the woman sitting on the ground are also important, and relate to the sky. Similarly, the general outline, which can no longer be described as a clear sequence of arches, has become more complex.

62 *Country Pleasures*, ca. 1715
Oil on panel, 31 x 44 cm
Musée Condé, Chantilly

The tree trunk in the center divides the surface area into
two halves. In front of the tree, and the focal point on
which the composition turns, sits the musician with his
cornett; elegantly dressed couple to the right are
dancing to its music. There is a view of an open landscape
behind them. The woman has moved close to the
musician, but Watteau does not let them overlap. The
reclining man in the foreground is deliberately placed
between the central seated figure and the recumbent dog
with which the composition of the left-hand side of the
picture begins. The attitude of the seated shepherd, shown
on the diagonal as he clumsily embraces a girl instead of
attending to his sheep, is chosen with equal care. These
figures and the head of another man form a carefully
constructed triangle. Behind them, the wood opens out
into a ride where a man is pushing a lady on a swing.
Geometric order mingles with freedom here, just as the
townsfolk mingle with the rustics. The picture resembles
The Pleasures of the Ball (ill. 44) in the delicacy of its
brushwork. Its comparatively free composition, however,
does not seem to have satisfied Watteau, and in *The
Shepherds* (ill. 63) he reworked it, in much the same way
as he revised the first version of the *Pilgrimage to Cythera*
(ill. 55) for its reincarnation as the *Embarkation for
Cythera* (ill. 57).

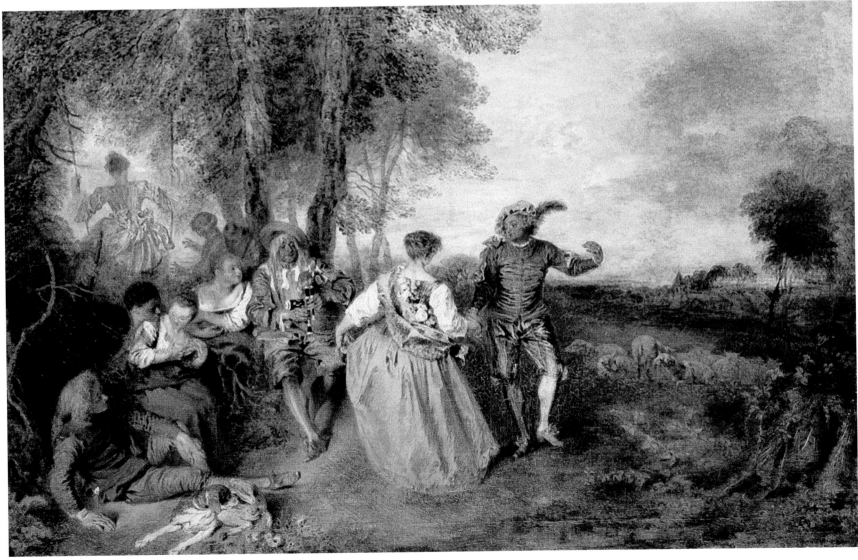

64 (right) *The Dreamer*, ca. 1714
Oil on panel, 23.2 x 17 cm
The Art Institute of Chicago, Chicago

The title, taken from the 1729 engraving of this work by
Pierre Aveline, does not express the true character of the
small picture, which depends on the Polish costume in
which the lady confidently presents herself. Its orange red
is attuned to the green of the vegetation, but in its radiance
it competes with the sky, covered with lightly moving
clouds in the upper-right hand side of the painting.

63 *The Shepherds*, ca. 1719
Oil on canvas, 56 x 81 cm
Schloss Charlottenburg, Berlin

This painting is almost twice as tall and wide as *Country
Pleasures* (ill. 62). The group of figures develops in a
harmonious curve, beginning with the dog and the youth
seated on the ground, moving on to the rustic lovers – a
strapping peasant girl and a rather foolish-looking boy –
then to the central figure of the bagpiper, and so without a
break to the dancing couple. The left arm of the male
dancer, his hand with its delicate fingers gracefully bent
and clearly relating in form to the beginning of the line of
figures, has open sky behind it, unlike its equivalent in
Country Pleasures. The whole landscape has opened out.
The trees with their delicate foliage are seen in more
individual detail, the air is slightly misted by a summer
haze, and the water in the foreground right has been
replaced by sheaves with brambles growing over them,
indicating the autumnal season. The attractive figure of
the woman on the swing has come closer, and she is now
surrounded by the sky as if by an aureole; the clumsy figure
of the peasant looking enquiringly up at her is closer to the
other figures in the center. All the details have merged into
a single large form. On the left, the man seated on the
ground, the pair of lovers, and the woman on the swing
move upward like a musical chord, and the movement of
the whole line comes to rest in the male dancer's left hand,
allowing the landscape more space. To the extreme right,
there is another unobtrusive human figure in the form
of a shepherd in the painting.

explain the conscientious way in which the artist im-
proved on all the details. In 1733, when the repro-
duction was engraved, the picture was in the possession
of Jullienne, and it is possible that Watteau painted it
for this most faithful friend of his. Jullienne was
married on July 22, 1720, and if the picture was
intended as a wedding present, then that would explain
the modifications in this later reworking as compared
to the earlier, Paris version.

66 Nicolas de Largillière
*Double Portrait of a Lady and a Gentleman
as Pomona and Vertumnus*, ca. 1710
Oil on canvas, 146.5 x 105 cm
Gemäldegalerie Alte Meister, Staatliche
Kunstsammlungen, Dresden

The lady is the main figure, presenting herself as Pomona,
the goddess of gardens and fruits. According to the Roman
poet Ovid, the god of the seasons Vertumnus won
Pomona's love when he courted her in the disguise of an
old woman. The enhancement of the subject through
mythology is reflected in the exaggeratedly complex
draping of the folds in the lady's dress; its brushwork and
coloring illustrate the brilliance of Largillière's painting.
The artificial is pretending to be natural.

The words "fashion" and "mode" derive from French, and
they were terms of great significance in the changing life-
styles of 17th-century France. Fashion emphasizes the
value of the present moment, which must always be
dressed in the latest mode. It is deliberately imposed by
interested parties, rather than resulting from the laws of
growth and decay. Fashion makes itself felt in almost all
areas of life, but especially in dress, since the clothes
people wear reveal what they would like to be. Assets of
any kind, particularly the possession of money, can be
displayed to the best effect in clothing.

Distinctions of dress, inevitably, were of great impor-
tance in the absolutist system of 17th- and 18th-century France,
which was based on a rigorous order of society and wished
its principles to be outwardly visible. Consequently Louis
XIV himself took a great interest in fashion, which he used
as a means of indicating status within the court hierarchy.
In 1664 he issued a decree stating that coats and vests with
gold and silver embroidery might be worn only by a select
circle, at first limited to twelve persons, later extended to
forty. It was easy to control dress codes of this nature after
1682, when the king had assembled the entire aristocracy
around him at Versailles. Anyone at court had to
demonstrate his position by wearing magnificent clothing,
even if he could not always afford it. Etiquette was of
central significance, and this included details of dress.

Changes in fashion were very expensive for courtiers.
Whole handicrafts profited by such changes – or suffered
from them if some decorative item fell out of fashion, as it
did in 1670 when the lavish use of ribbon bows as
decoration went out. The most striking fashion of the time
was the long wig (ill. 7), with its abnormal profusion of
locks suggesting great masculine vitality. Noblemen were
obliged to wear daggers.

Ladies were less subject to the changing fashions than
gentlemen, not least because of the unassuming part the
queen played by comparison with her husband.

The social pressures on courtiers to present a fine
outward appearance, even though it reflected no genuine
value, might give rise to aesthetic pleasure, but protests
were bound to be heard in the end.

Paris had begun to figure as the cultural center of Europe
in the 1660s, and its importance was founded on a number
of factors, not least the dictates of fashion, to which almost
all the aristocracies of Europe gradually subscribed. From
1670, accounts of the Paris fashions were made famous in
the journal *Le Mercure galant*, the word *galant* indicating
that it was etiquette to wear such modes.

Fashion plates were also distributed through the
medium of engravings. Several Parisian engravers – not
the best of them – produced full-length portraits of
famous personalities at court, but the sitter's clothing was
more important than his or her face. The main aim was to
link the name with the clothes.

Watteau himself, whose feeling for fabrics may have
been refined by his friendship with the textile manu-
facturer Jean de Jullienne, produced such fashion plates in
the *Figures de Mode* (ill. 65) around 1710, and etched
some of them himself. However, he seldom gave his
etchings names, and when he did the characters in them
were usually actors rather than aristocrats. His fashion
plates showed the modes, not the court itself, and blurred
the distinction between dress denoting rank and theatrical
costume, just as everyday clothing often appears side by
side with stage costumes in his paintings. Watteau
brought a more casual approach to the solemnity typical of
traditional fashion plates.

The light in which the upper classes of Paris wished to
be seen at the end of the Sun King's reign and during the
Régence is best illustrated in pictures by the leading
portraiture specialists, Hyacinthe Rigaud (ill. 7) and Nicolas
de Largillière (ill. 66), and a host of other painters who
were almost as skillful. The actual clothes that the sitters
wore seemed insufficient to express the requisite grandeur,
and theatrically exaggerated backgrounds were supple-
mented by great lengths of draped fabric, forming
dramatic folds and producing the effect of flashing light,
as if for some inexplicable reason mighty winds were
ruffling the draperies. Outstanding brilliance of brushwork
and coloring was necessary to give these grandiose
illusions at least some semblance of artistic credibility.

65 *Man Leaning on his Elbow*, ca. 1710
Etching, 11 x 7 cm
Kupferstichkabinett, Staatliche Museen zu Berlin –
Preussischer Kulturbesitz, Berlin

This print is one of seven fashion plates that appeared
under the title of *Figures de Mode*. The man leaning on a
pillar is casual in both his attitude and his clothing: only a
few of the central buttons of his vest are done up. The park
landscape behind him emphasizes the "natural" look of
such a fashion.

Watteau inv. et fecit

à Paris Chez Mecquet rue S.Iacques à S.Maur

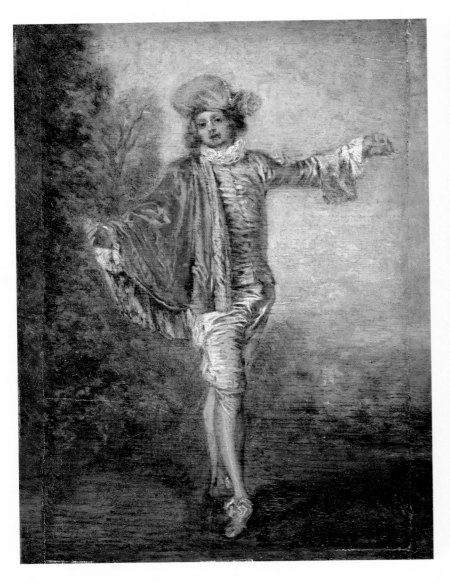

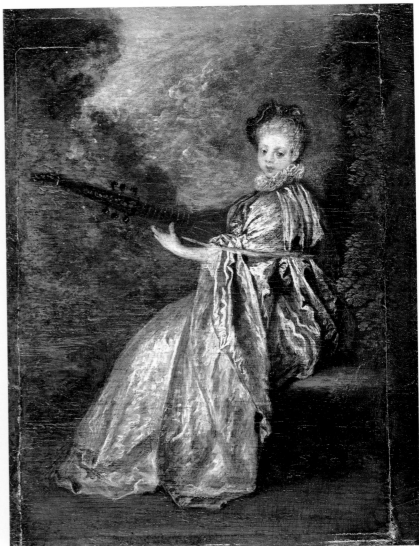

67 (left) *The Indifferent Man*, ca. 1717
Oil on oak panel, 25.5 x 18.7 cm, originally 23.9 x 16.3 cm
Musée du Louvre, Paris

68 (right) *The Artful Girl*, ca. 1717
Oil on oak panel, ca. 25.3 x 18.9 cm, originally 23.7 x 16.1 cm
Musée du Louvre, Paris

These two pictures – companion pieces illustrating the arts of dance and music – are among the smallest and the most famous of Watteau's works. Their titles (*L'indifférent* and *La finette*) are taken from the engraved reproductions of 1729, and do not suggest that the persons represented have especially admirable qualities. Or were such characteristics in fact regarded as desirable in a certain class of society eight years after Watteau's death? We cannot know whether the titles express Watteau's intentions or are the interpretations of a younger generation. "Indifference" primarily suggests narcissistic indifference to the opposite sex, and "artfulness" may in this case describe a sophistication and intensification of the intellect, a combination of coquetry and refinement for the sake of personal enjoyment: the attitudes of a decadent urban society.

However, the figures, which derive from Watteau's depictions of costume, cannot be properly understood without the landscapes in which the artist has set them. *The Indifferent Man* would appear less well balanced if the wood in the background were not there, and if his raised left arm did not relate to the view of a castle in the distance.

The beginning of the dance seems to correspond to the beginning of a day. In the companion piece, the head of the doll-like beauty is set against the light of an evening sky, the shape of its wrinkled, ornamental clouds continuing in the white gown's cascade of folds. The natural background conveys a strong sense of melancholy, which we can imagine was accompanied by the deep sound of the bass lute. The separation of the man and the woman, despite their pairing as symbols of dance and music, or as the dawning day and the coming of night, suggests not only emancipation but poignant experience. Companion pieces of a man and a woman set side by side usually suggest portraits of married couples, but the pair in these pictures are far from giving such an effect. The extremely small format, in a relationship of tension with the full-length figures, contributes to this impression. All the solemnity generally associated with the full-length portrait becomes a different kind of dignity, the dignity of the artist, and to that extent the painter does indeed seem to identify with the figure of the Indifferent Man.

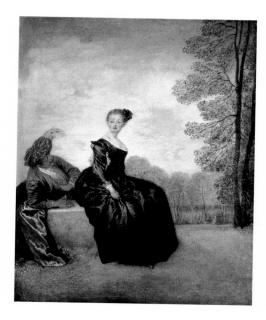

69 *The Sulky Woman*, ca. 1719
Oil on canvas, 42 x 34 cm
Hermitage Museum, St. Petersburg

There is a touch of comedy in this late painting. The
graceful woman seated in a stiff, self-conscious attitude
and wearing black, a color Watteau seldom used for
clothing, has her back to the gallant behind her and turns
only her eyes his way, while he seems to be trying to soothe
and seduce her. The line of her décolleté is continued in
the contour of the row of trees in the background, where a
number of people are enjoying themselves; the couple
seem to have moved away from this company. To the
right, two trees painted in an easy, translucent style close
the scene.

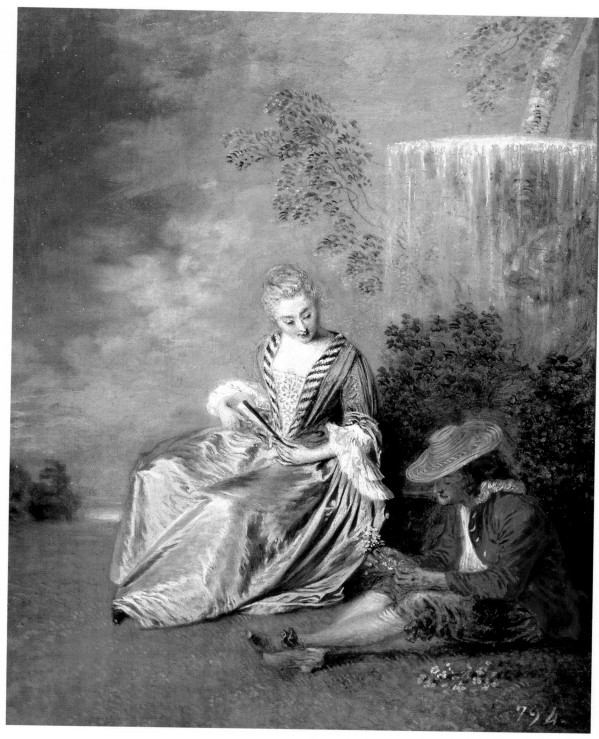

70 *The Anxious Lover*, ca. 1719
Oil on canvas, 41 x 32 cm
Palacio Real, Madrid

This picture is the companion piece to another scene
containing two figures, *The Singing Lesson* (Palacio Real,
Madrid). A gardener is carefully and thoughtfully putting
together a posy of flowers to give to the lady who sits beside
him, watching attentively. The direction of her glance and
the axis of her body form the two diagonals dominating the
main area of the picture. Water falls like a transparent veil
from the basin of a fountain, dabbed in with brushwork as
delicate as that of the light, springtime foliage. A wide
landscape extends to the left. The geometrical rigor of the
composition adds to the charm of the narrative element,
which seems to be approaching a conclusion.

Beside magnificence of this kind Watteau's figures look
quite unassuming, despite their exquisite clothing. Above
all they look natural. They are members of the middle
class, people who obviously enjoy wearing fine clothes but
seem to be aware of the distinction between outward
show and real values. Hardly any of the men wear wigs.
The charm of the women's heads is increased by plain
hairstyles, for instance with the hair combed up in a line
that echoes the falling folds of a voluminous gown and
directs attention to the nape of a pretty neck. It is unusual
for anyone to be identified as a nobleman by a dagger,
and jewelry is not important. The historical elements im-
ported into a number of Watteau's paintings by stage
costumes borrow some of their relevance from fashion,
but many of the costumes he painted seem timeless.

FÊTES GALANTES

71 *The Concert* (detail, ill. 76)

The motif of the singer leafing through her music, undecided what to choose, was one that Watteau depicted several times, first, it seems, in *The Lesson in Love* (ill. 75), and last in *Entertainment in the Open Air* (ill. 112).

When Watteau was admitted to the Académie no generic term existed for the kind of work he produced, and he was therefore described as a painter of *fêtes galantes*. The word *galant* did not mean quite the same around 1700 as today, when it carries overtones of the superficial amorousness and calculated seduction. The "gallantry" of Watteau's day was more to do with the observance of etiquette and the preservation of social distance.

This idea is clearly perceptible in Watteau's depictions of elegant social occasions, even when love is the motive force behind them. A couple may embrace, but there is still a sense of decorous reserve between them. Uninhibited desire was considered a characteristic of primitive people, and Watteau portrayed it only occasionally (for instance in *The Shepherds*, ill. 63).

The dress worn by the figures helps to create this distance. When the clothes in Watteau's pictures are not theatrical costumes, they are the fashions of the time. They envelop the body almost entirely, and the graphic appeal of the artist's brushwork is seen to full effect in their folds. Clothing is a major subject of Watteau's art, and the note his pictures strike depends to a great extent on harmony of color in the garments his figures wear. His portrayals of festive occasions did not involve compositions assembled from nude studies, or naked bodies intertwining in the intoxication of an orgy, and his imagination moved in the field of mythology only rarely.

Watteau was not the first artist to paint fashionably dressed people meeting out of doors, not to engage in any notable activities but simply to enjoy themselves. The tradition of such pictures goes back to the Middle Ages; the "Garden of Love" was a popular theme in the 15th century. It was natural for the upper class to commission such works to adorn their houses, displaying their social rank and celebrating their luxurious lifestyle. Many such gatherings were painted in the Netherlands at the beginning of the 17th century, and Watteau was acquainted with them. In his own paintings, however, we cannot always tell whether the finely dressed couples walking in a garden or in the country are really members of the upper classes. There is nothing to mark them out as aristocrats, and fine clothes can make any good-looking young person appear high on the social ladder.

Among the masters of the 17th century whose tradition Watteau followed, Rubens was outstanding. His famous *The Garden of Love* (ill. 72), which he painted soon after his marriage to Hélène Fourment, as an expression of his personal happiness, and which passed into the possession of the Spanish crown after his death, was certainly known to Watteau from an engraving, and possibly from one of the many copies of it that had been made. It is a work that casts light on the path the younger artist chose to take.

Venus, presiding as a statue on a fountain, casts the human beings present into a state of intoxicating passion – some but not all of them have already formed couples – so that they will experience the sensation of union in love. The composition expresses the same idea. Although the picture begins with the statue, it cannot be read as a narrative like a work by Watteau, and reaches no particular concluding point. Instead, it concentrates entirely on the central scene, giving the impression that in the fulfillment of the moment time no longer exists. In spite of the rich clothes, Rubens directly conveys the captivating sensuality of human bodies embracing, and even the colors of the garments enhance that effect. Rubens uses the palatial architecture in which the scene is set to link the mythologically transfigured festivity with human society. The architectural setting and the clothes suit each other in a way that is the exception rather than the rule in Watteau's work, for instance in *The Pleasures of the Ball* (ill. 44).

The fountain sculpture in *The Garden of Love*, an important element in the picture, probably inspired Watteau to give the statues in his *fêtes galantes* a meaning that goes far beyond the mere ornamentation of a landscape which is the setting for a party. In Rubens' picture the flesh-and-blood *amoretti* or messengers of Venus, some flying, some running on the ground, create a link between the stone statue of the goddess and the living human beings.

There is a similar playfulness in the *Embarkation for Cythera* (ill. 57), and in earlier works by Watteau. Around 1710 he had already used painted sculptures as

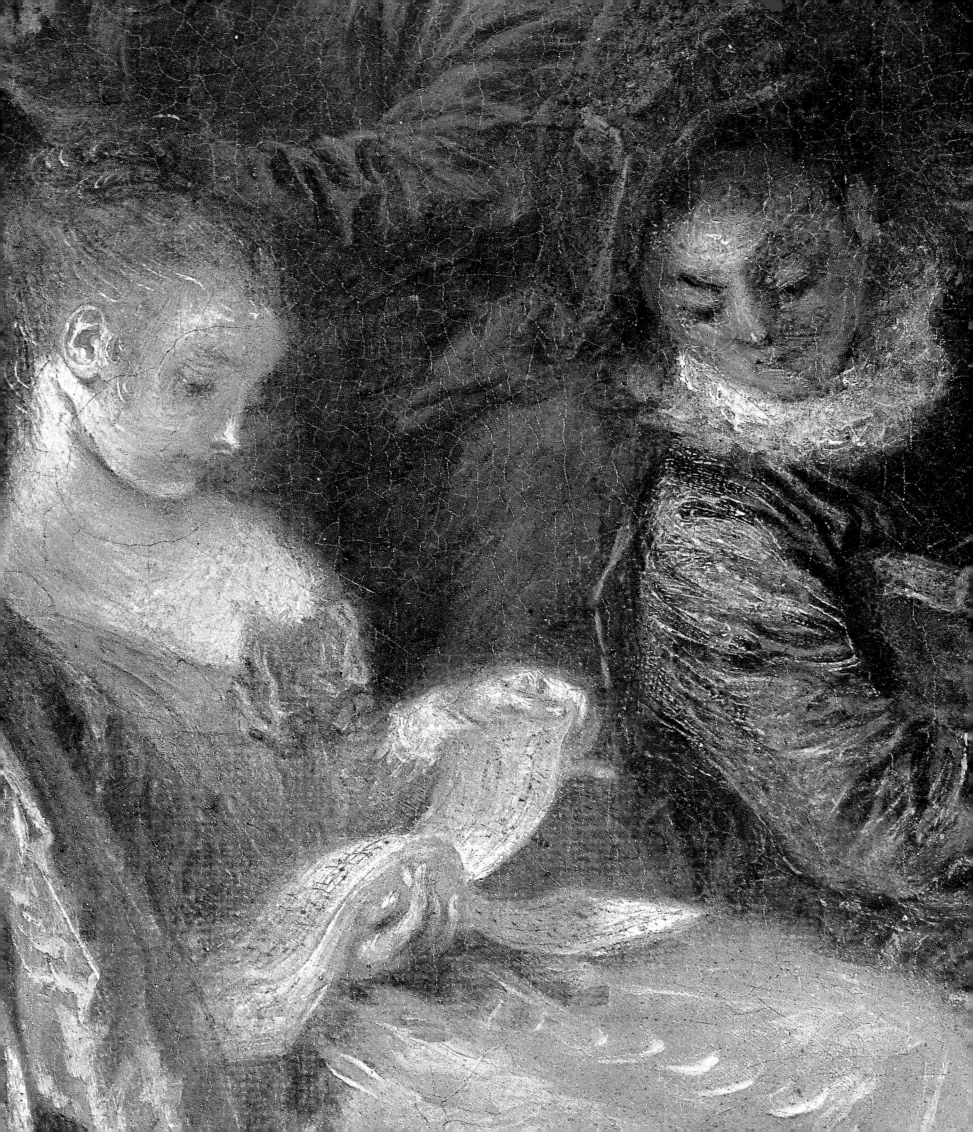

incidental figures populating a landscape, sometimes combined with a fountain. But the device first occurs as an expression of his own ideas, and in intense relation to the human figures in the picture, in *The Lesson in Love* (ill. 75) of around 1716.

Whether this company of five people is really a *fête galante*, however, is doubtful. The term is usually taken to describe a larger party of people, in the setting of a park or in the open country, with pairs of lovers interacting in various ways, while other groups and single figures lend the entire scene diversity of composition. The idea sprang from a number of different roots in Watteau's early work, and reached its full development only around 1715. The groups reclining in the open air in the early cycle of the Seasons (ill. 99), passing the time with music-making and other diversions, are still merely incidental figures. Other pictures of that period that have been preserved only as engravings lack the atmosphere of the *fête galante*, even when they are densely populated with human figures. A notable example is the *Return from the Tavern* (ill. 102), which may have been painted as early as 1707 and shows two intoxicated groups of rustics staggering down the

village street, contrasted with a distinguished company at table. It is noticeable that after about 1712 Watteau's figures are never shown eating, although such scenes had been common in the work of his Netherlandish precursors. Watteau concentrates on love, accompanied at most by wine and sometimes by music.

Among the earliest works in which the idea of the *fête galante* emerges fully formed is his *Gathering by the Fountain of Neptune* (ill. 74). Intended to be seen from right to left, and receding into the depths of the picture, no fewer than three sculptures stand in the overgrown park, but they still bear little subjective relation to the activities of the human figures, who are very loosely grouped around the grassy space. The magnificence of the fountain here has no equal in any of Watteau's other pictures. Its purpose is to emphasize the effect made by the woman on the right in yellow, seen from behind, who is linked on the left to the tall, narrow patch of sky seen through the trees, a connection of ideas that is clearly made for the first time here.

Sometimes Watteau places a dancing couple at the center of his social gathering, and the dancers of course need music. Music alone can unite its hearers. Even if the

72 Peter Paul Rubens
The Garden of Love, ca. 1633
Oil on canvas, 198 x 293 cm
Museo del Prado, Madrid

It is clear that Watteau knew this composition quite early; he used the idea of a little Cupid urging a woman to hurry on her way in his *The Island of Cythera* (ill. 54).

73 *The Marriage Contract*, ca. 1713
Oil on canvas, 47 x 55 cm
Museo del Prado, Madrid

The signing of a legal contract, a scene rather oddly set in a park, is made the focal point of the picture by the red draperies hanging behind the bridal pair. The couples dancing to the music are celebrating the wedding that has already taken place, as the church with the sky above it to the extreme left indicates. The relaxed amorous relationships of the *fêtes galantes* are here contrasted with an agreement into which the couple has entered for life.

74 *Gathering by the Fountain of Neptune*, ca. 1714
Oil on canvas, 48 x 56 cm
Museo del Prado, Madrid

This picture was slightly enlarged during the 18th century so that it could be hung as a companion piece to *The Marriage Contract* (ill. 73), which was probably painted rather earlier. The fountain was a creation by Gilles-Marie Oppenordt (1672–1742).

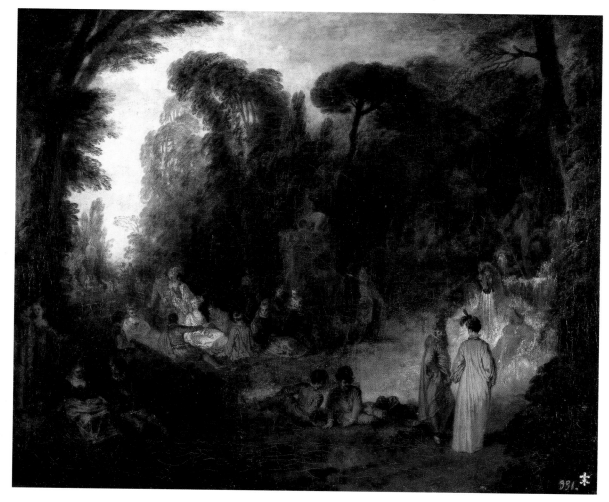

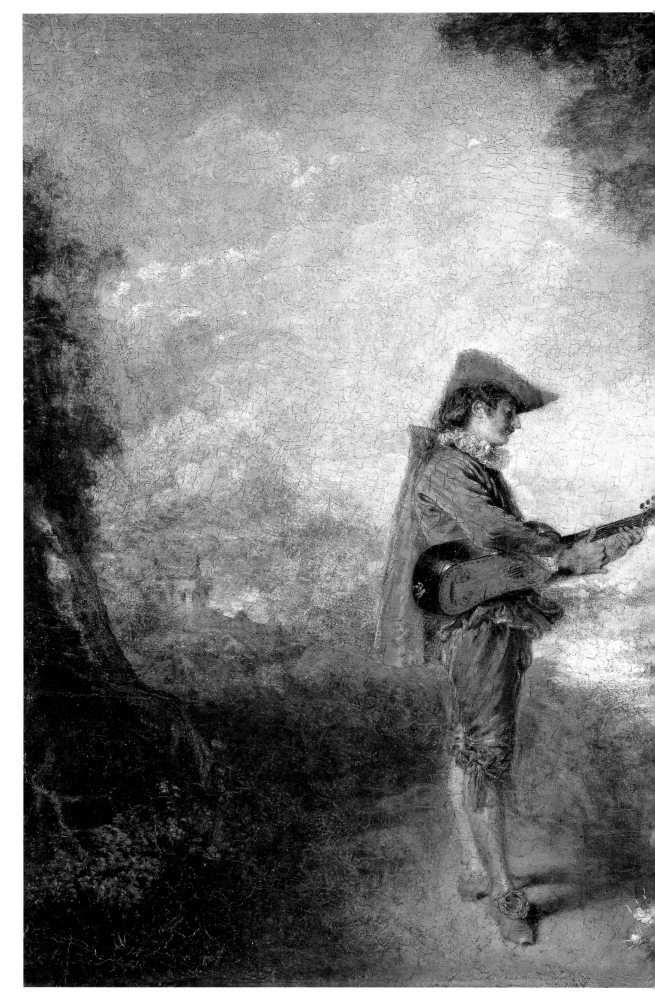

75 *The Lesson in Love*, ca. 1716
Oil on panel, 43.8 x 60.9 cm
National Museum, Stockholm

The Lesson in Love is only a provisional title. Who is the
teacher and who the pupil in this picture? It depicts an
entertainment, but is also a very concentrated
composition. There is to be music-making, but evidently
the woman singer still wants something explained to her,
and the handsome main character of the guitarist is merely
plucking a few notes playfully on his instrument. A
woman is picking roses and placing them in another
woman's lap, a movement leading down diagonally that
ends among the roses on the ground and begins with the
female sculpture, her body skillfully folded into a
geometrical figure. A window of sky opens behind her
head like a halo, giving her rather rustic figure the aura of a
Venus. As in many of Watteau's earlier pictures, the
pictorial area is vertically divided into two halves. The left-
hand side, with the guitarist, conjures up reminiscences of
the *Pilgrimage to Cythera* (ill. 55) with its hazy landscape of
mountains and river in the distance. The right-hand side
consists entirely of the overgrown foreground, the human
figures, and the statue.

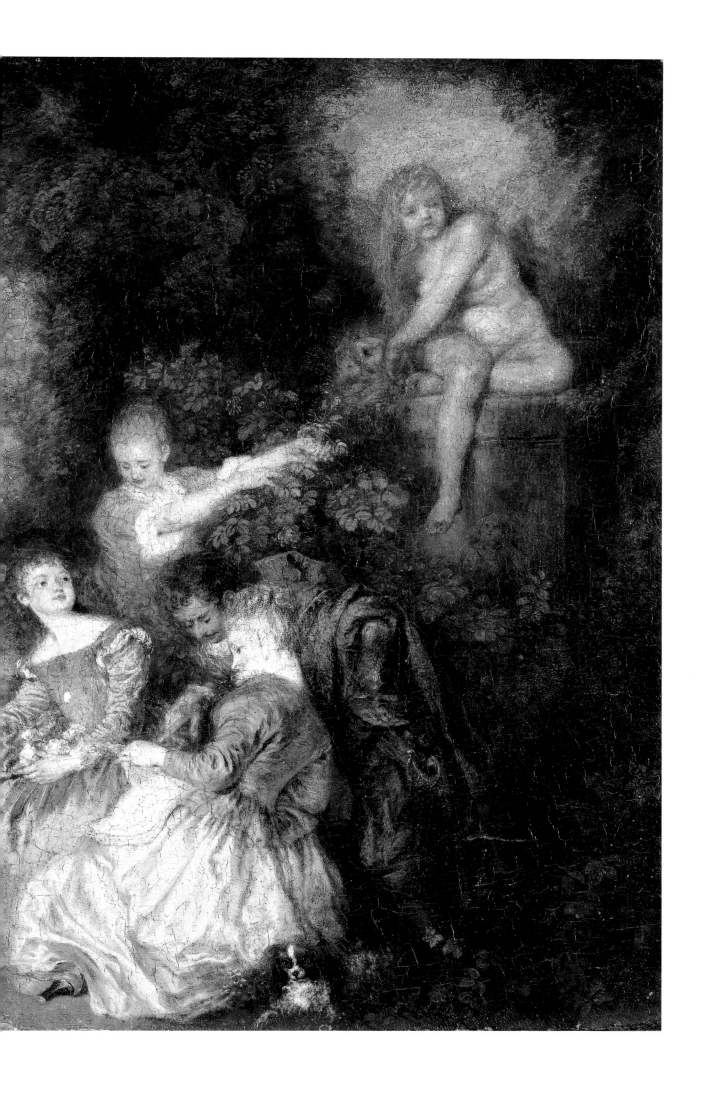

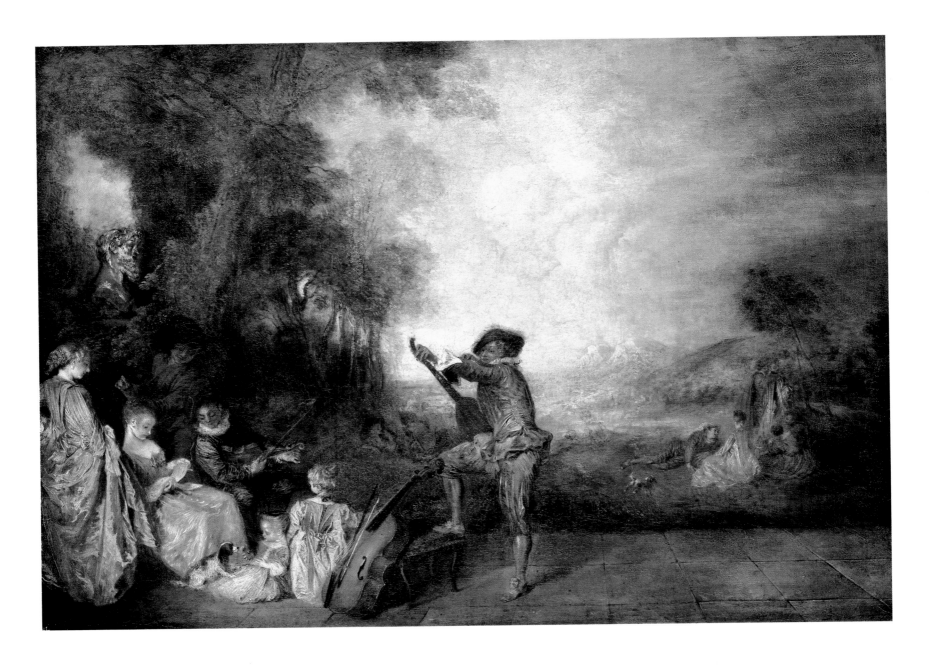

76 *The Concert,* ca. 1716
Oil on canvas, 66 x 91 cm
Schloss Sans Souci, Potsdam

Comparison of the lutenist with the guitarist in *The Lesson in Love* (ill. 75), a work of similar clarity, shows the way in which the subject has developed from an erect, self-contained figure to a mobile figure with a striking silhouette.

Comte de Caylus had not expressly mentioned that Watteau was musical and knew something about that art, it would be possible to deduce as much from his pictures.

In *The Concert* (ill. 76), one of Watteau's most sensitive paintings, the mere expectation of music creates an atmosphere finely balanced between tension and relaxation.

The extended silhouette of the lutenist tuning his instrument stands erect in front of the open landscape – an artist conscious of his own skills – while a group of four adults, two children, and a dog are crowded into the outline of a triangle that reaches its apex in the bust of Dionysus and stands out against the backdrop of the wood. The cello propped on a *tabouret* is the element linking the lutenist to the other figures.

The concert has not begun, and time is not yet governed by music; everything is still pending, in an intermediary state – only the foreground paved with stone flags gives order and rhythm to the space, to a depth of some three paces into the painting. Beyond this foreground area, the domain of mysterious nature

not subject to the laws of reason begins, and the pairs of lovers are in tune with it. The group in the triangle on the right echoes the foreground group, and if we look forward to *The Pleasures of Love* (ill. 82), now in Dresden, we see that *The Concert* contains the germ of the later work's mature construction.

Another idea too seems to be formulated here for the first time: the observation of a child's mind developing. The girl beside the cello shown from behind, with the light sparkling on the folds of her dress like painted music, is attentively observing adult interactions. She already guesses something of what the future may hold for her, while the smaller child, still perfectly innocent of such ideas, is busy feeding a little dog.

A comparison of *The Concert* with *The Pleasures of Life* (ill. 77) illustrates not just a variation on a theme, but another distinct step in Watteau's development. In the later picture, the sense of something in momentary abeyance is replaced by greater solidity, and magic gives way to reason. This is particularly evident in the landscape, clearly framed in groups of trees just as the

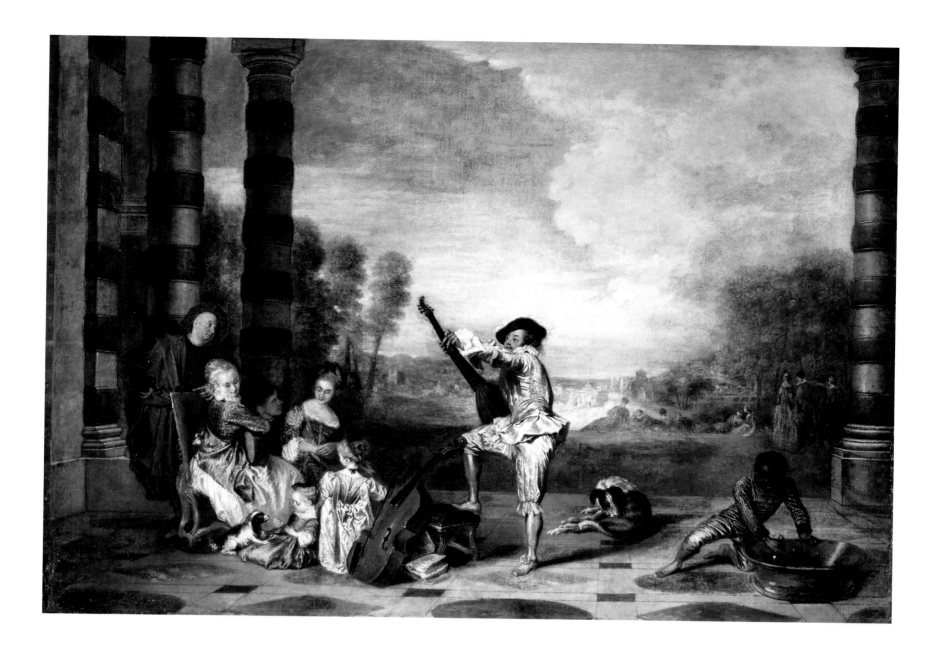

foreground is framed by the columns. An open stretch of turf marks off the foreground from the company in the middle ground and the town behind it, an unusual motif in Watteau's work.

By adding (on the extreme left) a portrait of his friend Nicolas Vleughels (1668–1737), with whom he had been staying until he left for London in 1718/19, Watteau not only indicates the date of this work but makes the whole scene more concrete. Its subjects are friendship, love, music, and the enjoyment of wine. The impression of greater solidity, however, is chiefly provided by the architecture, which is reminiscent of the architecture in *The Pleasures of the Ball* (ill. 44). There are more figures here, particularly in the foreground, including the boy serving wine and the dog who also appears in Gersaint's shop sign (ill. 9). *The Concert* and *The Pleasures of Life* relate to each other much as the *Pilgrimage to Cythera* (ill. 55) relates to the *Embarkation for Cythera* (ill. 57).

The variety of ways in which Watteau organizes his social gatherings is astonishing, even though he often

populates them with groups or single figures that he had used before. In his *Gathering in a Park* (ill. 80), the relationship of the relatively small figures to the majesty of the natural scene surprises the observer. A wide, perfectly still expanse of water divides a narrow strip of foreground from the more distant part of the park, where tall trees grow. The sky appears through a gap in the backdrop of foliage, running down to the horizon and thus dividing the surface of the picture into a square area on the right and a tall rectangle on the left, the kind of arrangement that Watteau quite often employed. This patch of sky is reflected in the water, and its line continues, shifted rather further left, in a woman shown from behind, a very typical stance for Watteau's figures. The cavalier on her left is a subordinate character. A group of three children, three women, and four men are crowded so close together in the lower right-hand part of the picture that they seem to be almost overshadowed by the woodland behind them, its weight and silent darkness contrasting with the liveliness of the company. The composition concludes

77 *The Pleasures of Life*, ca. 1718
Oil on canvas, 65 x 93 cm
The Wallace Collection, London

The architecture enhances the lutenist's stance yet further by comparison with that of the guitarist in *The Concert* (ill. 76). His form is echoed by the columns that frame him. Similarly, the triangular form of the group of figures on the left echoes that of the boy on the right.

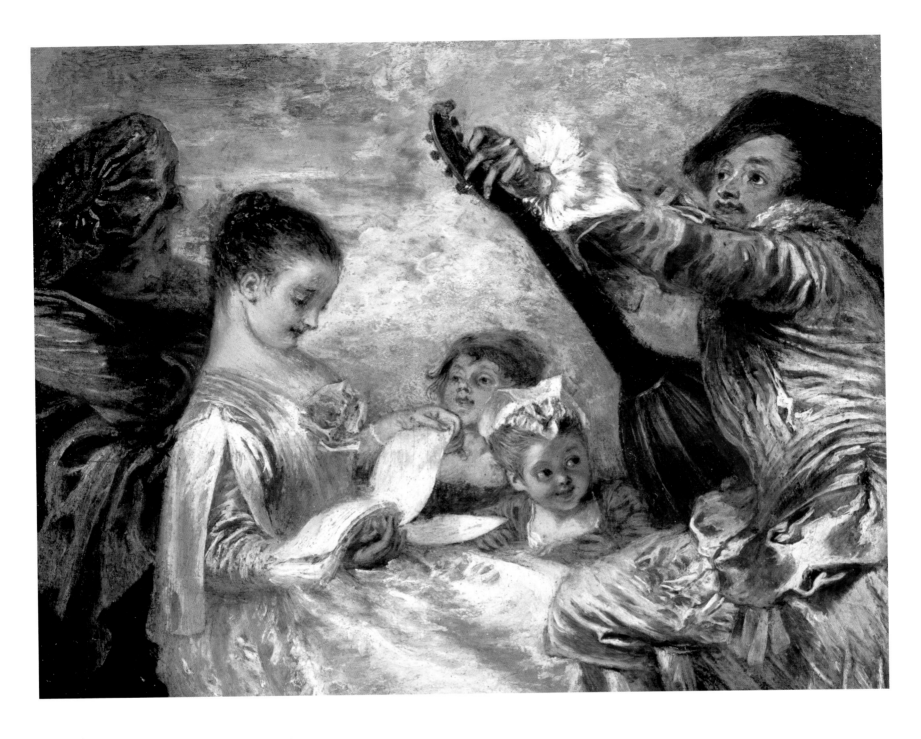

78 *The Music Lesson*, ca. 1719
Oil on panel, 18 x 23 cm
The Wallace Collection, London

The Music Lesson, a little panel in the smallest format Watteau
ever used, can be seen as a kind of abridgement of *The Concert*
(ill. 76). It was certainly painted later than that work, but
probably rather earlier than *The Pleasures of Life* (ill. 77), since the
woman leafing through her music, replaced in the later picture,
was taken from *The Concert*. In the swift movement of the
brushstrokes used to paint the lutenist, whose attention is entirely
concentrated on tuning his instrument, his glance raised
upwards, corresponds to his equivalent in the later picture.

Closely as this little work relates to the two larger versions, it tells
a different story. The two children looking cheerfully at the singer
and the lutenist might suggest that this scene is a family idyll – if
it were not for the man in the red beret standing behind the
singer, passing his right arm between her own arm and her breast
to reach for the sheet music. The boy seems to be watching this
maneuver with interest, while the little girl still appears naïve.
Children's reactions to the adult world are shown in many of
Watteau's mature works.

79 *Venetian Pleasure*, ca. 1718
Oil on canvas, 56 x 46 cm
National Gallery of Scotland, Edinburgh

The curve of the garlands from the ram's head on the huge urn
seems to set the tone for the entire composition. The figures are
arranged like a garland, and the body of the fountain sculpture
also curves up from the contour of the wall. At the same time the
effect of the falling water continues in the shimmering of light on
the garments, particularly the skirt of the woman sitting on the
left. The playful equation of objects different in kind was to be a
general design principle of the Rococo style.

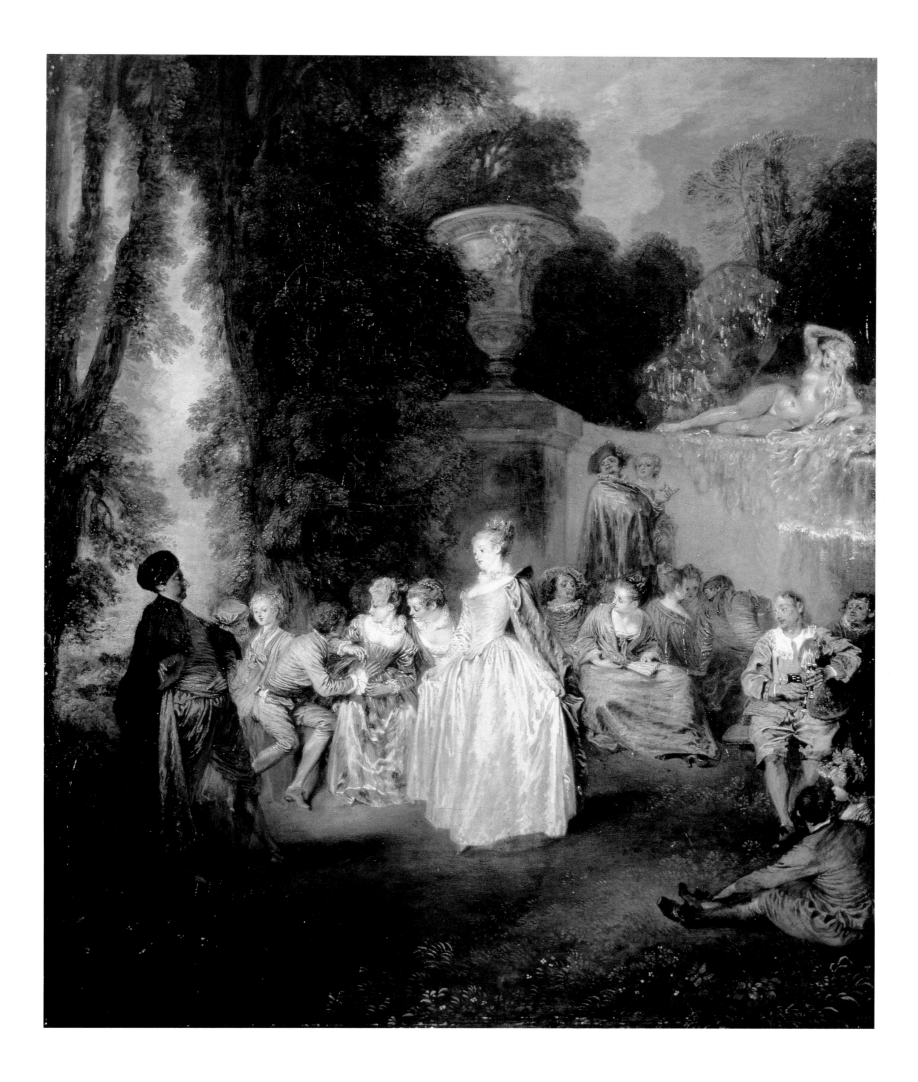

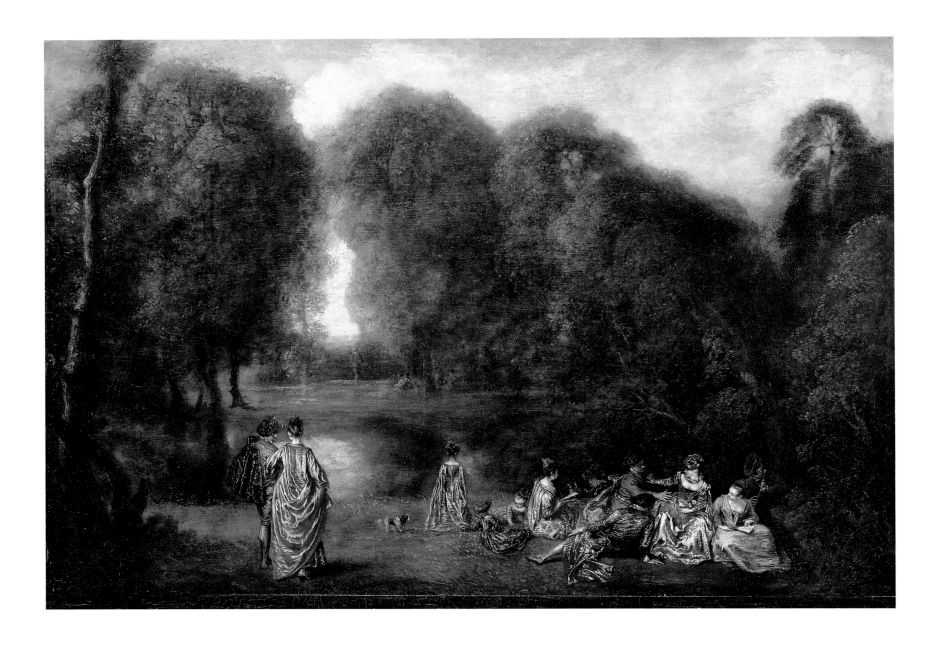

80 *Gathering in a Park*, ca. 1718
Oil on walnut panel, 32.4 x 46.4 cm
Musée du Louvre, Paris

Watteau usually sets his figures in a park, but never in the formal grounds of a château. His settings are always old landscaped gardens reverting to natural woodland. The cheerfulness of the human figures mitigates the melancholy impression of these overgrown parks. As time went on, Watteau's landscape settings developed from fantasy to something closer to reality.

with a flute player on the right who is turning away from the others; his figure is emphasized from above by a dip in the contour of the woodland, with a single tall tree rising above it. Two of the children are reclining on the ground like adults, and an older girl stands alone, lost in thoughtful contemplation of nature. Surrounded by a cheerful company, she seems to find her isolation all the more oppressive. As so often in Watteau, the viewer is tempted to pair off the men and women, but unlike the figures in both versions of the *Embarkation for Cythera* they cannot all be paired together as couples. More figures can be seen far away on the other bank, as if echoing the company in the foreground.

The picture entitled *The Perspective* (ill. 81) is related to the *Gathering in a Park* in the atmosphere of the park, with its extremely tall trees, but the figures bear themselves quite differently, and it is probably of a later date. It takes its title from the architectural structure appearing through a narrow opening in the forest beyond an expanse of water, showing a building very similar to the château of Montmorency where Pierre Crozat lived. Watteau visited it a number of times.

The blue of the sky, fading in its reflection in the water, pierces the darkness of the wooded meadow in a vertical line, mysteriously continued in the shimmering, silvery blue silk gown of the lady standing in the foreground. A cavalier is inviting her to enter the wood with him. Another man stands beside a wall crowned with an urn, talking to a beauty seated on the ground, and a third couple, a guitarist with a lady listening to his music, reclines between these two pairs.

On the right of the picture, a counterpart to the three pairs on the left is provided by two people gazing into the distance, and a couple on the right disappearing into the depths of the picture, but most of all by two small children playing on the ground – a self-contained group of cubic form. It is almost as if these two children were the main subject of this serious work, which is dominated by tones of deep green. Their youth forms a marked contrast with the age of the huge trees.

In *Venetian Pleasures* (ill. 79), Watteau again presents the tall and awe-inspiring trees as a contrast to human activities. Here, unusually for him, he chooses a tall format for a picture containing many figures.

The central figure is the dancing woman wearing a white dress and blue cloak, and she is also accentuated by her position in front of the pillar with the great stone urn on it. The fountain in the shape of a curving wall, only half of it visible, ends in this pillar. Water spouts from the mouth of a huge dolphin into a basin from which it continues to fall, although (as so often with Watteau's fountains) we cannot see where the water is going. The reclining statue of a naked woman lies beside the dolphin's head. She is foam-born Aphrodite, and as a cavalier throwing his head back rather arrogantly seems to be demonstrating by a gesture of his hand, she relates to the woman dancer. Directly below the goddess, and seen from behind, a fool is talking to two beautiful girls. He represents a countertype to Aphrodite. Somewhat further forward

sits the bagpiper who is playing for the dancer and her partner. The latter, richly dressed and dignified in manner, is posing in profile, and his left leg, placed in front of him, intentionally emphasizes the outline of his nose. This man, standing in front of the open sky, is made to appear taller by the way the trees incline toward each other – a somewhat ironic effect. He keeps his distance from the dancing woman, who is surrounded by figures deep in cheerful conversation. The seated man in the right foreground is one of the figures who so often strike the first note in Watteau's compositions, indicating that the scene is probably to be studied from right to left. The work is notable not only for its light yet precise brushwork, but also for the humor in the relationship of the figures to each other.

81 *The Perspective*, ca. 1718
Oil on canvas, 46.7 x 55.3 cm
Museum of Fine Arts, Boston

Few of Watteau's works are as symmetrical as this. The air of majesty is reminiscent of the time of Louis XIV, not least because of the architectural feature in the background. However, it is the overgrown park that gives that impression; no complete buildings are shown. The figures are irregularly distributed, yet do not disturb the equilibrium of this natural scene.

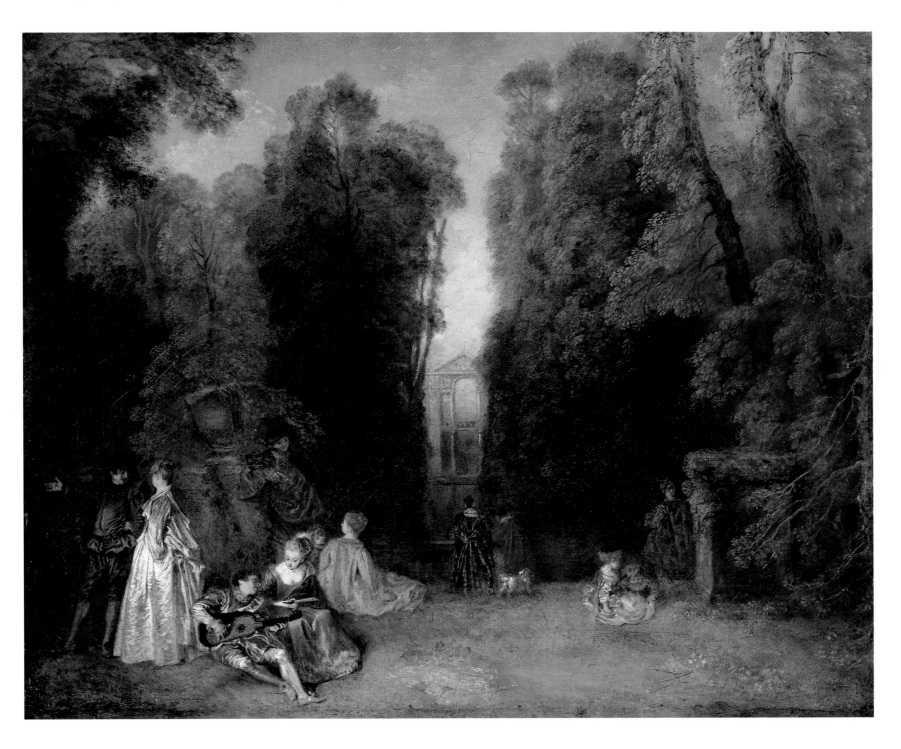

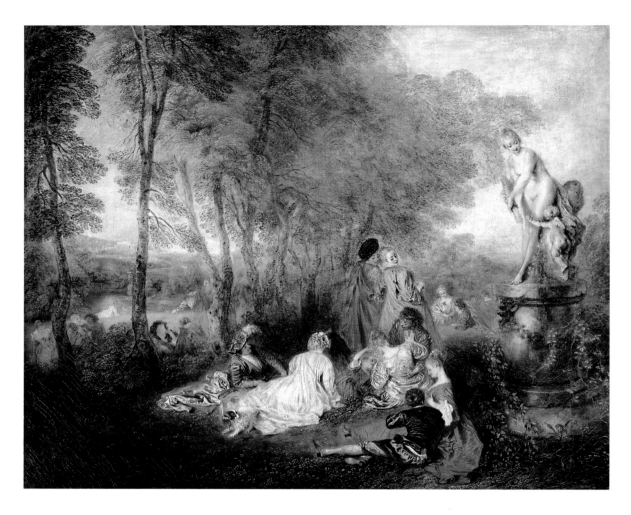

82 *The Pleasures of Love*, ca. 1719
Oil on canvas, 61 x 75 cm
Gemäldegalerie Alte Meister,
Staatliche Kunstsammlungen, Dresden

In Watteau's late work, sculptural forms and related angles
of vision become increasingly important elements of the
composition. A couple looking back as they walk away, for
instance, is a favorite theme, and reinforces the human
dimension of the picture.

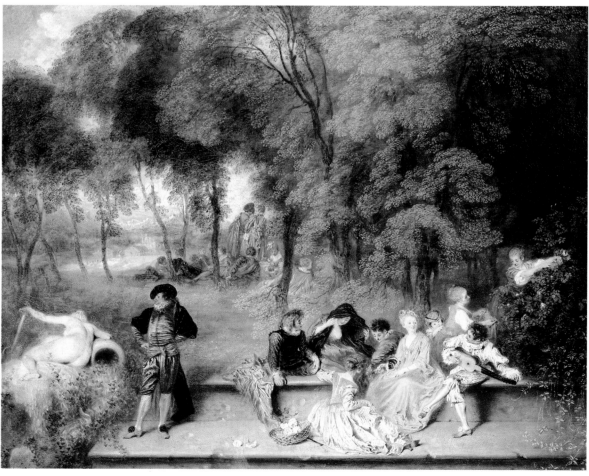

83 *Meeting in the Open Air*, ca. 1719
Oil on canvas, 60 x 75 cm
Gemäldegalerie Alte Meister,
Staatliche Kunstsammlungen, Dresden

This picture was painted with particular care; Watteau
clearly felt it important, for example, to record the damage
to the stone steps accurately. In this respect, he uses a
favorite effect of small Dutch cabinet paintings, but in a
relatively large painting.

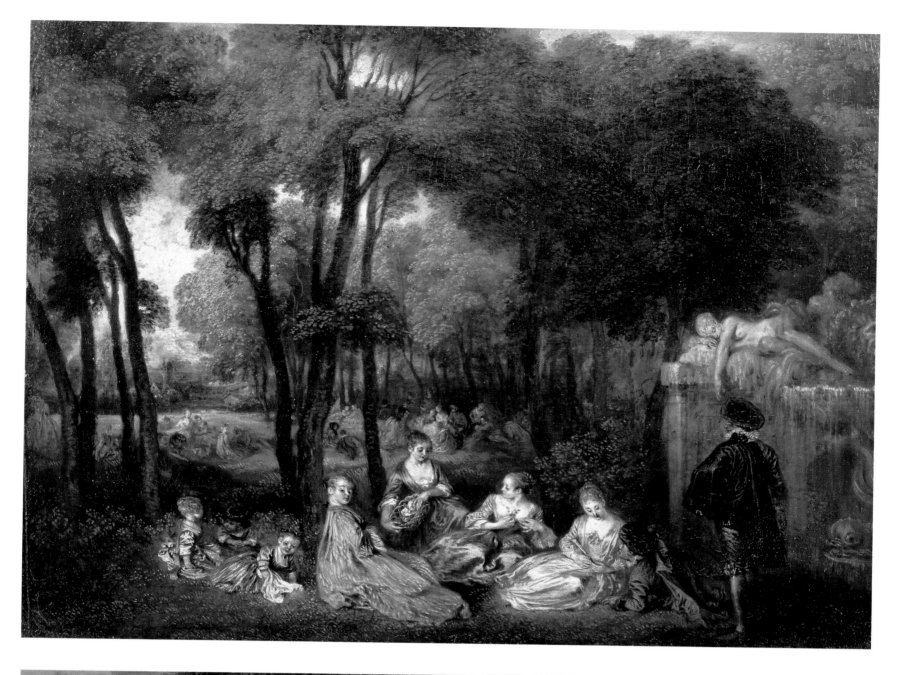

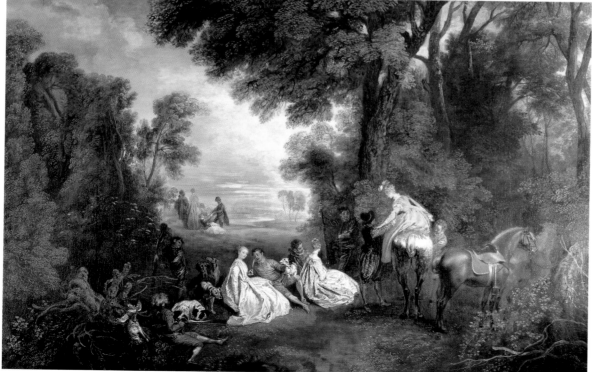

84 *The Champs-Elysées*, ca. 1719
Oil on canvas, 33 x 43 cm
The Wallace Collection, London

The gardens of the Champs-Elysées in Paris were named after the Elysian Fields of Attica, one of the most famous spas of classical antiquity, and date from the end of the 17th century. However, the picture does not depict a real situation. A wealth of figures reminiscent of Watteau's early work and painted with great verve is presented in a relatively small format.

85 *Halt During the Hunt*, ca. 1720
Oil on canvas, 124 x 187 cm
The Wallace Collection, London

The group consisting of the servant lifting a lady down from her saddle is taken from an etching by Jacques Callot. Watteau probably had to fall back on such a model, since studies of horses and their riders were not among his stock of drawings.

This masterpiece can be linked to *The Pleasures of Love* (ill. 82), probably of a later date. It contains a new pictorial idea in the row of trees leading into the depths of the composition, but ending right of the center of the picture and leaving clear sky as a background for the statue of Venus. The goddess is taking his arrows away from Cupid, who seems to be busy aiming at the couples. Watteau took this theme from the Berlin version of the *Embarkation for Cythera* (ill. 57), where it seems more compelling than here. The row of trees accompanies the central group of figures into the depths of the picture; Watteau has deliberately fitted them and their rather stiff attitudes inside a triangular shape, and the group thus links the main area of the painting with the depths beyond, a brilliant compositional idea which, as a rapid sketch for it shows, matured only gradually. The other figures in the middle ground are loosely arranged around the triangle. Within it, at the very center of the work, the woman in a blue-and-white striped dress seen from behind attracts the viewer's gaze. She echoes the blue and white of the sky on the ground, and is also linked to the statue of Venus, as if in some way they were on an equal footing.

The rhythm imparted by the row of trees is an innovation in Watteau's late paintings, and the open, wide landscape is a feature not found in this shape in his earlier works. It seems likely that the picture reflects impressions of his visit to England in 1719. This major work was never engraved, eluding Jullienne's efforts to publish his friend's complete works.

In the *Meeting in the Open Air* (ill. 83) the row of trees runs parallel to the stone bench in the foreground, a favourite theme in Antoine Watteau's late work, and marks it off from the background. The bench allows him to arrange the figures on it like musical notes on the lines of the stave, replacing the often indistinctly painted grassy bank of earlier works.

86 *The Pleasures of Love* (detail, ill. 82)

A drawing showing a delicately and evenly striped dress was used for the woman sitting on the ground. In the picture, the stripes are made wider, presumably to relate them to the trees above them. This suggests that Watteau had designed the pattern of such fabrics himself. The man is the same as the male figure in *The Sulky Woman* (ill. 69).

The surprising element in the picture is the well-dressed figure of a character who is obviously the stereotypical confirmed bachelor. He is turning away from the company in a self-confident pose, while the marble nymph turns her own back on him. She is part of a fountain; her right arm lies on a large vessel from which water is gushing forth. In a study for the *Italian Players* (ill. 52), painted in England, the original sculpture is seen beside Pierrot, which suggests that the *Meeting in the Open Air* may be dated to Watteau's London period. The line of demarcation between the solitary figure of the bachelor and the group is marked by the copper-colored cloth draped over the bench and the roses in the foreground, which themselves conclude a diagonal beginning (on the far right) with the woman picking roses. This diagonal moves on and down from the woman holding up her apron to the woman in yellow seated on the ground, in a movement similar to that in *The Lesson in Love* (ill. 75). The woman in the yellow dress is the central figure of the group, and the

gold of the countless leaves, painted with delicate dots, seems to emanate from her figure like a cloud.

Similar hazy masses of foliage, appearing to set the surface in vibrant movement, are also found in several other works probably of around 1719/20, for instance *The Champs-Elysées* (ill. 84), and the large composition *Country Amusements* (ill. 88) that developed from it. A new feature, perhaps also influenced by England, is the broad meadow landscape extending far into the background behind the light stand of trees.

The Champs-Elysées cannot have been painted much earlier. The picture begins on the right with the fountain, crowned with the statue of a woman in repose with her arm hanging down, a figure which translates the *Antiope* (ill. 89, now in the Louvre) into stone. This arm is almost touching the bachelor who has turned his back to the viewer and seems to have no eyes for the feminine charms around him, unlike the similarly dressed man reclining on the ground. He and the four women in the foreground form a group

87 *Country Amusements* (detail, ill. 88)

The identical group occurs in *The Champs-Elysées* (ill. 84), up to the cavalier on the left, who is replaced by another woman in that painting. Perhaps the artist intended to suggest new relationships forming between the couples.

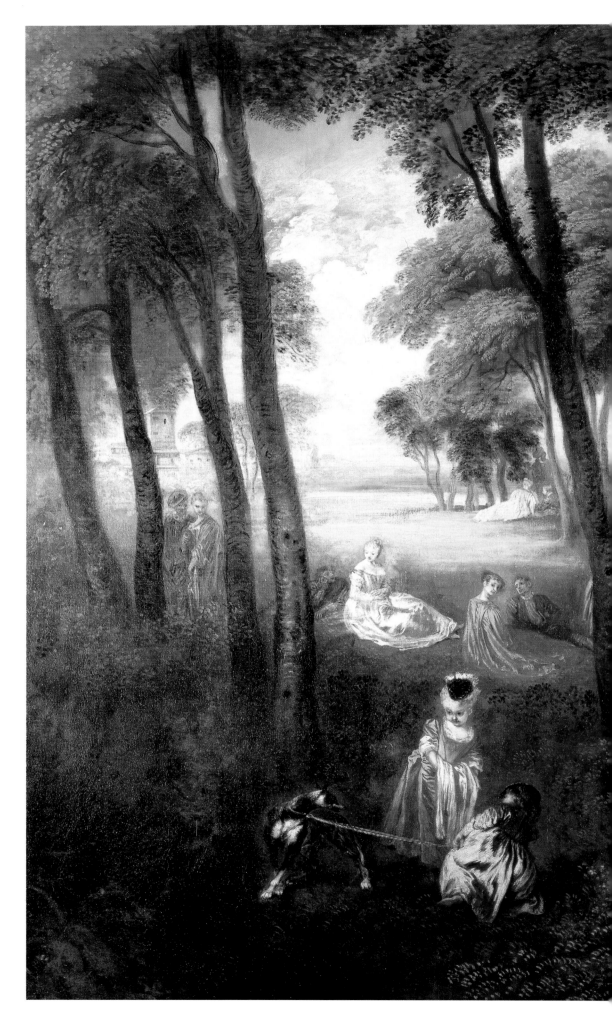

88 *Country Amusements*, ca. 1720
Oil on canvas, 125 x 188 cm
The Wallace Collection, London

The composition begins on the right with the comic group of the
statue of Venus, also used in *The Lesson in Love* (ill. 75), and the
bachelor below her. Her dangling leg and his standing left leg form a
vertical line. From here, the arrangement of figures inclines down to
the children and the dog on its leash. This large triangle has a smaller
triangular composition in front of it and facing the other way,
consisting of the seated figures and the reclining figure in front of
them. A diagonal leads from the bachelor's foot far into the picture.

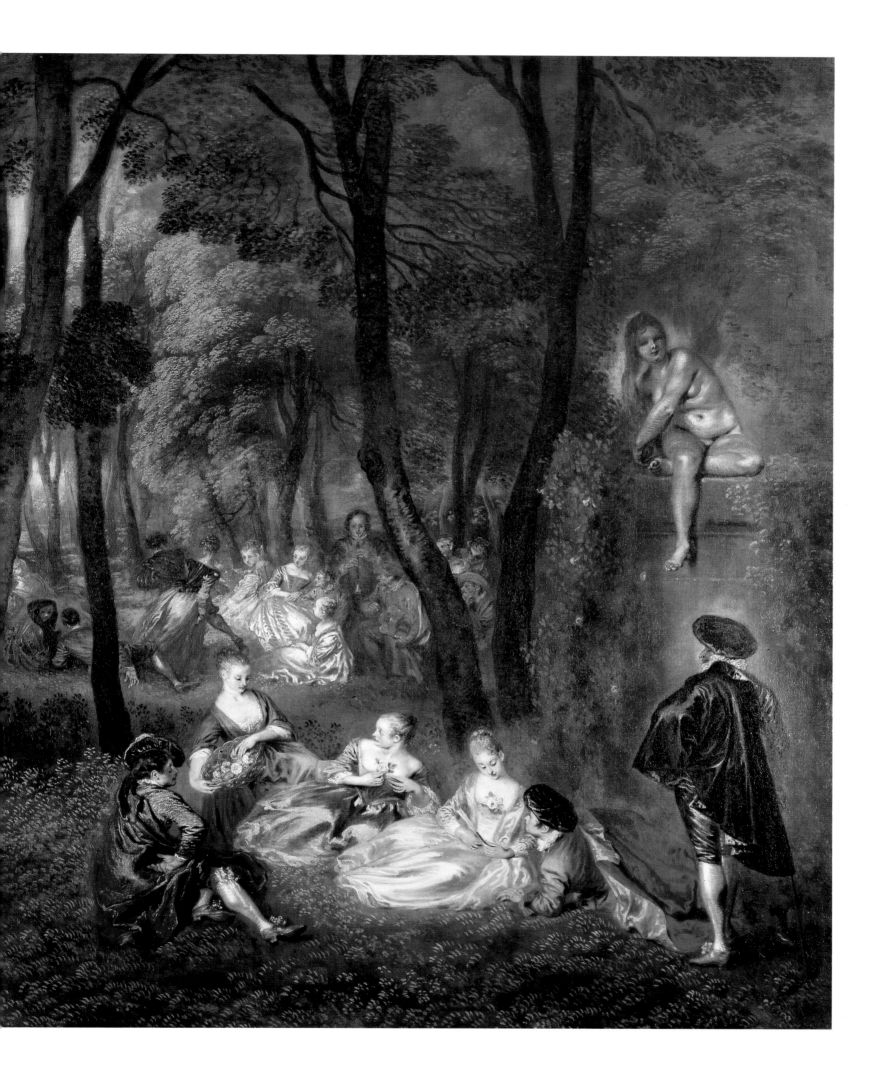

associated with the three children playing in the grass. The woman looking out of the picture and wearing a shimmering golden yellow dress forms a clear break in the composition, marked by the line of her straight back and the tree trunk growing behind her. To the left, the children's glances direct the observer's eye to the depths of the picture, and a light stand of trees fills the right-hand area. Everything is painted rhythmically with a finely pointed brush adding lines and dots.

Among the large-scale works of Watteau's late period, and related in its rather dry execution to *Country Amusements* (ill. 88), is the *Halt During the Hunt* (ill. 85). Watteau seldom painted hunting scenes, and the picture therefore occupies a position of its own among his *fêtes galantes*. If an English patron commissioned the work it might explain the choice of theme.

Here we are in aristocratic circles. The ladies have arrived on horseback; one is just being lifted down from her saddle by a servant in old-fashioned dress, and two others are already sitting in curiously parallel attitudes on the ground, while their horses rest in the shade of the trees. The chain of figures runs from right to left and, unusually for Watteau, says something

about the experience of hunting and the arrival of the company. To the left, a view of the depths of the landscape opens out. In the middle ground, two couples are arranged in Watteau's usual way, and do not seem to have anything to do with the hunting party.

The picture, beginning on the right with a dead branch, ends on the left with the curiously shaped branches and roots of the trunk of a tree with a dead hare hanging from it – a sad reminder that the season is late. This work makes a strangely ambiguous impression, but it is not the last ever painted by Antoine Watteau on his central theme of the *fête galante*. That final picture, entitled *Entertainment in the Open Air* (ill. 112), was left uncompleted.

89 *Jupiter and Antiope*, ca. 1719
Oil on canvas, 73 x 107.5 cm, oval
Musée du Louvre, Paris

This picture was probably originally a supraport to be placed above a doorway: its full effect is felt only when it is seen from below, and then the nymph's perilous and odd position beside an abyss with her arm hanging limply down begins to make sense. The roots are threatening in appearance, as they are in *Diana Bathing* (ill. 115), and Jupiter, who has transformed himself into a satyr, creeps up to Antiope like an animal, in a way that reflects his desires. The supreme deity lacks dignity here, and the rules of a *fête galante* are broken. Here again Watteau is mocking the hierarchical order. The landscape in the background was inspired by Venetian models.

90 *The Champs-Elysées* (detail, ill. 84)

This detail shows Watteau's fondness for turning a living figure into a statue, which was particularly evident in the statue of Venus in the *Embarkation for Cythera* (ill. 57). Here again, the figure obviously has to occupy a high position. The bachelor below her is the exact opposite of the lustful Jupiter in *Jupiter and Antiope* (ill. 89).

THE DRAFTSMAN

91 *The Toilette*, ca. 1719
Sanguine and black chalk
The British Museum, London

In his nude studies, Watteau liked to set his models in unusual attitudes in order to give scope to his draftsmanship. The same may be said of his paintings of sculptures. There are no purely academic nude studies done for the sake of anatomical knowledge among Watteau's known works.

Antoine Watteau is one of the great draftsmen in the history of European art, though drawing had only an ancillary function in his work. Few of his drawings are executed in full graphic detail and can claim independent artistic existence; most were made as studies, and he was always increasing his stock of drawings so that he could resort to it when composing his paintings. The critical catalog of 1996 by Pierre Rosenberg and Louis-Antoine Prat lists 669 works. In addition, the originals of 216 drawings are now lost, but they survive reproduced as engravings.

Watteau's stock of models for the ornamental work that made up a great part of his creative activity before 1715 has been especially badly depleted. These motifs obviously seemed less attractive to collectors. In addition, there are only a few composition studies for paintings. Those still extant were very swiftly done, and most of them belong to the late period.

The Comte de Caylus was therefore not quite correct in stating that: "He made not the slightest or most fleeting of studies for any of his pictures." But it is true that we know very little about Watteau's method of composition because so few studies have been preserved. Caylus confirms what the works themselves tell us: "He used to draw his studies in an album, so that he always had many of them at hand [...] When he took it into his head to paint a picture he would turn to his collection, choosing from it those figures that struck him as most suitable. Out of these he composed his groups, usually matching them to the landscape he had prepared or intended to prepare for them. Only rarely did he work in any other way."

The vast majority of Watteau's drawings are figure studies: full-length figures, heads, and other details. The structure of the hands in particular became increasingly important to him over the course of time. In general, the drawings show clearly where the artist's interest lay, and it was always concentrated on the human figure.

Many of the figure drawings emerge in the paintings, sometimes with slight modifications. If no drawing seems to exist as the basis for a painted figure, we may assume that there was a study, but it has been lost.

Sometimes Watteau used studies he had drawn many years earlier, adapting them to the style he now wanted, for instance by altering the proportions. In his early period, he liked to draw tall, very slender figures, which might be amended in later works.

Only a few of the drawings can be dated as precisely as can a series showing diplomats at the Persian Embassy in Paris in 1714/15. However, we can trace a development in Watteau's draftsmanship that enables us to arrange his drawings in an approximate chronological order – an order confirmed by the paintings in which they were used, since many of the studies were clearly made for a specific picture, and do not owe their existence merely to the artist's wish to increase his stock. Separate studies of pilgrims, for instance, were made for both versions of his *Embarkation for Cythera* (ills. 55, 57), and the paintings themselves can indicate whether groups were composed from existing material or as an original ensemble.

Erratic as Watteau's working process may sometimes seem, he did have a well thought-out method and seldom ventured on experiments. The method is evident in his technical skills as well. Dezallier d'Argenville gave a reliable account of his technique in 1745: "He generally used sanguine on white paper, so that he could make prints showing the subject from both sides; he seldom heightened his drawings with white, because the effect of white was produced by the paper background itself. Many of his drawings were done in two colors, in black chalk and sanguine or in graphite and sanguine, using tones of red for the head, hands, and skin; sometimes he used 'trois crayons,' and then again he might use pastel, or oil paint, or gouache. Anything was acceptable to him – except for pen drawings – if it would produce the effect he wanted. His hatchings were almost vertical, sometimes inclining slightly from right to left, or stumped and lightly washed with accentuating lines."

These remarks are confirmed by examination of the extant drawings, though so far no pastel has come to light, and only one oil study and one gouache. However, in his late work Watteau displays such virtuoso skills in his use of sanguine (red chalk) and black chalk – for instance in the shades representing the dark, glowing skin of African faces – that he comes very close to the pastel technique. His meeting in 1720

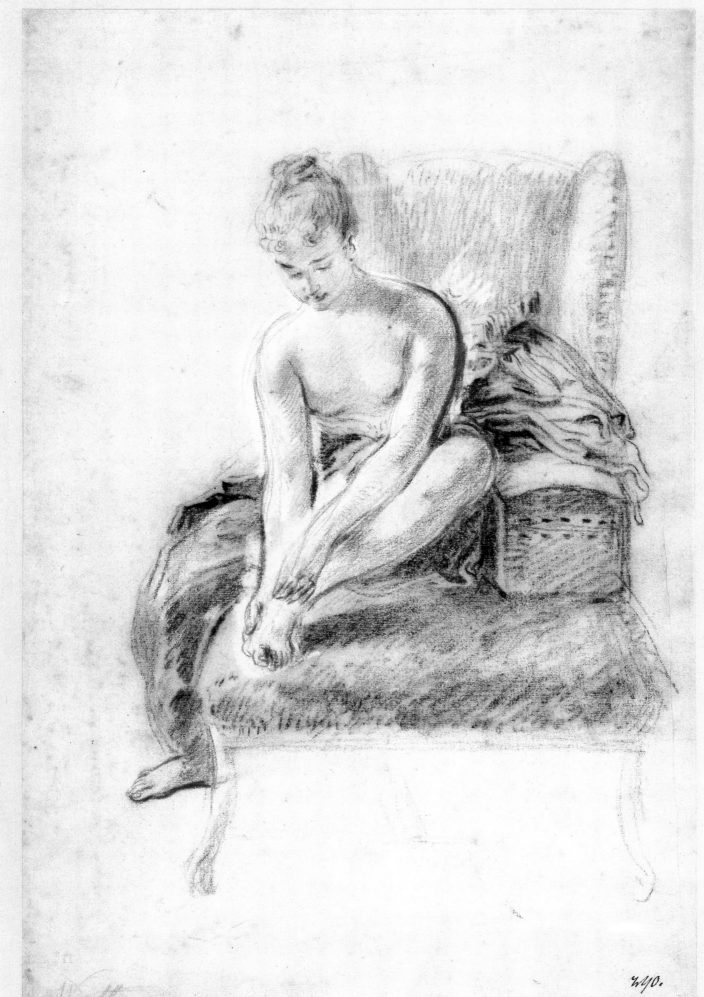

with the famous Venetian pastel artist Rosalba Carriera may have given him some ideas in this regard. However, pastel demanded a larger format than the one Watteau chose for his drawings, which seldom exceed 40 cm, though in spite of this small size he achieved great fidelity to life and expression in his drawn portrait heads.

The suitability of sanguine drawing for hand prints, which enable a study to be used several times, is probably not enough to explain Watteau's preference for this technique. The very earliest drawings, from the period when he was still working with Gillot, are executed in sanguine. It seems to have been the likeness of the color to a flesh tone and the rather grainy effect of the medium that appealed to him.

His dislike of pen drawing, which Gillot used together with a wash, is interesting. The firm, clear line of the pen drawing does not seem to have appealed to him. Using sanguine, however, he could combine colored areas with light hatching, and easily create a transition from the defining line to a painterly effect. In addition, Watteau used a brush only occasionally, with muted tones, and then always as an ingredient used sparingly in a drawing in sanguine, or in sanguine and black chalk.

The French tradition of the portrait drawing in black chalk and sanguine goes back to the early 16th century and Jean Clouet (ca. 1480–1540/41), sanguine being well suited to the delicate indication of flesh tones.

At first Watteau was sparing in his use of black chalk with sanguine, but about 1710 he began to employ

92 *Three Pilgrims*, ca. 1709
Sanguine, 16.5 x 19.9 cm
Städelsches Kunstinstitut, Frankfurt am Main

Watteau once drew a genuine pilgrim, not at all like the figures shown here, a devout figure showing clear traces of the hardships of his journey. He was therefore well aware of the difference between the ancient religious custom of pilgrimage and the playful, indeed blasphemous use of the idea around 1700 as a widely distributed Rococo theme.

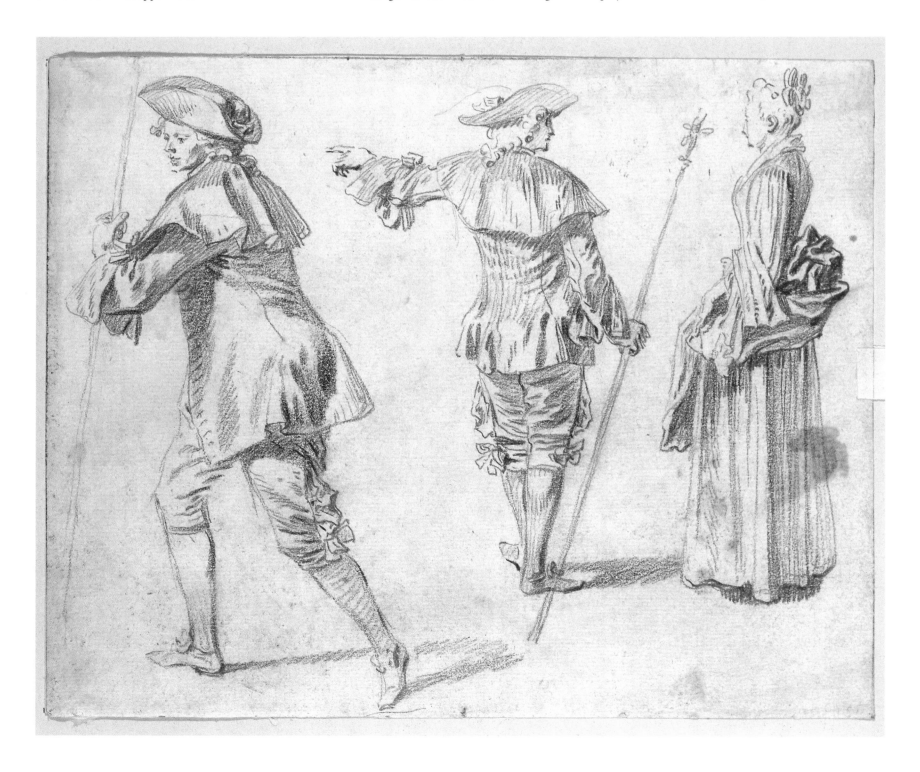

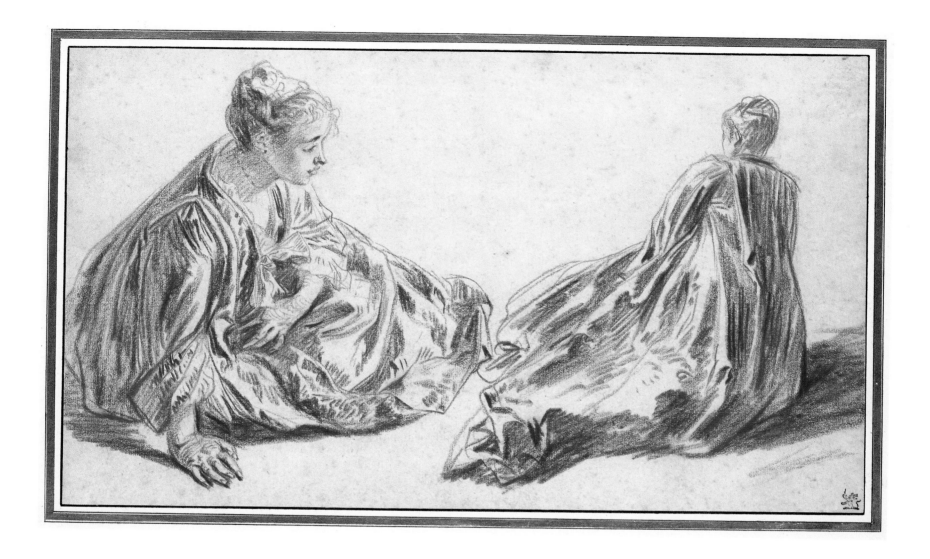

black chalk more energetically, and two or three years later he was already drawing in the *trois crayons* technique, mingling sanguine and black chalk on tinted paper and heightening them with white chalk. In subsequent years he developed a great mastery of this method, with an astonishing wealth of variations. Despite his very restricted range of subjects, Watteau never lapses into mere routine work, but always surprises the observer with new ideas.

The development of his genius can in fact be traced more clearly in the drawings than the paintings. The earliest known drawings, from the time when he was working with Gillot, are hesitant in execution, or pretend to a degree of skill they do not yet really have. In allegorical subjects, he reproduced existing themes. At the same time, however, he was training himself to note down what he observed, particularly at fairs and the theater; his models there did not pose for him, they were free.

Actors have to make larger-than-life gestures, so that they can be seen from a distance, and Watteau's little figures do appear to have been drawn from some way off. Sometimes they appear combined into groups and scenes in his studies, sometimes ranged side by side as if in a catalog, sometimes in two rows.

He observed the puppet-like aspect of an actor's movement, and developed a facility for depicting his

figures with only a few strokes, some firmly drawn or swiftly added, some far more delicate. Eyes, the joints of limbs, and details of dress are indicated by dots, short strokes, or little hooks. The figures all have an alert gaze, and the rhythmic lines give them a lively sparkle that is moderated by their statuary immobility. This easy and elegant manner obviously derived from decorative painting, notable for the musicality of its graceful play of lines.

Watteau's style of drawing had reached maturity around 1710, as witnessed by a study of pilgrims in sanguine (ill. 92) for the painting *The Island of Cythera* (ill. 54). Here the artist had access to models whom he could observe extensively, and out-of-doors, to judge by the way the shadows fall. He drew the pilgrim striding out on the left of the study first – he appears to the right of the painting, partly obscured. The shadows cast on his coat by his pelerine and left arm are clearly shown. A few strokes give a strongly expressive character to his face, which is framed by tight curls. Watteau shows different textures of fabric, for instance the fine, crumpled silk of the man's kneebreeches. The cut of the coat is evident in a single line at the hips, and even the buttonholes are clearly visible. A real costume could easily be made from this drawing, which clearly shows the artist's precise knowledge of fashion. But he has

93 *Two Studies of a Lady Sitting on the Ground*, ca. 1718
Sanguine, 20.2 x 34.1 cm
Rijksprentenkabinet, Rijksmuseum, Amsterdam

The woman sitting on the ground must have been drawn as a study for a *fête galante*, but it was not used in any of the known paintings. Obviously this was a study to be kept for possible future use, unlike the *Three Pilgrims* (ill. 92).

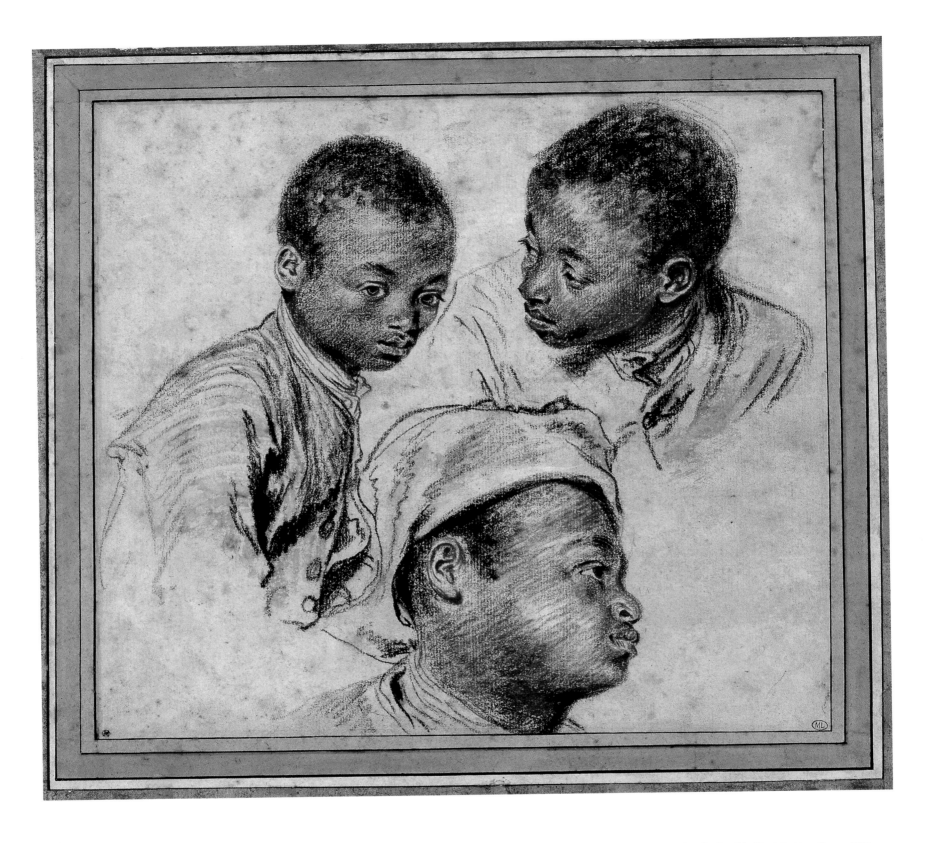

94 *Three Studies of the Head of a Negro Boy*, ca. 1715
Black chalk and sanguine, gray wash, 24.4 x 27.1 cm
Cabinet des Dessins, Musée du Louvre, Paris

Black boys as servants first occur in 16th-century Venetian
painting, particularly the works of Paolo Veronese, and
Watteau probably chose this subject in response to
Veronese.

also caught the shape of the body beneath the clothes. The man's calves are modeled by the pressure of the sanguine alone.

Watteau then used the same model for the center figure seen from behind, but placed it in a very different part of the painting. The hand pointing left is convincingly represented by a few strokes, and the face, turned to show the man's profile, wears a sternly commanding expression. Watteau may originally have intended the woman on the right, the final figure in the study, for the same picture, but in the end he did not use her. She stands quite still, as the women in Watteau's early work often do, so that the folds of her long skirt resemble the fluting of a column. In contrast, her upper garment billows out in vigorous movement behind her.

The three studies stand separate and side by side, yet the drawing is organized as a single unit. The spaces between the figures take on a life of their own, and nothing could be moved without endangering the harmony of the whole. The pilgrim's staff carried by the man shown from behind is placed on the ground just where the shadow cast by the left-hand pilgrim ends, and the staff in turn divides off an area of suitable dimensions for the figure of the woman. The confidence

with which Watteau has divided up the area of the study proves him a master of ornament. Perhaps the drawing owes its precision in recording the artist's observations to the many studies of soldiers he was able to make when he returned to Valenciennes in 1710.

With a very few exceptions, Watteau drew only figures and objects that would win a positive reaction; here, the element of mockery and criticism in the paintings can be read only between the lines.

Around 1715, when Watteau drew a whole series of poor Savoyards in ragged clothes, he portrayed them with sympathy, and has given them a dignity through his art that they would have difficulty in maintaining in real life. The artist who understood the elegance of fashionable dress so well could also see beauty in the timeless clothing of the poor, though depicting it required a different approach. Watteau did at least four drawings of the sturdy figure of the bearded old man, bowed by care and yet looking out of the picture with composure. He has put down his heavy pack, exhausted, and is resting with his vending tray on his lap (ill. 96). Black chalk and sanguine are mingled apparently at random to achieve a picturesque effect, and the artist produced intermediate tones by stumping the chalk. Here the man's appearance has inspired Watteau to draw more freely.

95 *Study with Eight Heads*, ca. 1716
Sanguine, black and white chalk, 25 x 38.1 cm
Cabinet des Dessins, Musée du Louvre, Paris

His work on the *Pilgrimage to Cythera* (ill. 55) increased Watteau's interest in the human face. After about 1714 the doll-like faces of his early period were increasingly superseded by more individual heads, some of which may be regarded as portraits.

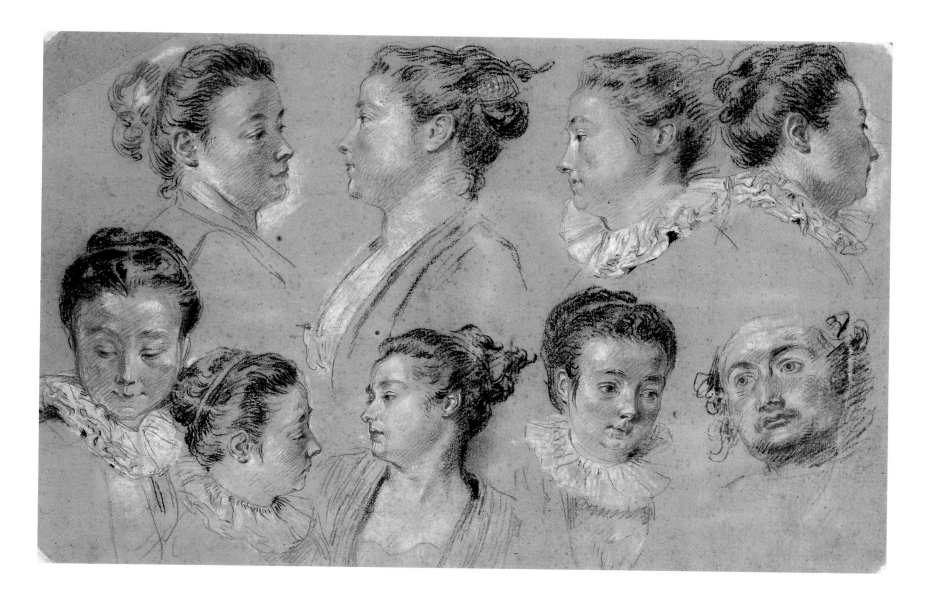

An interest in individual figures of striking and foreign appearance can be observed as early as Watteau's series of drawings of diplomats at the Persian Embassy in Paris, done in 1714/15. In the case of his Savoyard drawings, it has been suggested that they were inspired by the depictions of poor country folk executed by the Le Nain brothers (Antoine, 1602–1648; Louis, 1616–1648; and Mathieu, 1610–1677). But it is also possible that Watteau was drawn to such people because, like them, he was an outsider; as a Fleming who was only on the fringes of Paris society, not at its center, he may have felt an understanding for other borderline figures.

Another feature distinguishes the drawings of the Persians and Savoyards from the mass of Watteau's studies: he drew these people for their own sake, not as part of his stock of material for paintings. Although he did later paint a single figure of a Savoyard boy (ill. 98), the picture merely confirms that this model was an exception.

The studies of black boys, also dating from around the middle of the decade, are rather different. In all three works, black men feature as servants. Young and well dressed, they featured as interesting examples of exoticism in high society. Such people sometimes also appeared as luxurious adjuncts in portraits.

In the famous drawing of three studies of the head of a Negro boy (ill. 94), the way the artist draw his model from several angles indicates that his interest is not in the individual but the type. The study on the left was done first, and is a head and shoulders portrait; the boy's remote expression shows that he is obviously bored. Next came the study top right, in which Watteau was placed slightly above his model, who is looking both attentively and skeptically to one side. Finally, he gave the boy a cap and drew him again in profile, seen from just below, and emphasizing his full cheeks and chin. In all three studies Watteau tried to reproduce the effect of the boy's skin color with a mixture of black chalk, two shades of sanguine, and a gray wash. The cap covering the head in the study at the bottom was presumably chosen to avoid the presence of a dark area at the center of the sheet, and to form a link with the clothing in the two studies above it.

The way the artist distanced himself from his sitters is particularly clear in many studies of women's heads, which, though brilliantly caught, seem to be viewed through a pane of glass. Watteau has come close to his models, but has not let their personality touch him. Heads looking forward and appealing directly to the viewer are few. Jullienne remarked of his friend that he was cool and indifferent to others, an impression that can be gleaned from a drawing showing eight studies of the same woman wearing two different dresses (ill. 95).

She is not looking straight at the viewer in any of them. The first to be executed was the head in right profile, leaning slightly backward. The light falling in from the left illuminates the tip of her nose but leaves her face in shadow. The artist seems to have paid most attention to her hairstyle and her ear, a feature on which he also worked carefully in other studies. Next

Watteau drew her other profile, so that the faces are turned to each other, though they don't interrelate. Below is a slightly smaller variant on this position: the body is turned forward, but the head is turned away to one side. Watteau then drew the woman five more times in a different dress with a ruffled collar. The profiles top right, looking in opposite directions, are particularly curious, with their hair and collars touching, and with a touch of humor the artist has added the head of a man to the eight studies of the woman, to fill the remaining empty space. Of the various costumes worn by Watteau's models, Caylus tells us: "He had *galant* clothes, some of them stage costumes, in which he would dress the persons of both sexes who modeled for him, and whom he painted in the attitudes that nature suggested to him, preferring simple poses to any others."

Watteau's pleasure in depicting the lavish folds of voluminous female dress, a constantly recurring motif in his paintings, is also evident in a late sanguine study showing the same woman in the same attitude from both in front and behind (ill. 93). We can tell that he went around to her other side by the way the light falls from the right in the front view and the left in the back view. In the first study the model's charming head, seen in profile, and her lively hands are important features; in the second, however, the line of the folds drawn swiftly and energetically by the artist, observing the cut of the dress, are the almost exclusive source of interest. We guess at the body beneath the gown in an attitude that contrasts markedly with gown's elegance. The studies could have been used for a picture of a gathering in the open air, but do not occur in any painting. From the start Watteau must have intended to give the drawing a pleasing balance.

The atmosphere in which so lively a drawing was done can be imagined from a comment on Watteau by Caylus: "He spent most of his time in a few rooms I kept in different quarters of Paris, and which served us for the painting and drawing of models. Here, dedicated to art alone and free from all distractions, he and I, with a mutual friend of similar inclinations, experienced the pure joy of youth and the lively power of the imagination, both of them always at one with the enchanted spell cast on us by painting."

In these surroundings Watteau also drew nude studies, but he very seldom used them in his paintings. The *chaise longue* on which the woman feeling her left foot is sitting (ill. 91) occurs in several drawings of female nudes. Not only does her physical attitude, with her arms deliberately brought together and her left leg raised, remind one of the late *Diana Bathing* (ill. 115), but her delicate head is very like Diana's, and we may assume that the same model was used. The girl's dress, drawn in black chalk, lies between her arms and her body and is falling away to the left. Only the detail of the right foot drawn in sanguine emerges below, echoing the red collar of her dress to the top right. The contours of her body are drawn very strongly, in contrast to the softer modeling of the interior part, a feature that again clearly shows Antoine Watteau's

96 *Seated Savoyard*, ca. 1715
Red and black chalk, wash, 22.5 x 15.2 cm
Gabinetto dei Disegni e delle Stampe, Gallerie degli Uffizi, Florence

Savoy was a particularly poor region, and many Savoyards headed for Paris to earn money in hard and dirty jobs, frequently as seasonal laborers.

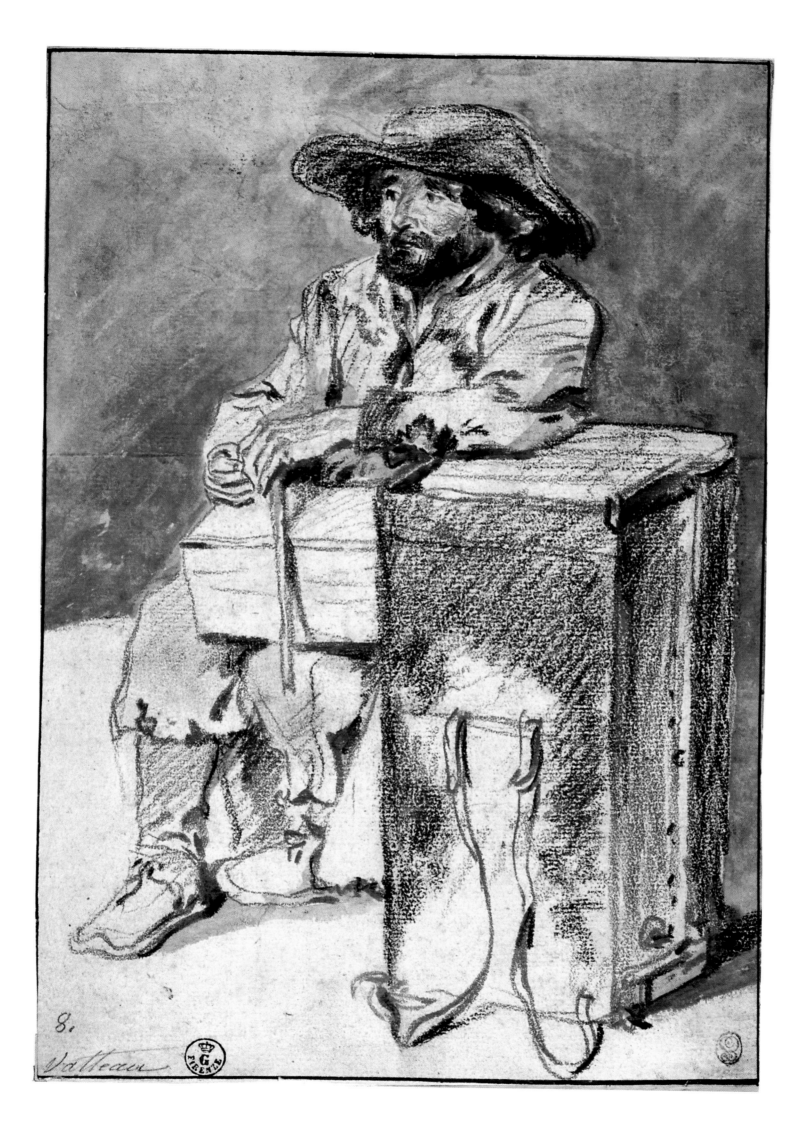

8.

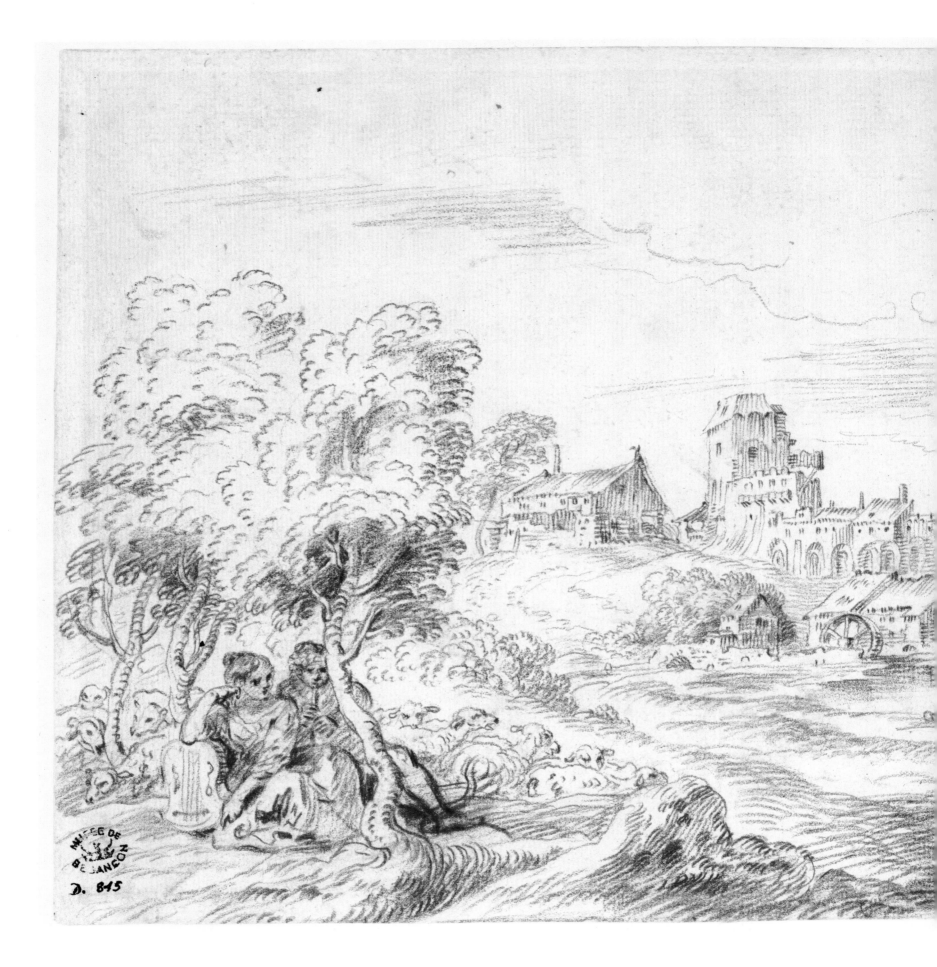

concern not only to depict sensuous charm but to achieve a clear and original form in this drawing.

The subjects of his drawings were almost all of the human figure, but there are some animal studies full of character, and a few landscape drawings recording the artist's immediate impressions of nature.

Finally, the works Watteau copied in drawings are informative in showing which artists he particularly admired. He drew copies after Rubens, van Dyck, Titian, Veronese, Giacomo and Leandro Bassano, Schedone, Feti, and the Le Nain brothers. The only one of his contemporaries whom he copied was Nicolas Vleughels. Copies after Domenico Campagnola (ca. 1500–1564), a contemporary of Titian, were particularly important for the landscape backgrounds of his paintings. Pierre Crozat had probably brought the originals back from Italy in 1715 (ill. 97).

1715 was the year of Louis XIV's death, and the regency of Philippe d'Orléans brought innovations into art. A new preference for a light, witty style was part of the springtime mood, and artistically it went hand in hand with a revaluation of the merits of drawing. Watteau was one of the artists who benefited; at least, that is the only way of explaining why Jean de Jullienne had no fewer than 351 of the master's studies reproduced in engravings, which he published in 1726 and 1728, and why this previously undervalued genre found enthusiastic collectors.

The golden age of 18th-century French drawing begins with Watteau. It was to be brilliantly continued in the work of François Boucher (1703–1770) and Jean-Honoré Fragonard (1732–1805).

97 Two Shepherds Under Trees, ca. 1716
Red chalk, 19.2 x 25.8 cm
Musée des Beaux-Arts et d'Archéologie, Besançon

A copy from Domenico Campagnola. In his backgrounds Watteau liked to use the architectural features typical of Campagnola – old, overgrown, partly ruined buildings with medieval features. Here Watteau has been influenced by Campagnola's style of drawing, with the vegetation, the contours of the terrain, and the buildings all rendered in short, rhythmic strokes and hooks, a style that also influenced Watteau's brushwork in his paintings.

Nature, Landscape, Children, Dogs

98 *Savoyard with Marmot*
Oil on canvas, 40.5 x 32.5 cm
Hermitage Museum, St. Petersburg

The boy is an entertainer who can make his marmot dance to the oboe – street theater of the simplest kind. With his knowing smile, the Savoyard boy shows a sense of self-confidence that is not to be suppressed by poverty. In his obvious ability to survive he may be compared to the fortune teller in the painting now in San Francisco (ill. 106). His vertical emphasis links him to the church steeple, and the deep blue sky, of a radiance found in hardly any of Watteau's other paintings, enhances his dignity in the same way.
The rapidly painted trees, similar to those in Watteau's late, swiftly executed sketches for composition, together with the rhythmic lines depicting grass, suggest that this is among the works of his later period. The companion piece, also statue-like in effect and showing a girl with a distaff, is now lost and known only from an engraving.

Very few of Watteau's scenes are set in interiors. Those few are three paintings of female nudes (ill. 61), where the intimate atmosphere demands an enclosed setting; two small pictures with half-length figures; a genre picture anticipating Chardin (1699–1779) with an old woman spinning, a younger woman sewing, and two children; the early *Louis XIV Awarding the Cordon Bleu to the Duke of Burgundy*, which stands alone among Watteau's works; and another remarkable picture, *The Little Players. Gersaint's Shop Sign* (ill. 9) does show an interior, but the foreground is the street. This picture and the *Expulsion of the Italian Players* (ill. 23) of 1697 are the only works with settings that can be placed in the center of the city of Paris. All Watteau's other pictures have a landscape background, even if it consists only of the sky.

The open air was therefore the setting for the great majority of his pictures of groups or individuals. Watteau did not like the metropolis. Nature attracted him to the outlying areas of the city, and on into the open country. The late painting *Savoyard with Marmot* (ill. 98) has a typical setting on the city outskirts. It shows buildings on three floors on one side of the work, village cottages and a modest church on the other. Watteau makes it clear that this picture is set in France.

Important as nature and the natural landscape were to the painter, none of his works apart from some of his drawings show landscapes without human figures, and only a few of the paintings can really be called landscapes. In most of them, the figures are harmoniously balanced with the natural scenes around them.

A real location can be identified in only three depictions of landscapes: the setting of *The Island of Cythera* (ill. 54) is Saint-Cloud near Paris; *The Perspective* (ill. 81) shows the grounds of the château of Montmorency; and a study painted on paper and now in private ownership is a view of the little river Bièvre near Gentilly. Being painted on paper, however, the latter is closer to the drawings, and cannot be considered as a painting on a par with the others.

Landscape painting had a subordinate role in 17th-century France. The great French landscape painters – Nicolas Poussin, Claude Lorrain, and Gaspard Dughet (1615–1675) – worked mainly in Italy. The best representatives of the genre in France were Pierre Patel (1605–1656) and his son Pierre-Martin Patel (1647–1708). Laurent La Hyre (1606–1656) also occasionally painted landscapes. Watteau's landscape settings were therefore not in a typically French tradition, but they are also largely independent of Dutch and Flemish models. He derived his main inspiration from 16th-century Venetian landscape painting.

The variety of Watteau's ideas is even more startling in his landscapes than in any other genre in which he worked. It is difficult to place them in any clear line of development; they are best regarded as an erratic series of experiments.

A cycle of the Seasons of which the original is now lost, but probably dating from before 1710, is worth noting because it showed nature ordered and shaped by man, with the pleasures appropriate to each season. These artificialities were enjoyed by a courtly society. Watteau's only winter landscape (ill. 99) was one of this cycle of the Seasons; they were also important in the artist's development because the roots of the *fêtes galantes* lie here.

Four landscapes, also now lost and extant only in engravings, shown ideal southern landscapes with mythological scenes: they are *The Rape of Europa*, a reclining *Venus* caressing Cupid, a *Diana* asleep beside a nymph, and the story of *Acis and Galatea* (ill. 100). The long landscape format of the Acis and Galatea picture suggests that it was originally a supraport, and may have had a companion piece in the shape of another landscape of the same proportions. With the exception of the depiction of Diana, water plays a great part in all these paintings, as it does in the cycle of the Seasons. It is difficult to date these pictures, but they must have been painted before 1715.

While all these works relate to those of other masters, Watteau strikes a note entirely his own in some of the early rural subjects, also extant only in engraved reproductions and a few drawings (ill. 101). These pictures show humble farmhouses with small gardens in which people are working, and it is immediately clear that the painter actually saw these natural scenes. He shows the small dwellings of ordinary people, rendering them faithfully and almost in the manner of

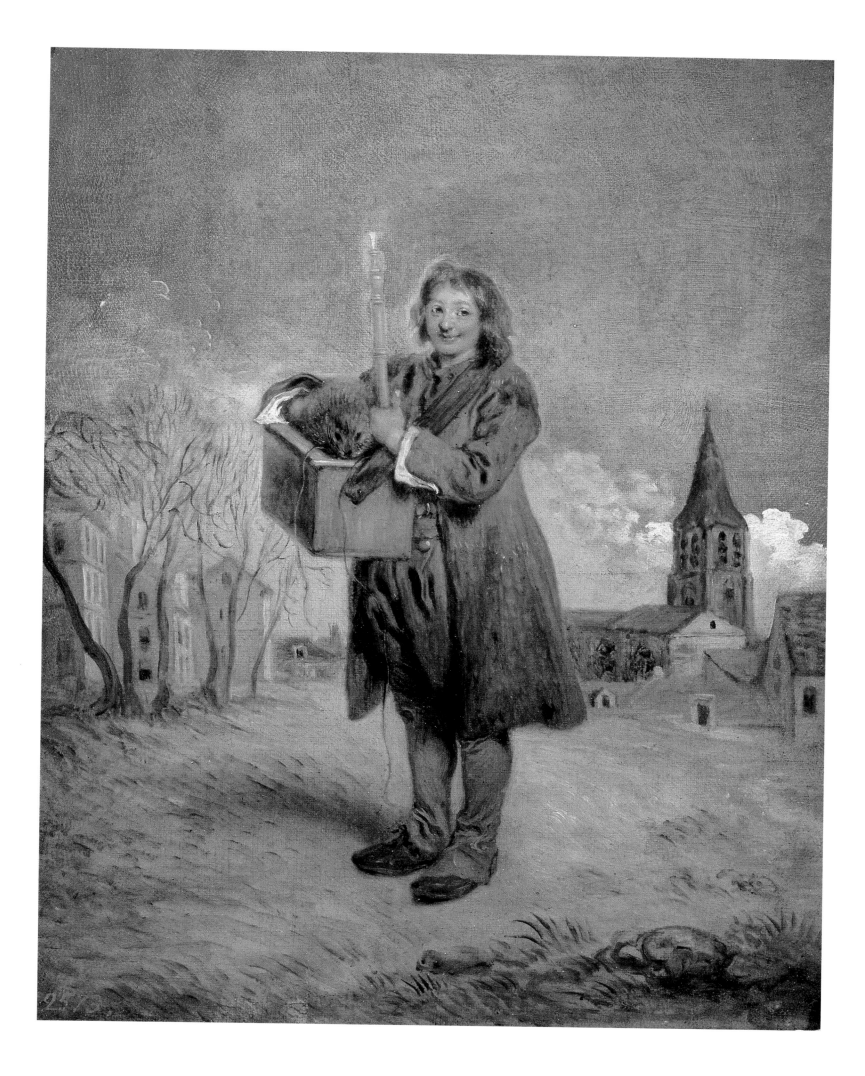

A. Watteau pinxit.

N. De Larmesin Sculp.

L'HIVER.

Gravé d'après le Tableau original peint par Watteau, haut de 1.pied 5.pouces et large de 1.pied 8.pouces.

Du Cabinet de Mr de Jullienne
à Paris avec Privilege.

99 Nicolas Larmessin IV, after Watteau
Winter, ca. 1708
Etching, 29.8 x 37.3 cm
Kupferstichkabinett, Staatliche Museen zu Berlin –
Preussischer Kulturbesitz, Berlin

This scene is entirely dominated by the architecture and the company amusing themselves against its setting. The large stone urn on the pillar became a favorite motif of Watteau's.

100 Comte de Caylus, after Watteau
Acis and Galatea, before 1710
Etching, 18.3 x 36.2 cm
Kupferstichkabinett, Staatliche Museen zu Berlin –
Preussischer Kulturbesitz, Berlin

The wide expanse of water dividing the landscape occurs several times in Watteau's works. Here he is looking ahead to the Cythera theme.

Peint par Watteau.

grave par C.

On n'aime guerres sans rivaux,
Mais il en est qui sont a craindre:
En aimant on souffre des maux
Dont souvent on n'ose se plaindre.

Acis et Galathe.

A PARIS { Chez Duchange Graveur du Roi ruë S.Jacq près les Mathurins.
Chez Gautrot et Joullain Quay de la Mejisserie à la Ville de Rome.

Si pour quelque jeune beauté
Vous sentez comme Acis une tendresse extreme,
Songez pour vôtre seureté
A vous mettre a couvert des traits de Polipheme.

A. Watteau pinxit. L. Jacob Sculp.

LE MARAIS

a Paris chez Fihereau graveur du Roy rue St Jacques aux 2 pilliere d'Or avec privilege du Roy.

A. Watteau pinxit. P. Chedel Sculp.

RETOUR DE GUINGUETE.

Gravé d'après le Tableau original peint par Watteau de même grandeur de l'estampe.

Du Cabinet de Mr de Courleonvre ancien Capitaul de Toulouse.
Se vend a Paris avec Privilege.

101 Louis Jacob, after Watteau
The Market Garden, ca. 1710
Etching, 23.7 x 31.1 cm
Kupferstichkabinett, Staatliche Museen zu Berlin –
Preussischer Kulturbesitz, Berlin

The world of rural life is a world of work, but Watteau gives the costumes of the figures in the foreground a touch of urban luxury.

102 Pierre Quentin Chedel, after Watteau
Return from the Tavern, ca. 1708
Etching, 24.5 x 27.7 cm
Kupferstichkabinett, Staatliche Museen zu Berlin –
Preussischer Kulturbesitz, Berlin

This lost picture is most closely related to the *Fair with Players* (ill. 43) in the movement of the tipsy villagers, in the power of the way in which the depths of the picture open out, and in the scene showing a company of people of a higher class at table.

a still life instead of depicting the grandeur and breadth of the landscape. The clumsy perspective seems to negate the wide space around; here naivety is used deliberately as a stylistic method.

In certain pictures containing many figures (ill. 102), dating from around 1710 and in some cases earlier, and again preserved only in engravings, the buildings are comparably modest, but are sometimes combined with a powerful movement toward the depths of the work. A sense of a bleak landscape is also expressed, at about the same period, in the natural scenery of Watteau's military pieces.

After about 1712 the usual landscape in which he set his social gatherings became a park laid out by man, with tall trees – sometimes including pines and cypresses, which were often included to suggest Italy. Here nature and art meet, but the forces of natural growth are always stronger than the regulating hand of man. Formally, the dark green of the foliage brings out the bright colors of the clothing.

Around 1716 Watteau turned to a new kind of landscape. Whereas he had previously expressed his longing to see Italy only by depicting pines, cypresses,

and southern architectural features, he now painted landscapes inspired by Titian, and even more by Titian's Paduan contemporary Domenico Campagnola, featuring distant and sometimes snow-covered mountains, rivers, and old-fashioned castles and farms. Watteau could see these models in his friend Pierre Crozat's extensive collection. Crozat had gone to Rome in 1714 as an agent to procure works of art for Philippe, Duc d'Orléans, and came back the following year with many treasures, including some that he kept for himself. As Dezallier d'Argenville tells us, Watteau had studied "paintings and drawings of the great masters" in Crozat's collection, and he copied drawings by Domenico Campagnola. Many of these copies are still extant (ill. 97), and in some cases it can be shown that Watteau adopted themes directly from them for his own landscape backgrounds.

These models are enhanced to become an intoxicating vision in the background of the *Pilgrimage to Cythera* (ill. 55) of 1717. The hazy atmosphere allows us to guess at the beauties of this delightful natural scene rather than actually to see them. Tall mountains and deep river valleys, castles and mighty

103 *River Landscape*, ca. 1716
Oil on canvas (transferred from panel), 70 x 106 cm
Hermitage Museum, St. Petersburg

It is possible that this work was originally a supraport. Although the atmosphere of the scene is emphasized, the landscape appears artificially constructed rather than the result of direct observation. Emotion and reason meet, but remain alien to one another.

104 (previous page)
Landscape with Goat, ca. 1717
Oil on panel, 26.5 x 18.5 cm (reproduced almost original size)
Musée du Louvre, Paris

This small panel, the same size as *The Indifferent Man* (ill. 67) and *The Sulky Woman* (ill. 69) was inspired by the landscape drawings of Domenico Campagnola that Watteau had copied. The tall format of this clearly constructed work is striking; Watteau chose it for the sake of the steep crag crowned by a fortress. Waterfalls were part of the general image of Italian landscapes – those of Tivoli were the most famous – and here the cascade falling to the depths is balanced by the tree with which the picture begins, the castle built on the steep slope, the rock behind, and the clouds towering above. Both the red sky and the light, which as the shadows on the façade of the castle show is falling at a slant into the ravine, give the impression that it is evening. The little figures suit this evening atmosphere. The peasant woman with the large, polished copper vessel, obviously about to milk the goat, is reminiscent of similar attractive and dignified figures in the work of Rubens and Jan Siberechts (1627–1700/3), while the format, extremely small for a landscape in spite of the grand scenery, is found elsewhere only in Dutch landscape painters of the 17th century.
Today this small landscape is isolated among the rest of Watteau's oeuvre, though it is difficult to imagine a picture painted with such ease and confidence being unique. Perhaps similar small works of this kind have been lost.

105 *Love in the Country*, ca. 1718
Oil on canvas, 56 x 81 cm
Schloss Charlottenburg, Berlin

The observer's eye falls first on the sleeping dog and the guitarist looking ahead of him, setting the tone of the picture. The upward and downward contour of the mountains and valleys prepares the eye for the outline of the three couples. The standing couple, with the mountain peak above them on the left and the tree on the right, are the *repoussoirs* that frame the scene.

trees create an elevated atmosphere corresponding to the emotions of the human figures shown against them. This was Watteau's idea of Cythera, where Venus was born of the foam of the sea. In several pictures, for instance *The Lesson in Love* (ill. 75), he provided a view from a height looking down on an earthly paradise of this kind.

A relatively large *River Landscape* (ill. 103) now in the Hermitage Museum seems to be early evidence of Watteau's still tentative approach to Campagnola. The river flows down from the tall, snow-covered mountains toward the observer, while the small incidental figures in the scene – the rather stiff pair of lovers walking in elegant town dress, the country people in the middle ground, and a flock of sheep – are all moving away and into the painting. Rather oddly, however, the shepherd supposed to be with the flock is sitting under a tree, playing his pipe. He is an integral part of this natural scene, whereas the lovers shown walking seem like an extra added to it. The contrast is further emphasized by the way in which Watteau places them at the extreme edges of the picture, with the river between them. The distorted trees on the shepherd's side, reminiscent of the stunted willows in the early military pieces, lend this bank of the river an austere quality, whereas the other bank is idyllic in appearance.

Love in the Country (ill. 105) demonstrates the way Watteau's feeling for landscape increased, and his representations of it became closer to reality after the *Pilgrimage to Cythera* (ill. 55). In *Love in the Country* his concept of nature and his view of human beings have become more realistic. To a great extent the landscape in the background still resembles that of the *Pilgrimage*, but the exhilaration of the Cytherean vision has given way to a calmer, sober mood. The mountains do not tower up as steeply, and the water is not so wide. Finally, there is even a shadow falling over the scenery to suggest that all is transitory: a rain cloud is coming up from the left, where a ruin stands on a rocky height. The delicately reddened clouds in the distance show that it is evening, and a smoky autumnal haze reveals the season, a message also conveyed by the tree on the right. The castle and the two obelisks behind it are the same in both pictures.

The mood of cheerful departure in the *Pilgrimage* is superseded here by a sense that the couple's happiness will not last, but is as fleeting as the music. Was this modification to do with Watteau's experience of illness? We can only guess.

As in the *River Landscape* in the Hermitage, a shepherd and his flock are part of the picture here. While the bright clothes of the young people contrast with the deep green of the vegetation, like flowers in the grass, the shepherd hardly stands out from his surroundings at all. Watteau used the same approach in *The Shepherds* (ill. 63).

Details of Watteau's depiction of the landscape such as trees, bushes, and meadows also show his sense of reality increasing and his observation becoming sharper. The expanses of grass in the two great Cythera pictures differ in that the ground in the earlier version

is softly enlivened by blurred patches; while in the later version the artist painted individual grasses with short strokes, lending a vibrant rhythm to the whole surface. While the trees of the first version are still very much the expression of powerful growth rising from within, and depicted with swift brushstrokes, in the second the structure is more firmly based on observation. Later, Watteau represented the vast number of leaves on a tree with countless little dabs of paint, a method suggested to him by the very wealth of nature that he saw before him. Other details, for instance brambles in the foreground, became stereotypical in his landscapes of his late period.

With this development, Watteau finally came back to the simple French villages that he had painted in earlier years, but now they are set in a wide landscape, for instance in *The Shepherds* (ill. 63) and *The Dance* (ill. 108). *The Dance* in particular shows the painter's longing for original simplicity, expressed both in nature and in children, whom he associated with the landscape.

The girl at the center of this picture wears a dress of English silk; records show that its printed pattern dates from 1718. This relatively large work was therefore probably painted during Watteau's visit to England in 1719/20. In addition, the head of the boy with the shepherd's crook derives from a painting by the Le Nain brothers that Watteau must have seen in England.

The design of the composition – a group in front of a woodland background, and a central figure with the open sky behind it – was one he had often used before. The new feature here is his exclusive concentration on the subject of childhood, or rather of childhood growing to maturity. The three children on the left, one of them playing a pipe, are waiting for the somewhat older girl to dance to the music. But she hesitates. The action pauses, and her thoughtfulness, which makes the viewer thoughtful too, is the real psychological subject of the picture. The girl guesses that childish play is merely a prelude to the life that lies ahead of her. The basket of roses and the arrow beside a board with painted hearts indicate that love will determine her future. The overcast sky leaves the coming change in the weather undecided, and reflects the girl's mood, hovering between joy and melancholy. The view of the landscape with the shepherd and the church is also a perspective of life.

Watteau turned to the world of childhood quite early. Children occur in the military scenes as pathetic adjuncts to the women who follow the soldiers, and they stress the contrast between war and childhood. Such children, observed in their natural surroundings, are very different from his naked and sometimes winged *putti* frolicking on the ground or flying in the sky, conjuring up happy childhood images – figures that recur once more in the angels' heads in *Rest on the Flight into Egypt* (ill. 117). These companies of *putti* were a Baroque convention that Watteau took over from Gillot. It is in their nature to remain eternally young. After about 1716 small children who do not yet have the power of reason, but are gradually growing into the adult world, joined Watteau's sociable gatherings of

106 *The Fortune Teller,* ca. *1710*
Oil on panel, 27 x 28 cm
Museum of Fine Arts, San Francisco

Here two worlds meet, the vine marking the border between them. A young woman of high rank in shimmering, silvery dress with a salmon-pink border, accompanied by an equally noble lady and a servant maid, has come to consult the mysterious knowledge of a gypsy woman who reads her hand – we may be sure that love is the subject of the consultation. The gypsy places her right forefinger to her lips in a grave and enquiring gesture: she will be rewarded for her soothsaying. With her, the old woman has a shaggy mongrel and a barefoot boy in ragged clothes. The wide landscape with the blue sky stands behind these poverty-stricken figures: nature and nurture, city and country meet. The theme of the fortune teller, popular since around 1600, also occurs in the earlier painting *Fair with Players* (ill. 43).

107 *The Happy Age*, ca. 1718
Oil on panel, 20.7 x 23.7 cm
Kimbell Art Museum, Fort Worth

The title of this small picture is taken from the beginning of a verse underneath the engraved reproduction by Nicolas Tardieu, but it is rather misleading. Watteau is linking children's play with the world of the theater, for the main figure, an overweight boy looking rather unhappily out of the picture, wears the costume of Pierrot. He could be the son of *Gilles* (ill. 53). His little legs do not yet reach the ground. The girl in front with the whip, the attribute of Harlequin, is looking challengingly at this enthroned main figure. She seems to be the leader of the little troupe, but no play is in progress. Movement and time have paused. The tambourine lies idle on the ground, and one of the girls has placed her head in her hands in a melancholy gesture. The gloomy weather suits the children's mood, and a few dry branches even indicate natural death, an unusual theme for Watteau. Unlike Watteau's depictions of *putti*, the picture has none of the merriment that adults like to imagine as part of the world of childhood.

elegantly dressed couples, and the more his art matured the greater was their importance in his work. The idea of children as the fruit of love, through whom the present moment looks to the future and a sense of responsibility enters life, became increasingly prominent in Watteau's work, and finally lead to the depiction of the Holy Family *Rest on the Flight into Egypt*, where the Christ Child occupies the center of the composition. Watteau obviously developed his eye for children from independent observation, and in this he distanced himself from the Parisian culture around him, where as portraiture in particular shows, children were of hardly any importance. On the other hand, the painter may have felt encouraged by the Dutch and Flemish portrait and genre painting of the 17th century,

in which children and their upbringing are an important subject. However, there is no educational tendency in Watteau. He saw children as natural creatures, and their view of the world interested him because they were looking at it from outside, just as he did. He may also have found encouragement for his feeling for children in England, where children's portraits were an important genre.

He saw dogs as well as children as creatures still living in harmony with nature. One cannot fail to see how often dogs feature in Watteau's early period as companions to man. The painting *The Fortune Teller* (ill. 106), of around 1710, sharply distinguishes between two worlds: the town with its sophisticated culture, represented by a lady and her two finely dressed female

108 *The Dance*, ca. 1719/20
Oil on canvas, 97 x 116 cm
Gemäldegalerie, Staatliche Museen zu Berlin –
Preussischer Kulturbesitz, Berlin

This painting was originally round, its diameter reaching from the group of children on the left to the church tower on the right. A piece of canvas has been added at the top, and a tree painted on the left. It may have been painted as part of an interior decoration scheme.

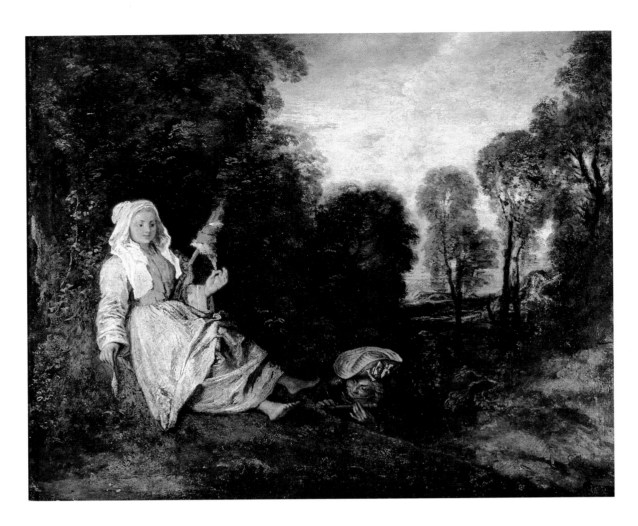

109 *The Indiscreet Man*, ca. 1716
Oil on canvas, 55 x 66 cm
Museum Boijmans Van Beunigen, Rotterdam

The uninhibited sexual instincts of the peasant class were part of Watteau's idea of nature. Consequently, he sets this suggestive scene in a lively landscape of a very Venetian type, among the kind of dense woods that he always saw as a mysterious setting for love. The girl spinning sits helpless as a doll, while the sly peasant youth is coming up with his pipe from a depth we cannot see to seduce his childlike sweetheart.

companions, and the country with the ragged gypsy woman, consulted by the lady who is so much higher in social rank for her secret and perhaps misleading knowledge. But social differences may be forgotten when love is at stake, as presumably it is here. The blue sky behind the fortune teller balances the splendid color in the dress of the three women from the city. The gypsy has not only a boy with her but also a mongrel dog. The shop sign (ill. 9) contains a dog that both concludes the composition on the right-hand side and also relates to the landscape on the wall. In *The Shepherds* (ill. 63), the arabesque of the rows of figures begins with a dog licking itself without inhibitions, and a dog lies in the central foreground of *Love in the Country* (ill. 105). In both versions of the *Embarkation for Cythera* (ills. 55, 57) a small dog is the link between the two large groups of figures, and here Watteau carefully chose his dog breeds in line with the different character of the two pictures. In the earlier version it is a small spaniel – a lapdog belonging to one of the women pilgrims – looking hesitantly behind it; in the later version an ordinary sheepdog follows the pair of peasants. In *The Concert* (ill. 76), a little dog running into the picture links the groups in the foreground and the middle ground. There are as many as four dogs in *The Pleasures of the Ball* (ill. 44), including an elegant greyhound forming the link between the lady dancing and two children. Naturally there are hounds in the late painting *Halt During the Hunt*. This picture also contains three horses; animals otherwise found only in Watteau's war scenes, and not very congenial to his personal pictorial world because of their function as status symbols.

110 *The Misste*, ca. 1719
Oil on canvas, 40 x 31.5 cm
Musée du Louvre, Paris

This painting and its format place it with the compositions of the late period that contain two figures (cf. ills 69, 70), but it is no longer concerned with decorous courtship. The woman is fending off the man's pressing advances. The red and yellow garment suggests an alarm signal. In *The Pleasures of Love* (ill. 82), the scene occurs again, but defused by the presence of another pair of lovers, so that it appears light-hearted, and as it were justified by the inclusion in it of the child.

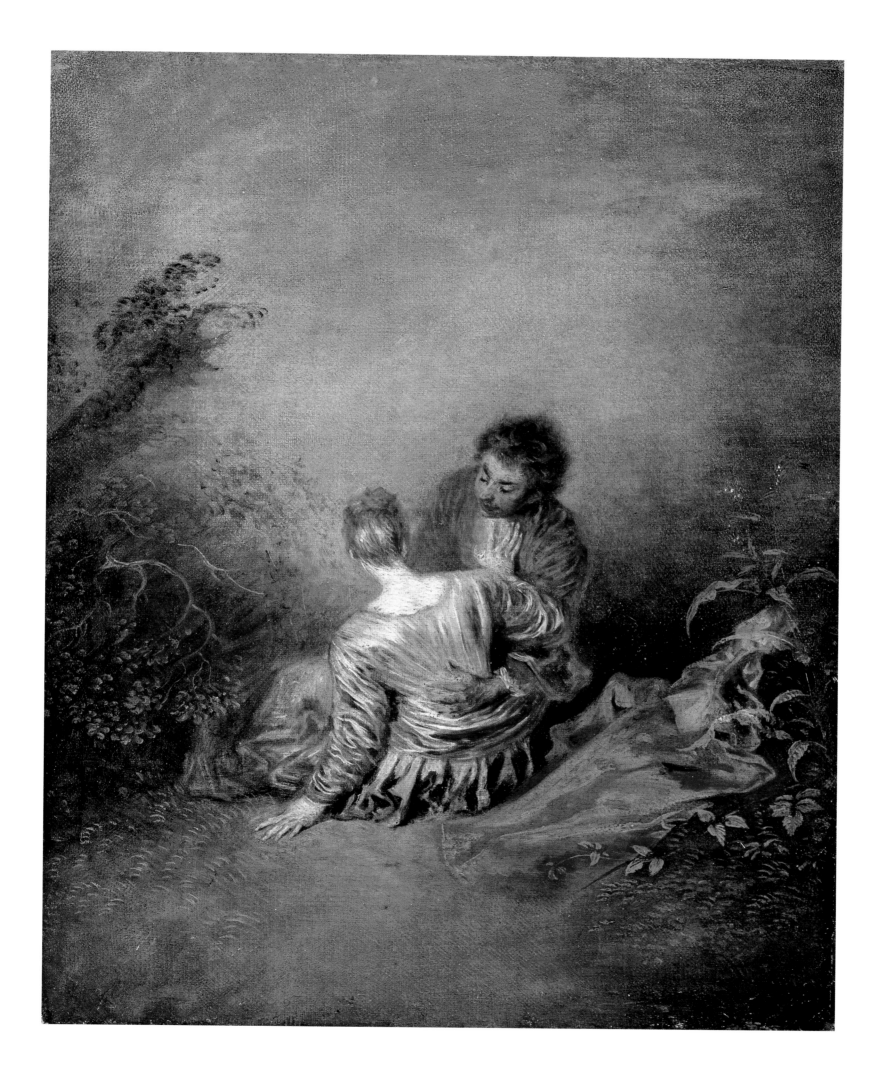

LAST YEARS AND LEGACY

111 *Mezzetin*, ca. 1720
Oil on canvas, 55.2 x 43.2 cm
The Metropolitan Museum of Art, New York

A comparison with *The Serenader* (ill. 49) shows Watteau's progress in imparting animation to his figures. It seems likely that the weakly painted wall on the right is not by his own hand: the wall suggests that Mezzetin is looking up to the window of his beloved, to whom he is singing a serenade, but narrative features of this kind are alien to Watteau's approach.

When Watteau returned to Paris in the summer of 1720, after a visit to London lasting several months, he had about a year of creativity ahead before his death on July 18, 1721, in Nogent-sur-Marne, a village east of Paris, six kilometers from the place where the Marne flows into the Seine. He had retired there in the spring, and his friend Paul Maurice Haranger made arrangements for him to live with a Monsieur Le Febvre. He could no longer realize his wish to go back to Valenciennes. According to Gersaint, Watteau was still hoping to return to health only a little while before his death, and had gone on working in Nogent-sur-Marne. He had painted a *Christ on the Cross* for the village church, a work that was apparently sold at the end of the 19th century and is now lost. It must have been quite a large picture, and this surprising new departure into sacred painting can certainly be explained by his illness, as can his decision to destroy all the pictures he thought salacious. The *Wedding of St. Catharine* in the shop sign (ill. 9) points in the same direction.

We know that Watteau was still able to devote the last weeks of his life to art from a message sent to Gersaint by Jean-Baptiste Pater. According to Pater, he was Watteau's pupil in the last month before his death. Twelve years younger than Watteau, he too came from Valenciennes, and had already spent a short time training with Watteau, who soon dismissed Pater, however, because he made such slow progress. Watteau did not enjoy teaching, and Pater was his only pupil. There are works by Pater so close to his master's style that it seems likely they were painted in the summer of 1721 or soon after. The additions to the shop sign (ill. 9) have been ascribed to him, and we may also suspect that his hand is to be traced in pictures which were left incomplete in Watteau's studio after his death, and had to be completed if they were to be sold. And to whom but Pater could Watteau's heirs have entrusted the task?

To get an idea of the style of Watteau's final year, we may start with these uncompleted works that were finished by another hand. In addition, certain works may be placed in the period around the painting of the shop sign, both because of theme and because of the swift brushwork, and may therefore be dated to the very end of the artist's life. However, he also produced some very carefully executed paintings in these last months, for instance *Mezzetin* (ill.111), originally designed as an oval. In the perfection of its painting, and particularly the delicate coloring, the main figure is comparable to the lady sitting in the foreground of the shop sign (ill. 9). However, the fluently painted forest background, with a statue standing among the trees as if turning away, seems to have been by another hand. The work is reminiscent of the double portrait of Jullienne and Watteau (ill. 6), also by an imitator, perhaps Pater.

A major problem in the study of Watteau is our meager knowledge of the work he did in England. These, after all, were the pictures immediately preceding his final creative phase, and dividing those last works from those he had previously executed in Paris. All we know is that Watteau painted two pictures for the London doctor and art connoisseur Richard Mead, one at least of which, the *Italian Players* (ill. 52), has been preserved in an engraving and a good copy.

Prolific as he was, it may be assumed that Watteau painted a great deal in England, where he very probably produced *The Dance* (ill. 108). In other pictures we may only suspect as much. Ideas that came to him in England, apart from the dress of the main figure in *The Dance*, however, seem to have most influenced his concept of landscape.

Nor do we know what induced Watteau to go to London at all in 1719 in his poor state of health, and in the late fall when the weather would be bad. Was it another involuntary attempt to get away from Paris, like his absence from the capital of ten years earlier, even a kind of flight? Or did some particular factor draw him to London? Was his visit to England planned to be temporary or long-term?

French artists such as Nicolas Largillière had visited England quite often toward the end of the 17th century. Such visits ended in 1688 with the flight to Paris of King James II of England and Scotland (r. 1685–1688), and the accession to the throne of William of Orange (r. 1688–1702), victorious leader of the Protestants against the Catholics. In 1711 two French painters, Nicolas Dorigny (1658–1746) and

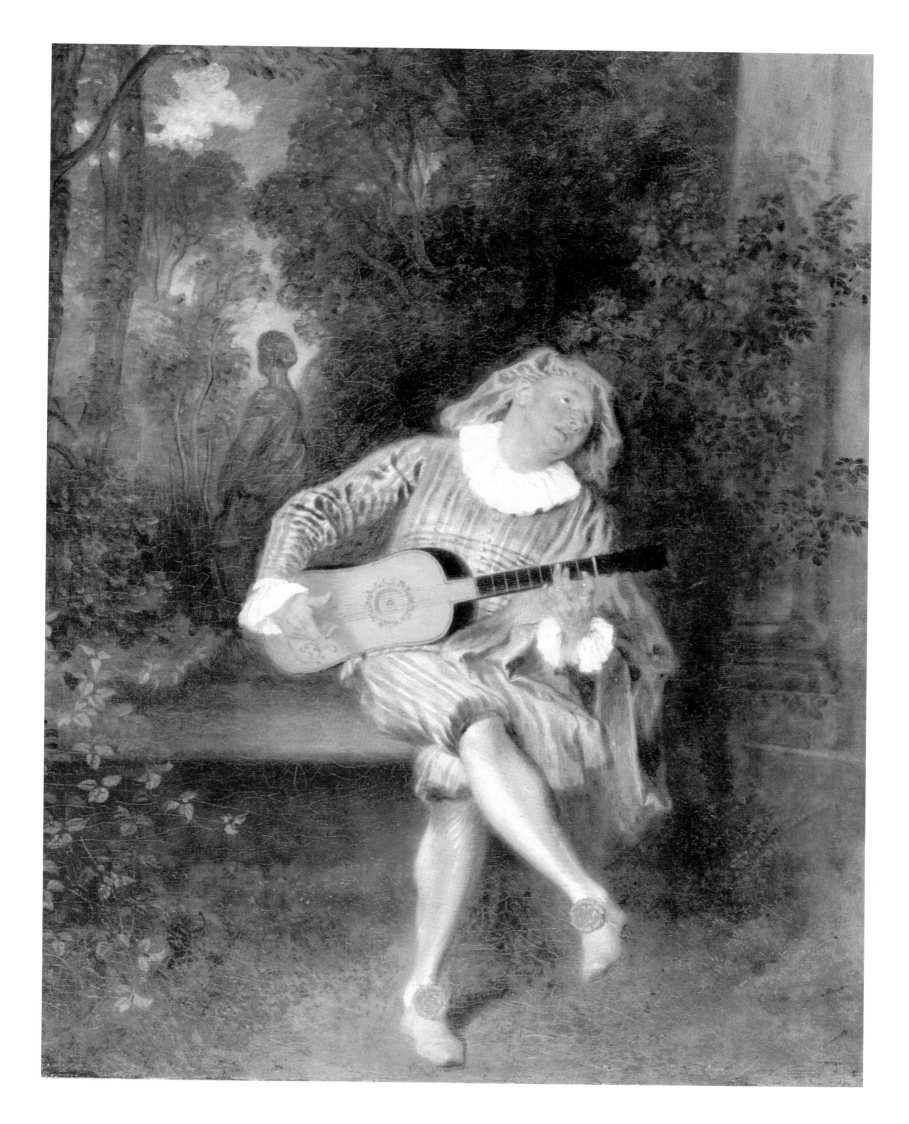

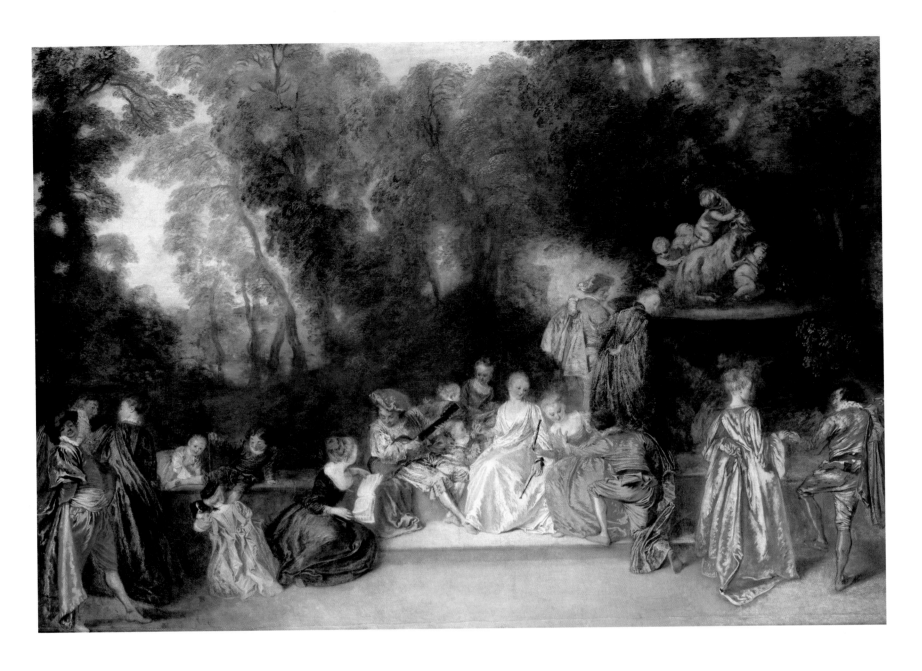

112 *Entertainment in the Open Air*, ca. 1721
Oil on canvas, 111 x 163 cm
Gemäldegalerie, Staatliche Museen zu Berlin –
Preussischer Kulturbesitz, Berlin

No other work casts such light on the painter's working
methods. In the time of Frederick the Great it was hung in
the Kleine Galerie of his palace of Sans Souci. The richly
carved frame is Prussian, though it was given to the
painting only after World War II (the frame in which it
originally hung in Sans Souci was lost in the war).

Louis Goupy (ca. 1700–1747), visited London, but it
was not until the regency of Philippe d'Orléans, who
ended the hostilities between England and France, that
the British Isles again exerted any great attraction on the
French. In 1717 a major Parisian painter – Alexis-
Simon Belle (1674–1734) – visited the English capital,
so Watteau's journey was not an isolated instance.

The most important of the incomplete paintings
Watteau left is the large *Entertainment in the Open Air*
(ill. 112), now in Berlin, which was originally probably
of about the same size as the two Cythera pictures in
Paris and Berlin (ills. 55, 57), and as two other paintings
in the Wallace Collection in London (ills. 85, 88) – that
is, about 125 x 190 cm. The painting now measures only
111 x 163 cm. Two early copies show that about 13 cm
have been trimmed from the top, and about 16 cm from
the right-hand side. The forest setting now ends very
abruptly at the top, and the expansive gesture of the
cavalier on the extreme right really needs more room.

As in Gersaint's shop sign (ill. 9), the composition
develops from left to right, and was probably painted

in that order, for the couple on the right are the least
finished, and the stone bench behind them is merely
indicated.

Scholars have not always liked this picture: "It is […]
among the least popular of the Watteaus now in Berlin,
and in our opinion with good reason," wrote Pierre
Rosenberg, the well-known Watteau expert, in 1984.
However, he also observes that Watteau here created "a
new type of composition, more sculptural, symmetrical,
and classic than in his other works." The picture does
indeed lack the relaxed sense that marks, for instance,
both of the *fêtes galantes* now in Dresden (ills. 82, 83).
The severity of the composition, which seems incon-
gruous for an image of amorous, light-hearted couples,
could be explained by Watteau's state of mind during the
last months of his life, particularly since the same feature
is found in other works of his final period. The figures are
arranged in clear groupings. On the left, the picture
begins with the characteristic figure of the confirmed
bachelor, the only person to be looking at the viewer, and
he is linked to a couple walking away into the picture.

Then there are three children at play. The figure of the girl with the little dog, turning to her left, is clearly separated from the lady sitting on the ground in a green dress and turning to the other side. She is the beginning of the group arranged in a gable shape, again culminating in three children, although visually the woman in the pale blue dress is its focal point. This woman is the center of the whole composition, and the color of her dress relates to the blue of the sky shining through the trees in "windows" of various sizes. The rising diagonal of the gable shape continues in the standing couple and, on a higher level, in the statue on the fountain with the children and the goat. This sculptural group, picking up the theme of children for a third time, is set above the figure of the woman in the copper-colored dress seen from behind, so that this figure and her partner form a contrast on the right of the work of the bachelor on the far left who began the composition. In none of his other open-air gatherings does Watteau relate children so strongly to the luxuriant natural scene around them, as the fruit of love and a promise for the future. Few of his pictures have been so carefully thought out.

113 *Entertainment in the Open Air* (detail, ill. 112))

The movements of the figures seem purposeless; one cannot imagine the next steps they will take. Their sole function is to balance the composition. It is as if time stood still.

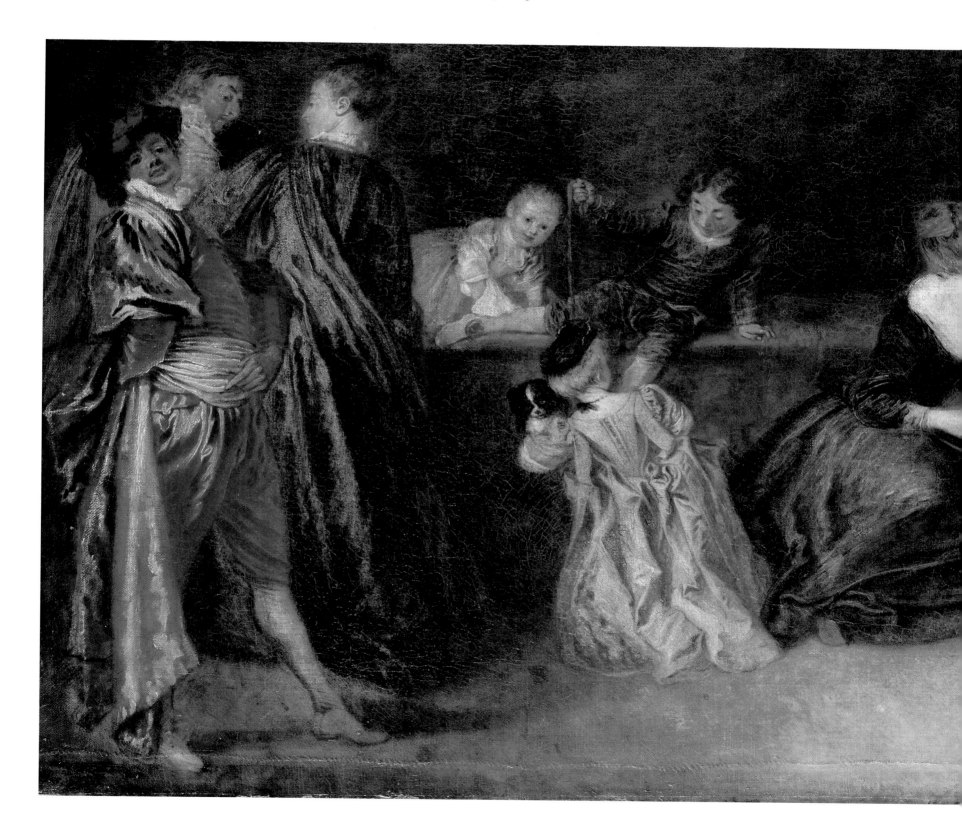

Reasons can also be cited for placing one of Watteau's few mythological paintings, *Diana Bathing* (ill. 115), in his last period. The self-contained figure of the goddess of the hunt is composed like a sculpture, and is reminiscent of the seated figure of Venus in *The Lesson in Love* (ill. 75). However, she is in fact borrowed from a painting by Louis de Boullogne the Younger (1654–1733), showing Diana with her nymphs bathing in a forest pool. Such pictures were popular, and often had additional themes added, for instance the discovery of the nymph Calisto's pregnancy, or the transformation of the hunter Actaeon into a stag. Watteau's picture is unusual in showing the goddess by herself, and in placing her in a bleak landscape. She is cooling her foot in a mere pond, and the stump of a tree on the right with its strangely shaped branches is like the stunted willows seen beside similar pools in the early military pieces. As a huntress, Diana kills; this is the factor linking her picture to the scenes of war, and the strange formation of roots with the dead hare in the late painting *Halt During the Hunt* (ill. 85) can probably be explained in the same way. This bleak presentation of nature contrasts with Diana's charming, soft, breathing female body. Parallel to the contour of her back, a slanting cloud of smoke rises. The swift execution, the rhythm of the brushwork as it adds dots of color, and the deliberate construction of the composition all convey a sense of conflict that must have had its roots in the painter's state of mind.

The relaxed painting of the nude and the chalky tone of the whole are very reminiscent of the Venetian painter Antonio Pellegrini (1675–1741), brother-in-law of Rosalba Carriera, who stayed with her in Paris in 1720 and must have met Watteau at the time. The architecture in the background is also Venetian, inspired by landscapes of Domenico Campagnola.

Not least because of its relatively large format, this picture may be set beside the shop sign (ill. 9), and can also therefore be dated to the artist's last period. Two small, sketch-like pictures are related to it: *The Judgment of Paris* (ill. 116) and *Vertumnus and Pomona*.

Rest on the Flight into Egypt (ill. 117) should probably also be assigned to these last months because of its dimensions – its height agrees with the later large-scale pictures – but even more because of its rapid, generous style, and the religious subject. The motif of the family is connected with the landscape, and just as the *fêtes galantes* of the late period always convey the idea that the pleasure they show is fleeting, this picture depicts only a short rest on the arduous way to the end of the Holy Family's journey. It is evening, and the darkness of night is falling from above right. The ruin in the background shows that there is nowhere for the Family to stay, and the opening in the vault to the left is probably to be taken as a reference to the tomb of Christ. This darkness is countered by the white dove of the Holy Ghost on Joseph's hand. The Christ Child is looking at the bird in amazement. His head is in the exact center of the picture, and His dangling right leg forms a vertical that continues above His and Mary's heads and divides the surface area. Mary could be a

sister of Diana. In the foreground is the large column base from the ruin, and it is on this that the Christ Child sits, indicating the work of salvation to come. The angels' heads are also part of the composition, and are clearly thought out despite their swift execution in the Venetian style. We may perhaps suppose that the lost *Christ on the Cross*, Watteau's last completed work, was executed in a similar manner.

Scarcely any other master has received such tributes immediately after his death, far exceeding the recognition given to Watteau in his lifetime. There are two main reasons: first, the existence of his imitators and successors, who were already active in the second decade of the 18th century; and, second, the reproduction and thus the distribution of his works through engravings. It was Jean de Jullienne, the painter's friend – two years younger and the prosperous manager of a textiles factory – who had the wealth of drawings Watteau left engraved and published in two volumes, in 1726 and 1728, under the title of *Les Figures de différents caractères*. Watteau had left these drawings, almost all studies and not finished works, to his friends Jullienne, Gersaint, Paul Maurice Haranger, and Nicolas Hénin (1691–1724, an amateur draftsman himself), and so they were readily available. It is remarkable that mere studies of this nature were thought to be well worth reproduction.

Jullienne also tried to acquire as many of Watteau's paintings as possible, and have them, too, reproduced as engravings. In 1739 the volumes – four in all – containing Watteau's entire oeuvre as far as it was obtainable were ready. His decorative wall paintings, now lost except for a few remnants, or the designs prepared for them were also reproduced. No fewer than 287 works were published in the two volumes containing his paintings.

This publication was unique, and in offering a complete view of an artist's entire oeuvre can be compared only with the engravings of the works of Rubens. It formed the basis for the wide distribution of Watteau's art in all European countries, but it also enabled them to be trivialized. The prints served as the

114 *Entertainment in the Open Air*, 1720/21
Oil on canvas, 78.5 x 95.5 cm
Schloss Sans Souci, Potsdam

As an engraved reproduction of 1733 shows, this painting, left uncompleted by Watteau, has been cut down on all sides, particularly on the right and the left. In a laborious process of restoration, the picture, already mentioned as much damaged in 1750, has had the 19th-century overpainting removed from almost the entire surface, and has recovered much of its original charm. The composition is simple. Three couples are arranged almost symmetrically. The central group, placed within a triangle, is flanked by two other pairs: one is turning toward us, the other turning away. It is difficult to understand the purpose of the woman with the little dog beside the guitarist, painted in the 19th century. Was there originally to have been a child here? Such an idea would be in tune with Watteau's thinking in his late period. The figure of Venus in the extreme left, known from the *Venetian Pleasures* (ill. 79), and the bachelor on the right, are turning away from each other, and are also separated by the light clump of trees.

115 *Diana Bathing*, ca. 1721
Oil on canvas, 80 x 101 cm
Musée du Louvre, Paris

This painting is obviously a late work, not least because of its firm composition. The line of the left leg dipping into the water is elongated into an axis above Diana's head, and divides the picture into two carefully balanced halves, just as the horizon divides earth and sky into zones of roughly similar size. What appears wild and chaotic in the landscape is subject to a compositional order. The torso of the mighty tree, first rising at a slight slant and then moving into the vertical, responds to the attitude of the

goddess of the hunt. This vertical divides a square on the left, with its diagonals formed by the back of Diana and her angle of vision. The color too is carefully calculated. The flesh tone is a mixture of the white of her shift and the red of her upper garment, and the arrangement of their folds traces the outline of her hips. The colors reappear in the arrows, together with the dull blue of the sky. The ideas developed in the *Halt During the Hunt* (ill. 85) are used here in a mythological setting.

116 *The Judgment of Paris*, ca. 1720/21
Oil on oak panel, 47 x 30.7 cm
Musée du Louvre, Paris

This sketchlike little picture has its closest relatives in the paintings invented by Watteau for Gersaint's shop sign (ill. 9). The naked back of the goddess of love dominates and divides the picture. The shift she is just taking off over her head falls like a cascade to the right, and Cupid, reaching up, responds to this movement. Mercury and Paris on the left of the picture give the effect of a single body. The feet of Cupid, Venus, and Paris, with the right foot of Athena as she angrily turns away, and the head of Paris's sleeping hound are all close together, and the composition grows organically from this point. Venus's shell-shaped chariot is the crown and conclusion. Juno is looking back at her rival as angrily as Athena does. The revelation of the beauty of Venus is the element of surprise that produces all the movement in the composition.

model for decorative paintings on walls, porcelain, boxes and similar items, and single motifs were often separated from the context of a composition and thus lost their real meaning. In this way the name of Watteau became a synonym for carefree dalliance and lighthearted pleasure, so that these reproductions, on which his popularity was based, quite often stood in the way of appreciation of the more profound aspects of his art.

However, the engravings also pushed up the prices for Watteau's paintings. Jullienne acted not only as a friend who wished to set up a memorial to his friend, but also as a good businessman. Once the engravings had publicized the many works he had acquired, he sold most of them at a good profit. The most famous collector of works by Watteau and his circle was Frederick the Great, who finally possessed about a hundred works in this genre. From the middle of the 1730s he developed his enthusiasm for the painter purely through looking at the engravings.

Among Watteau's successors Nicolas Lancret (1690–1743), six years his junior, was the most gifted and successful, and many connoisseurs thought that the two painters, who had met in Gillot's studio, were equal in merit. In 1719, when Lancret became a member of the Académie, he was described as a *peintre de fête galante*, and was thus, in effect, officially recognized as Watteau's successor. The relationship between the two men was good at first, but there was a breach between them when Lancret exhibited two paintings in the older artist's style, and Watteau received congratulations from people who thought they were his own work – an incident that casts light on his sensitivity.

Lancret showed great skill in his very French style, and gave his paintings an enchanting surface bloom, but at the same time he suppressed the underlying questions inherent in the genre, and encouraged the untroubled enjoyment of his art. Unlike Watteau, Lancret corresponds entirely to the popular idea of the Rococo period.

Jean-Baptiste Pater took the same approach. He adopted Watteau's style even more wholeheartedly, and also preserved the Flemish elements in his art, but he produced works so prolifically that he contributed to the trivialization of the genre.

François Boucher (1703–1770) took ideas from Watteau but developed them much more independently. He was one of the engravers of the complete works, and thereafter was an enthusiastic admirer of Watteau. Other Parisian artists of the time were Pierre Antoine Quillard (1701–1733), who went to Lisbon in 1701, Jacques de la Joue (1687–1761), Michel Barthélemy Olliver (d. 1784), François Octavien (ca. 1688–1740), and Bonaventura de Bar (1700–1729). In addition there were many unknown and mediocre painters who copied, varied, misrepresented, and even forged works by Watteau, something that is bound to happen when great demand for a painter outstrips the supply of his authentic works. A generation later, Jean Honoré Fragonard (1732–1806) took over Watteau's

ideas and developed them in a way that was quite consistent with his own. Just as the older artist had ushered in an epoch, the younger took his style to such extremes that the end was clearly in sight. It came like a thunderstorm when the French Revolution broke over the country.

In England, Philippe Mercier (1689–1760) was the most zealous imitator of Watteau. In Berlin, Antoine Pesne (1683–1757) painted several works in his style, and in Dresden Christian Wilhelm Ernst Dietrich (1712–1774) was the most skillful painter of works in the manner of Watteau.

With the awakening of German national feeling in the Romantic period, the French art of the 18th century was condemned as a product of decadence, and in Berlin only Frederick the Great's enthusiasm for it saved it from general contempt. However, the writer Wilhelm Heinrich Wackenroder (1773–1798) praised Watteau in his *Herzensergiessungen eines kunstliebenden Klosterbruder* ("Effusions from the Heart of an Art-Loving Monk") of 1797, a work that was a major source of inspiration for the devout art of the Nazarene brotherhood. When the Rococo rose in general esteem again in the second half of the 19th century, Watteau's reputation rose with it, and art historians began to study him. In the 20th century the 200th anniversary of his death in 1921 and the 300th anniversary of his birth in 1984 inspired studies of him. On the occasion of a great Watteau exhibition in 1984 in Washington, Paris, and Berlin, an extensive catalog was published by Margaret Morgan Grasselli and Pierre Rosenberg, as well as two excellent monographs on the painter by Marianne Roland Michel and Donald Posner. Without these three important works the interpretation of the painter that has been attempted here would not have been possible.

Watteau never used his genius to achieve power in the world of art, or beyond it in society. Nothing makes that clearer than a comparison with his fellow countryman Rubens, whom he admired so much. Rubens proved the political power of his art by his forceful use of it with a wide range of subjects and formats. Watteau, with his preference for small pictures, displayed the sensibility of one living on the fringe of society, observing events without taking part in them, but exerting a subversive influence simply by depicting what he sees.

117 *Rest on the Flight into Egypt*, ca. 1721
Oil on canvas, 129 x 97.2 cm
Hermitage Museum, St. Petersburg

Toward the end of his life Watteau was planning to return to Valenciennes, escaping from Paris as he had in 1709. If this is really one of his last pictures, its subject may be read as referring to his situation at the time.

CHRONOLOGY

1684 October 10: Baptized in Valenciennes. Born the son of a roofer, Jean Philippe October Watteau, and his wife Michele Lardenois.

1694/95 Watteau possibly becomes a pupil of the Valenciennes painter Jacques-Albert Gérin.

1702 Arrives in Paris, perhaps with one of the set painters employed at the Opéra in Paris. Paints copies for a picture dealer.

ca. 1707 Enters the studio of Claude Gillot. Works chiefly as a painter of interior decoration.

ca. 1708 Watteau becomes a colleague of Claude Audran III, curator of the royal art collections in the Palais du Luxembourg, which include the cycle on the life of Marie de' Medici by Rubens.

1709 April 6: admitted to the competition of the Académie.
August 31: wins second prize. He goes back to Valenciennes, then involved in the War of the Spanish Succession. The date of his return to Paris is not known.

1712 July 30: Watteau applies for admission to the Académie in Paris, and is asked to paint a reception piece.

1715 June 13: Watteau is visited by the Swedish collector Carl Gustav Tessin, who mentions the encounter in his journal.

1716 Watteau's friendship with the influential banker and collector Pierre Crozat, for whose dining room he provides paintings, is first mentioned. Crozat introduces Watteau to the Venetian painter Sebastiano Ricci, then staying in Paris.

1717 August 28: finally accepted as a full member of the Académie after delivery of the reception piece, *Pilgrimage to the Island of Cythera* (ill. 55). Stays with Crozat.

1718 Stays with his friend Nicolas Vleughels.

1719 Toward the end of the year, already suffering from consumption, Watteau travels to London, for reasons unknown to us. While there, he paints two pictures for the famous doctor Richard Mead.

1720 Returns from England in the summer. Rosalba Carriera mentions in her journal, on August 20, that she has seen Watteau at Crozat's. Watteau paints a shop sign for the art dealer Gersaint, with whom he is staying.

1721 Severely ill, the artist retires to Nogent-sur-Marne near Paris in the spring. Jean-Baptiste Pater becomes his pupil. Watteau dies at Nogent-sur-Marne on July 18, aged thirty-seven.

GLOSSARY

Académie, academy (Lat. *academia*; Gr. *akademia*), an institution or society for the encouragement of artistic or scientific studies and training. The first modern Academies were set up during the Renaissance in Milan and Florence, in imitation of the schools of classical antiquity. In the period of absolutist government, the idea of the Academy spread throughout Europe. The models were the Académie Française, founded in 1635, and the Académie Royale de Peinture et Sculpture, founded in 1648. In Venice, the Academy of the Visual Arts was not founded until 1754.

The term derives from a grove in Athens with facilities for gymnastic exercise that was dedicated to the Attic hero Akademos. Plato liked the place, and gave its name to the school of philosophy he set up in 387 B.C.

Allegory (Gk. *allegoria*, from *allegorein*, "express something differently"), imagery involving the pictorial depiction of abstract terms, subjects, and ideas, usual with reference to literary concepts. Allegory is usually concerned with characters, actions, and symbols; allegory was frequently employed in the 19th century in sculpture on buildings and monuments.

Amoretti (pl. of It. *amoretto*, diminutive form of *amore*, "love"), figures of small naked boys imitating the Roman god Amor or Cupid, usually winged, and appearing as deities of love in secular scenes.

Ancien régime (Fr., "old government"), term applied in particular to the absolutist form of government in the 17th and 18th centuries, to which the French Revolution brought an end.

Antiquity (Fr. *antique*, "old-fashioned," from Lat. *antiquus*, "old"), the classical antiquity of Greece and Rome. The period begins with the early Greek immigration of the 2nd century B.C., and ends in the West in A.D. 476, with the deposition of the Roman emperor Romulus Augustulus (ca. A.D. 475), and in the East in A.D. 529 with the closing of the Platonic Academy by the Emperor Justinian (r. 527–565).

Arabesque (Fr., from It. *arabesco*, "Arabic"), an ornament first occurring in classical antiquity and revived in the Italian Renaissance, consisting of stylized leaves and tendrils, and usually also including heads, masks, or figures. The arabesque became a graphic pictorial genre in the 18th century, when the stylized, sinuous line took on abstract qualities over and above its purely decorative aspects, and became a kind of reflective medium making statements about the relation-ship between the natural model and its artistic reproduction.

Arcadia, a pastoral region of Greece. At various periods, Arcadia or Arcady has been nostalgically presented in pastoral poetry as a place of sublime happiness with its inhabitants leading an ideal rural life, close to nature.

Attribute (Lat. *attributum*, "added"), an item shown with a character to identify or symbolize that figure, usually with reference to some important event in his or her life.

Baroque (from Port. *barocco*, "small stone, irregularly rounded"), in European art, the period between the end of Mannerism (ca. 1590) and the beginning of the Rococo (ca. 1725). The term comes originally from goldsmiths' work, in which *barocco* meant an irregularly shaped pearl.

Boulle, André-Charles, French cabinetmaker (1643–1732). The fine furniture made from his designs or in his workshop is described as "buhl," "boule," or "boulle." Its typical features are simple, clear design and great artistic and technical perfection. Boulle used all kinds of materials for inlay work, including tortoiseshell, ivory, tin, brass, and copper. His favorite motifs are bouquets of flowers enlivened by birds and butterflies. His major works come from the period of 1690–1710, and were made exclusively for Louis XIV. A "buhl clock" means a tall grandfather clock with its wooden case ornamented as described above.

Brighella (It.), stock character in the *commedia dell'arte*: a cunning servant, always involved in intrigues. He is related to Scapino, who was established as a figure in French comedy by Molière under the name of Scapin.

Cabinet painting (Fr. *cabinet*, "cabinet, small room"), a painting particularly suitable for a private cabinet because of it distinctive subject and its small format, and thus its portability. Cabinet paintings were first painted in the 15th century, their development closely linked to the rise of private collecting.

Capriccio (It. "caprice, conceit, product of the imagination"), a term for all kinds of fantastic depictions, usually grouped together arbitrarily under a certain theme. The capriccios of Francisco de Goya (1746–1828) are the most important in the genre after the pictures of Giuseppe Arcimboldo (ca. 1527–1593).

Colombine, stock female character of French comedy in the 17th century, derived from the flirtatious maidservant Colombina (Ital., "little dove") of the *commedia dell'arte*. She lived on in comedies of other European countries as a mistress, lady's maid, and general soubrette stereotype.

Column, usually a supporting architectural member, tapering upward slightly, with a round section, consisting of the base (foot), the shaft (central portion), and the capital (upper part). Most descriptions refer to the form of the shaft, for instance monolithic columns, made of a single piece; drum columns, made of drum-shaped sections; or fluted columns, with vertical grooves.

Commedia dell'arte (It. "comedy of art"), a genre of impromptu comedy performed by professional actors, dating from the middle of the 16th century in Italy. It developed from traditional spectacles at carnivals and fairs, and popular plays staged by traveling troupes who added differences of local color and dialect. There was no established text for these comedies, only a rough scenario on which the actors improvised monologs and dialog, supported by such

dramatic methods as mime and comic routines. The players impersonated stock types. Of the main roles, the more serious of these stock characters, particularly the pair of young lovers, were contrasted with the masked and costumed comic figures who reflected and caricatured human folly, figures often drawn from certain distinct Italian regions.

Complementary colors (from Fr. *complémentaire*, "complementary"; Lat. *complementum*, "complement"), pairs of colors that, because they are each other's opposites in the color circle (circular arrangement of the primary colors red, yellow, and blue, and their shades), have the maximum contrast and so, when set side by side, intensify one another. Green and red, blue and orange, and yellow and violet are complementary colors.

Copperplate engraving, a method of printing in which a print is pressed from a copper plate into which a design has been cut by a sharp instrument such as a burin; an engraving produced in this way. Invented in southwest Germany about 1440, the process is the second oldest graphic art after woodcut. See *Etching* below.

Crayon (Fr.), a term for sticks of color prepared with oil or wax to bind them. They include pastel, sanguine (red chalk), and black chalk. Originally the term was used for a number of different media for drawing, made of ground pigments and binding substances, shaped or cut into cylindrical or rectangular sticks about six or seven cm long.

Crispin (It. and Fr.), stock male character in French comedy of the 17th and 18th centuries. The actor Raymond Poisson imported the character of this ingenious and often unscrupulous servant into French comedy from the Italian *commedia dell'arte* (see above) in the middle of the 17th century.

Diana, an ancient Roman goddess, originally a deity worshipped by the Latin or Sabine tribes, goddess of wild beasts, and patroness of birth in both humans and animals. As a fertility goddess, she was equated with the Greek Artemis. From the Renaissance onward, scenes from the story of Diana were frequently depicted in art. Until the 18th century she was often shown as goddess of the hunt on decorative paintings and tapestries, in statues, and in cycles of the classical gods in Baroque outdoor sculptural ornamentation.

Doctor Baloardo, the character of the talkative, pedantic, pettifogging lawyer in the *commedia dell'arte* (see above). Learned, long-nosed, and pompous, he usually wore the black coat and white ruff of the lawyers of Bologna. Less frequently, he appeared as a doctor of medicine.

Etching, a form of engraving (invented around 1500 in Augsburg by Daniel Hopfer) in which the drawing is incised with an etching needle on a carefully polished copper plate covered with an acid-proof substance (the etching ground). When the plate is placed in an acid bath, the acid penetrates the areas of the plate thus exposed, producing a set of lines that will hold the ink for printing. Compared with the linear and regular appearance of an ordinary copperplate engraving (see above), etching allows a freer play of lines and more complex shading, creating painterly effects.

Europa, in Greek mythology the daughter of the Phoenician King Agenor and Telephassa. She was abducted by Zeus in the shape of a bull while she was playing on the seashore, and taken to Crete.

Fête galante (Fr. "gallant festivity"), one of the main themes of French Rococo painting (see below). It outstanding exponent was Antoine Watteau, for whose admission to the French Académie the genre of *fêtes galantes* was specially defined, as an artistically refined interpretation of the pictorial subject of social gatherings in the open air. Around 1900, under a different sense of alienation from nature and a new yearning for more humane relationships, the pastoral subject was revived by artists including Edouard Manet, August Renoir, Paul Cézanne, and Paul Gauguin in their groups of nude figures and bathing scenes.

Gable, in architecture, the triangular section at the end of a pitched roof.

Genre painting (Fr. *genre*, "kind, genre"), painting that takes as its subjects the depiction of scenes from everyday life. Elements of everyday life had long had a role in religious works; pictures in which such elements were themselves the subject of a painting developed in the 16th century with such artists as Pieter Bruegel the Elder (ca. 1625–1669). It was in Holland in the 17th century that it became an independent form with its own major achievements, Jan Vermeer (1632–1675) being one of its finest exponents.

Gilles, a stock male character of the French *parade*, a loosely linked sequence of dramatic scenes performed in the open air at the fairs of Paris at the end of the 17th century. At first related to the Pierrot of French comedy, Gilles increasingly became a pathetic figure, always down on his luck and a butt for the jokes of the other characters.

Grotesque (from It. *grottesco*, "wild, fantastic"), a decorative form originating in Hellenistic and Roman antiquity, with fantastic ornamentation including plant and animal themes. The term, coined in the 16th century, derives from the location of such decoration in underground areas (It. *grotta*, "grotto") of the Baths of Titus and the Golden House of Nero in Rome.

Grounding, the preparation of the support for a picture (e.g. canvas, wooden panel, paper) with a ground suitable for the required effect. Its absorbency and color depend on the materials used, the choice of a binder (leather glue, animal glue, casein adhesive), filler (chalk, natural plaster), and pigments (white zinc, white lead, green earth). The ground determines the appearance of the surface of a painting and affects its durability; in some circumstances it also allows conclusions to be drawn about its date.

Gouache (Fr., "watercolor painting"; It. *guazzo*, "watercolor"; from Lat. *aquatio*, "pool," and *aqua*, "water"), opaque watercolor painting, with gum arabic or dextrin as a binder and white pigment added. It is applied thickly, will lighten in color as it dries, and produces a grainy effect similar to pastel. It was used in illuminated manuscripts and portrait miniatures, and has been revived in modern times. Gouache is also the term for a picture executed in gouache technique.

Hand print, a method of graphic reproduction in which the print is made not by a press but merely the pressure of the hand, usually on a raised surface. The process can also be used to make copies of drawings executed in grainy media such as sanguine (red chalk). Prints of the French *cliché* type are similar; in this method fairly wear-resistant surface printing plates receive moldings of clay, plaster, or paper, and are used to reproduce the design. Such plates have been in use since the 16th century and today are usually made of plastics or metal.

Harlequin (Fr. Arlequin; It. Arlecchino), a comic character in the Italian *commedia dell'arte* (see above) created by J.M. Moscherosch in 1642. Arlecchino was originally one of the two servants among the stock characters, but developed later into a crafty and very witty figure. After the end of the 17th century his character took over the functions of the clown, and underwent many modifications in the French Comédie Italienne.

Hatching, in a drawing, print, or painting, a series of close, parallel lines that create the effect of shadow, and therefore of contour and three-dimensionality. In *crosshatching* the lines overlap.

Herm, column or pillar with a human torso and head, usually male, at the top. In classical Greece it was originally associated with fertility worship, and took the form of a square pillar with the bearded head of Hermes, messenger of the gods, and a phallus. Other deities were depicted on herms after the 4th century A.D.

Iconography (from Gk. *eikon*, "picture," and *graphein*, "write"), term referring to the content, meaning and symbolism of pictorial representations, especially in Christian art; originally, the art of portraiture in classical antiquity.

Insignia (Lat.), the emblems or symbols of the power and dignity of the state or of high social rank.

Kunstkammer (Ger., "art chamber"), paintings that represent a collector surrounded by his collection of art works. The genre emerged at the beginning of the 17th century, its creator being the Flemish artist Frans Francken II (1581–1642).

Landscape painting, an independent genre of painting dating from the late Middle Ages and the Renaissance, its subjects including the realistic or stylized depiction of landscapes combined with small incidental figures and architectural features. An *ideal landscape* is the depiction of a clear, harmonious, usually forested landscape full of sun and

light. Such works combine selected aspects from nature into a formal composition. Other characteristics are a foreground constructed like a stage set, and a view into the distance. This kind of landscape painting was developed around 1600 by Italian and northern European painters working in Rome. If historical or mythological figures and classical buildings appear in this genre, it is a *heroic landscape*. Another type of landscape is the *panorama*, which developed in late 16th-century Dutch painting. It displays a wide and extensive landscape seen from a height, with all the elements shown in miniature and of equal importance in the structure of the picture. A special form of the genre is the *pure landscape* (with no small incidental figures) of the 18th and more particularly the 19th centuries.

Maulstick (Dutch *maalstok*, "painting stick"), a stick used by painters as a hand rest while working. They often have a ball of leather or fabric at one end so that it can be laid on the painting itself without damaging the surface.

Memento mori (Lat. "remembrance of death"), a motif in images or texts on the subject of death. It emerges in literature and art in the Middle Ages, and in the same moralizing way as the *vanitas* theme it reminds readers or viewers of the transitory nature of life and earthly goods. A skull, an hourglass, an extinguished candle, or faded flowers are frequently examples of a memento mori, often directly confronting themes of sensuality and prosperity, especially in the Baroque period.

Mezzetin, a stock character of the 17th-century French Comédie Italienne. Mezzetin, the creation of the actor Angelo Costantini, was descended from the Mezzetino (It., "half-tone," because dark-complexioned) of the *commedia dell'arte* (see above), and was a direct parallel to and variant of Brighella (see above). He initially wore a servant's white linen smock and trousers, mask, and hat, and carried a wooden sword; later he also wore red and white striped clothing. He is graceful, extremely agile, bold and enterprising, musical, and he can do vocal imitations of many musical instruments and dance. He also appears in allegorical costumes.

Nazarene brotherhood, a group of German artists who worked largely in Rome 1810–1830. Inspired by their religious faith, they attempted to revive the spirit of medieval and Renaissance art and Christianity. One of the leading figures was Johann Friedrich Overbeck (1789–1869).

Neo-classicism (from Fr. *classique* and Lat. *classicus*, "excellent, of the first class"), stylistic development between 1750 and 1840 based on the example of classical Greece and Rome. It superseded Rococo (see below).

Oil paint, an opaque painting medium in which pigments are mixed with drying oils, such as linseed, walnut, or poppy. Though oils had been used in the Middle Ages, it was not until the van Eyck brothers in the early 15th century that the medium became

fully developed. It reached Italy during the 1460s and by the end of the century had largely replaced tempera. It was preferred for its brilliance of detail, its richness of color, and its greater tonal range.

Palladio, Andrea, real name Andrea di Pietro della Gondola (1508–1580), Italian architect and theoretician, active in Vicenza and Venice. His aim was to revive architecture on the model of the buildings of ancient Rome that he had studied in Rome and in the works of Vitruvius (ca. 84 B.C.). He designed his buildings with almost no decorative additions, giving full expression to the beauty of their proportions and the rigor and clarity of the design. His style was particularly influential in English architecture from about 1600, under the name of Palladianism or Palladian classicism, and was also the forerunner of neo-classicism in France and the Netherlands in the second half of the 17th century.

Panel painting, a picture painted on wood, or, in smaller formats, sometimes on copper. Panel paintings were a common method in the 12th century, and were widely distributed, particularly before the introduction of canvas as a support.

Pantalone (It.), one of the central male stock characters of the *commedia dell'arte* (see above). His dialect and costume identify him as a Venetian merchant. Although he is old, and usually unwell and tormented by gout, the miserly Pantalone casts a lustful eye on young women.

Pastel (from It. *pasta*, "paste"), a soft drawing stick, in a single color, made from pressed powdered pigment. Pastels, already recorded as being in use in France before 1500, and later made according to various recipes, were at first used in combination with more durable drawing media (silverpoint, charcoal, sanguine) merely to add color to the execution of a drawing (as in portrait drawings). These drawings were usually done on soft, tinted paper. The technique was used in the 16th and 17th centuries in Italy, France, and the Netherlands, and reached its peak in France in the 18th century. A leading figure in the use of pastels was the Venetian artist Rosalba Carriera (1675–1757).

Pastoral (from Lat. *pastoralis*, "of the shepherd's life"), the depiction of idyllic scenes of country life; found in the wall paintings of classical antiquity, revived in the Renaissance, and popular in the Baroque and Rococo eras.

Pelerine (from Fr. *pélerine*, really "female pilgrim"), a short, sleeveless shoulder cape of the kind originally worn by pilgrims.

Perspective (medieval Lat. *perspectiva* (*ars*), "to see through, see clearly"), a technique for representing three-dimensional objects on a flat surface. Perspective gives a picture a sense of depth. The most important form of perspective in the Renaissance was *linear perspective* (first formulated by the architect Brunelleschi (1377–1446) in the early 15th century), in which the real or suggested lines of objects converge on a vanishing point on the

horizon. The first artist to make a systematic use of linear perspective was Masaccio (1401–1428), and its principles were set out by the architect Alberti (1404–1472) in a book published in 1436. The use of linear perspective had a profound effect on the development of Western art and remained unchallenged until the 20th century.

Pierrot, (Fr., "little Peter"), comically melancholy figure of French comedy, with a baggy white costume and a white face; he developed during the 17th century in the Parisian Comédie Italienne from the character of a servant called Pedrolino or Piero in the *commedia dell'arte* (see above).

Pigments, the coloring ingredients (usually powders) that are mixed with water, oils or other mediums to form paint.

Prix de Rome, a prize granted from 1666 by the Académie de France in Rome, consisting of a stipend to allow French artists to stay in Rome and study there.

Putto (It. "little boy," from Lat. *putus*, "boy"), a small naked boy, with or without wings, originating in the early Renaissance in Italy, with reference to Gothic child angels modeled on the Cupids of classical antiquity.

Régence (Fr. "regency"), stylistic period in French art between the classical Baroque and the Rococo periods, i.e. during the regency in France of Philippe Duc d'Orléans (1715–1723). The center of this tendency was in Paris. Typical features of Régence art are unpretentious forms aiming for gentle transitions rather than abrupt contrasts (shallow pilasters, curves, the intertwining of ceiling and wall decorations). Exponents of this style were the architect R. de Cotte (1656–1735), the decorative artist N. Pineau (1684–1754), the furniture maker and inlay artist C. Cressent (1685–1768), and the ornamental draftsman G.-M. Oppenordt (1672–1742). The style influenced neighboring regions of Germany and the Netherlands. The interior decoration of the new town houses of the aristocracy, now liberated from the stiff ceremonial of the court of Versailles, was dominated by the symmetrical play of lines designed to clear geometrical principles, with intertwining leaves and acanthus tendrils.

Renaissance (Fr., It. *rinascimento*, "rebirth"), the progressive cultural period of the 15th and 16th centuries, originating in Italy. The late phase, from about 1530 to 1600, is also known as Mannerism. The term goes back to the word "rinascita" coined in 1550 by the artist and art historian Giorgio Vasari (1511–1574), which he meant at first merely to denote progress beyond medieval art. Through humanism, which called on the model of classical antiquity to create a new image of humanity, the world, and nature, with the emphasis on this world rather than the next, the Renaissance developed the idea of the *uomo universale*, the fully rounded man, talented and educated both intellectually and physically. The visual arts rose from the status of craft to

that of the liberal arts, and artists attained higher social status and greater self-confidence. Art and science were now in direct contact and influenced each other, for instance through the discovery of mathematically calculable perspectives and anatomical knowledge. Architecture drew on the theories of the Roman architect Vitruvius (ca. 84 B.C.) and was distinguished in essence by the adoption of features of classical building, and the development of palatial and castle architecture. The centrally planned building, in which everything related to the central point, was a typical Renaissance design.

Replica (from Fr. *réplique*, "answer, response, imitation"), the reproduction of a work of art by the artist himself, or his workshop, and almost identical with the original.

Repoussoir (from Fr. *repousser*, "push back"), an object, usually dark, placed in the foreground (and usually at the side) of a picture to reinforce the impression of depth.

Rocaille (Fr., "rock work, shell work"), asymmetrical Rococo ornamentation, in the shape of shells and undulating lines.

Rococo (from Fr. *rocaille*, see above), a European style of design, painting, and architecture between 1720 – 30 and 1770 – 80. Developing in the Paris town houses of the French aristocracy at the turn of the 18th century, Rococo was elegant and ornately decorative, its mood light-hearted and witty. Louis XV furniture, richly decorated with organic forms, is a typical product. In painting, the color palette became lighter. Leading exponents of the Rococo style included the French painters Antoine Watteau and Jean-Honoré Fragonard (1732 – 1806), and the German architect Johann Balthasar Neumann (1687 – 1753). Rococo gave way to Neo-classicism (see above).

Sanguine (also red chalk), a soft reddish brown drawing stick made from a mixture of red (iron) ocher and earth; it was already being used as a color in the Stone Age. It is pressed into sticks, and used in the form of red chalks. Sanguine was used from the end of the 15th century to the 18th century for sketches, and particularly, because of its likeness to flesh tint or carnation, for nude studies and portrait studies, often combined with other chalks. See *Trois crayons* below.

Scaramouche (Fr.), character from French comedy of the 17th century. A variant of the character of Scaramucca from the *commedia dell'arte* (see above), himself developed around 1600 in Naples from the character of the Capitano.

Stumping, the technique of rubbing the chalk or pastel marks on a drawing with the point of a slender roll paper of to create soft modulations of tone.

Supraport (It. *sopraporta*, "above the door"), decorative area above a door, containing a painting or sculptural relief.

Tabouret (Fr. "stool"), a four-legged stool.

Trois crayons (Fr., "three crayons"), drawing technique using black, red, and white chalk, usually on tinted paper. Antoine Watteau was the foremost exponent of the technique in the early 18th century.

Wash, a layer of thin watercolor or ink painted on a drawing.

SELECTED BIBLIOGRAPHY

Adhémar, Hélène: *Watteau, sa vie, son oeuvre*, Paris 1950

Boerlin-Brodbeck, Yvonne: *Antoine Watteau und das Theater*, Basel 1972

Börsch-Supan, Helmut: *Watteaus Embarquement im Schloss Charlottenburg*, Berlin 1983

Brookner, Anita: *Watteau*, London 1967

Champion, Pierre: *Notes critiques sur les vies anciennes d'Antoine Watteau*, Paris 1921

Dacier, Émile, and Vuaflart, Albert: *Jean de Jullienne et les graveurs de Watteau au VIIIe siècle*, 3 vols, Paris 1922–1929

Eisenstadt, Mussia: *Watteaus Fêtes galantes und ihre Ursprünge*, Berlin 1930

Ferré, Jean et al.: *Watteau*, 4 vols, Madrid 1972

Goncourt, Edmond de: *Catalogue de l'oeuvre peint, dessiné et gravé d'Antoine Watteau*, Paris 1875

Goncourt, Edmond and Jules de: *L'Art au dix-huitième siècle*, Paris 1859–75 (translated as *French XVIII Century Painters*, London 1948)

Macchia, Giovanni, and Montagni, E.C.: *L'opera completa di Watteau*, Milan 1968

Mathey, Jacques: *Antoine Watteau, Peintures réapparues, inconnues ou négligées par les historiens. Identifications par les dessins. Chronologie*, Paris 1959

Morgan Grasselli, Margaret, and Rosenberg, Pierre: *Watteau 1685–1721*, exhibition catalog, Washington, Paris, and Berlin 1984, 1985

Moureau, François, and Morgan Grasselli, Margaret (eds): *Antoine Watteau (1684–1721), le peintre, son temps et sa légende*, Paris and Geneva 1987

Nemilova, Inna Sergeevna: *Watteau and his works in the Hermitage* (Russian text with French résumé), Leningrad 1963

Parker, Karl Theodore: *The Drawings of Antoine Watteau*, London 1931

Parker, Karl Theodore, and Mathey, Jacques: *Antoine Watteau. Catalogue complet de son oeuvre dessiné*, 2 vols, Paris 1957

Posner, Donald: *Antoine Watteau*, London 1984

Roland Michel, Marianne: *Watteau 1684–1721*, London 1984

Rosenberg, Pierre, and Camesaca, Ettore: *Tout l'oeuvre peint de Watteau*, Paris 1970

Rosenberg, Pierre: *Vies anciennes de Watteau*, Paris 1984

Rosenberg, Pierre, and Prat, Louis Antoine: *Antoine Watteau 1684–1721. Catalogue raisonné des dessins*, 3 vols, Milan 1996

Stuffmann, Margret: *ean-Antoine Watteau. Einschiffung nach Cythera, L'Ile de Cythère*, exhibition catalog, Frankfurt 1982

Tomlinson, Robert: *La Fête galante. Watteau et Marivaux*, Geneva 1981

Vidal, Mary: *Watteau's Painted Conversations*, New Haven and London 1992

Zimmermann, Ernst Heinrich: *Watteau, Klassiker der Kunst*, Stuttgart 1912

Zolotov, Yuri: *Antoine Watteau*

PICTURE CREDITS